# Pictures of Innocence

The History and Crisis of
Ideal Childhood

**INTERPLAY**

THEORY · ARTS · HISTORY

# Pictures of Innocence

## The History and Crisis of
## Ideal Childhood

Anne Higonnet

With 100 illustrations, 8 in color  T & H  Thames and Hudson

© 1998 Thames and Hudson Ltd, London

First published in the United States of America in 1998 by
Thames and Hudson Inc., 500 Fifth Avenue, New York,
New York 10110

Library of Congress Catalog Card Number 97-61994

ISBN 0-500-01841-3 (hardcover)
ISBN 0-500-28048-7 (paperback)

Printed and bound in Slovenia

# Contents

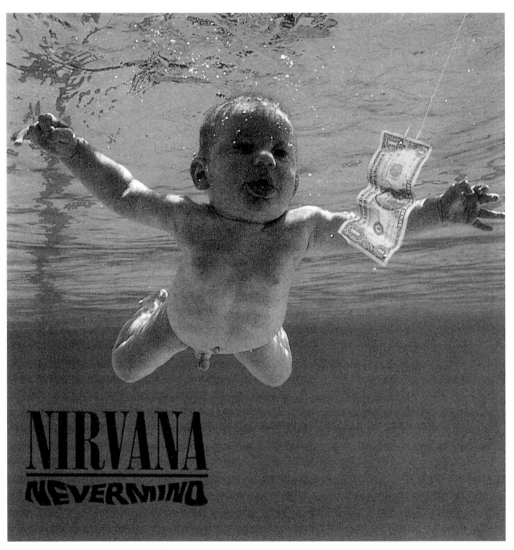

1  NIRVANA *Nevermind* album cover 1991

Pictures of children are at once the most common, the most sacred, and the most controversial images of our time. They guard the cherished ideal of childhood innocence, yet they contain within them the potential to undo that ideal. No subject seems cuter or more sentimental, and we take none more for granted, yet pictures of children have proved dangerously difficult to understand or control. This book is about how pictures have represented children, and about how an ideal of childhood innocence has entered a crisis out of which a new definition of childhood is emerging.

On a troubling edge between accumulated tradition and the unfamiliar, pictures of children in all visual media, including the most popular, must now contend with hopes and fears felt acutely by millions of people. Take the quite ordinary, and therefore all the more revealing, case of an advertisement launched in the summer of 1997. The Estée Lauder company introduced its fragance called *Pleasures for Men* with a photograph of a man and a boy resting together in a hammock. In many ways the image is traditionally idyllic. Both people are beautiful, and their hammock is slung above a watchful dog; behind them stretches a white picket fence: signs of peaceful, faithful, domesticity. Above all, the image resonates with harmonious family snapshot memories. The Lauder image, however, was apparently not ideal enough. By September of 1997, the original version had been withdrawn from circulation and another put in its place. The only difference between the old and new versions was the addition of a tiny but densely symbolic detail: a wedding band on the man's ring finger.

Today, all photographs of children hinting at "pleasure" are suspect, let alone photographs of children explicitly titled "pleasures for men." Everyone brings to an understanding of photographs the associations, good or bad, suggested by their cultural climate, and now associations with pictures of children are anxious ones. Advertisements seek the identification of consumers with their images, so it is safe to assume the Estée Lauder company only wanted to appeal to a stylishly updated family ideal. But to be able to call any intimacy between an adult and a

child "pleasure" required negotiating deep concerns that childhood is no longer being experienced the way it used to be, either by adults or by children. At their most tragic, those concerns include a growing recognition of sexual child abuse.

We are living through a major change in our culture's understanding of childhood. But ideas about childhood have changed profoundly before. The last major change, which gathered critical momentum during the eighteenth-century Enlightenment, under the impulse of such influential texts as Jean-Jacques Rousseau's 1762 *Emile*, was not perceived as a threat, though its importance was acknowledged. Now we are going through what feels like a crisis, because any change in our current ideal of timelessly natural innocence is bound to seem threatening, if not entirely negative. The change we perceive also seems dangerously unfamiliar because it is so visual. While pictures did eventually reflect new notions of childhood by the eighteenth century, they certainly had not inaugurated those changes. In a highly visual late twentieth century, however, pictures lead. They offer us the first glimpse of what childhood might seem like in the future. And they have already become the most fraught focal point for resistance to any alteration in the idea of childhood. In the broadest sense, the image we have of childhood now is just that – an image.

Historians date the modern, western, concept of an ideally innocent childhood to somewhere around the seventeenth century. Until then, children had been understood as faulty small adults, in need of correction and discipline, especially Christian children who were thought to be born in sin. Pictures represented children accordingly. Art historians have observed that pictures of children underwent a major transformation during the Enlightenment, but have treated this shift as the discovery of a natural truth, rather than as a brilliant pictorial version of an invented definition. Precisely because the modern concept of childhood was an invented cultural ideal, it required representations. Fictions about lived experience were more consistent, more convincing, and more beautiful than any lived experience could ever be.

Visual fictions played a special role in consolidating the modern definition of childhood, a role which became increasingly important over time. To a great extent, childhood innocence was considered an attribute of the child's body, both because the child's body was supposed to be naturally innnocent of adult sexuality, and because the child's mind was supposed to begin blank. Innocence therefore lent itself to visual representation because the immediate visibility of pictures has always had a privileged ability to shape our understanding of

our bodies, our physical selves. The same modern period that created the ideal of childhood innocence, moreover, placed its faith in visual evidence. Sophisticated pictures ostensibly based on the eye's empirical observations, or, better still, the camera's optical machinery, could appear at once compellingly beautiful and persuasively real.

The first great movement in the visual history of childhood innocence was led by elite eighteenth-century British portrait painters, among them Sir Joshua Reynolds, Thomas Gainsborough, and Sir Henry Raeburn. Borrowing, distilling, and altering elements from the art historical past, these painters introduced a new vision of the child, a set of visual signals brilliantly embedded in individual pictures, and so basic they could inform all future pictures. I call this vision, this collective image, Romantic childhood. Romantic childhood caught on quickly. After its initiation in the mid-eighteenth century came its diffusion during the nineteenth century. Gradually, the visual invention of childhood innocence permeated popular consciousness, swept along by the proliferation of image technologies which generated more diverse and inclusive types of pictures, artists and audiences. From its origins in elite painting, the image of Romantic childhood spread to popular genre paintings – some of which, such as Sir John Everett Millais's beloved *Cherry Ripe*, were turned into best-selling prints or advertisements – and from there into the mass market of industrially produced illustration. As it was being commercialized, the image of the child was simultaneously being feminized. Most of the women who aspired to painting careers were effectively allowed no other choice of subject. Artists as gifted as Kate Greenaway, Mary Cassatt, and Jessie Willcox Smith were therefore dedicated to perfecting the image of Romantic childhood, not despite but because of its decline in esthetic status.

Photography inherited their work. The visual habits so thoroughly acquired during what is known as the Golden Age of Illustration passed directly into the medium of photography. More convincingly realistic than any other medium, photography made it possible for the ideal of Romantic childhood to seem completely natural. Cheap, easy camera equipment and film processing put pictures of children at almost everyone's disposal, both to look at and to make. The more people saw or made photographs of children, the more axiomatic the image of childhood innocence became. Today, approximately half of all advertisement photographs show children. The most successful commercial child photographers, notably Anne Geddes, sell millions of pictures. Billions of amateur snapshots of children are taken each year – somewhere between 8.5 and 12.5 billion in the mid 1990s in the United States alone.

Yet it is photography which at the same time has precipitated the current crisis in childhood's image. The conditions of that crisis were latent in the ideal of absolute childhood innocence itself, and have been vividly revealed because of a similarly absolute belief in photography's objective neutrality. In practice, rigid oppositions between childhood innocence and adult passion, particularly sexual passion, are difficult to maintain. Nor can a photographer's subjective participation in the photographic process ever really be eliminated. Intentionally flagrant violations of cultural ideals such as childhood innocence and photographic objectivity do, of course, occur constantly. More subtle and powerful, however, in the long run, are the inadvertent slips allowed by conscious adherence to those same ideals. The most challenging pictures of children have been produced by a combined faith in the child's innocence and the camera's neutrality: photographs which force us, as viewers, to see what our ideals deny, just as they expressed what their own makers could not admit. Take the notorious example of Lewis Carroll, author of *Alice in Wonderland* as well as photographer of little girls. Carroll insisted his camera, being mechanically automatic, could do nothing but capture the truth of childhood, which, he also insisted, was inherently innocent. Somehow, though, Carroll's photographs suggest otherwise. And Carroll's photographs were not the only ones. Ever since the medium was officially inaugurated in 1839, photography has been unsettling the certainties of ideal childhood, marginally at first, and now unavoidably.

As photographic variations on innocence accumulated over time, reaching the most popular commercial mainstream, as well as the canon of photographic history, it became inevitable either that the ideal of innocence would be challenged, or that photography would be accused of endangering that ideal (or both). More and more sexual meanings are now being ascribed to photographs of children both past and present, whether because of what is in the photograph or what is in the eye of the beholder. Neither the esthetic quality of a picture nor its author's explicitly stated purposes can prevent the mutation of its meanings – on the contrary. Great photographs and articulate programs attract multiple interpretations, sometimes layered on each other, as in the case of Edward Weston's hallowed 1925 *Neil* series. The trend to see sexuality in photographs of children accelerated in the late 1970s, leading to scandals over controversial art photographs like Robert Mapplethorpe's, but even more significantly over mass-media commercial photographs like Calvin Klein's notorious 1995 jeans ad campaign. Erotically suggestive images of children – perhaps deliberately erotic –

now pervade all media, appearing with increasing frequency in spectacles ranging from fashion photography to Disney movies to intellectually ambitious art works to televised sports and beauty pageants. All the difficulties of Romantic childhood have surfaced.

When we look at troubling images of children we not only see abstract meanings, but dread real consequences. At every moment in all societies, the connection between some kind of representation, some form of expression, and actual behavior arouses extreme anxiety, social revulsion, and state repression. In late twentieth-century western societies, pictures of children scare us more than any others. It is terrifying to think of a picture causing someone to harm a child, and particularly horrifying to think of a picture causing someone to molest a child sexually, inflicting a heinous combination of physical and psychological damage.

One reaction against fear has been to protect children by controlling pictures. Law, public criticism, commercial pressure, the withholding or withdrawal of pictures from exhibition or publication, all have been deployed against images. While all these means can have powerful effects, law clearly wields the most force. During the last fifteen years, prohibitions against child pornography have been introduced and constantly expanded in several western nations, most dramatically in the United States. Extremely precise and unassailable measures concerning real children and real actions are mingled in this legislation with measures purporting to protect real children, but in effect censoring the interpretation of images. Most problematically, recent measures have moved child pornography law into zones of completely subjective interpretation. Suddenly, any image of a child in which someone, anyone, sees sexuality can be prosecuted as criminal child pornography. Inherently personal opinion now suffices to send someone to jail for years, or to launch investigations that may never bring even indictments, let alone convictions, but can still shatter reputations, consume years, and cost astronomical legal fees. At first, child pornography laws were aimed at photographs that documented crimes perpetrated against real children; then they targeted photographs suggesting sex acts, whether those acts were simulated or not; next they attacked photographs of child nudity, followed by all remotely suggestive pictures of real children, clothed or unclothed; and as it now stands child pornography law includes in its scope all images of children's bodies, regardless of whether the image represents a real child or not. All computer-generated images are therefore potentially suspect, and so, by logical analogy, are also all paintings, drawings, sculptures, etc.

Because some images, especially photographs, look realistic, all images are being treated by child pornography law as if they were themselves real, as if images were the same as actions.

All pictures of children are now suspect, yet the existence of child pornography laws allows us to hope we can easily draw a line between the safe and the dangerous, between the good and the bad. The demonization of something branded "child pornography" lulls us into ignoring our own quite ordinary complicity in a culture-wide phenomenon. Everywhere we look, the image of childhood is changing, aided and abetted by eager media consumers of all ages. In many different ways, the image of the child is becoming more physical, and more involved in the world of adults. Some of those changes may be negative or exploitive, but the magnitude itself of the transformation indicates a major shift in an entire culture's ideas, not a fringe criminal phenomenon.

Combined with a lack of historical perspective, denial of the present prevents us from coping with irreversible change by fixating us on mythic nostalgia and false culprits. Whether we want to recognize it or not, the visual definition of childhood invented in the eighteenth century is being reinvented. We are now uncomfortably caught between two ways of defining childhood, and neither is easy to live with. In its death throes, the old Romantic ideal reveals its weaknesses and falls prey to ruthless demands for profit and publicity. At the same time, however, another vision of childhood is emerging. Images by a growing number of photographers, many of them the parents of their subjects, represent children who, far from being psychically or sexually innocent, are what I call Knowing children. Unlike Romantic images, Knowing images, for the first time in the history of art, endow children with psychological and physical individuality at the same time as they recognize them as being distinctively child-like. It is difficult to turn from cherished and polished traditions to these new pictures. Being new, they can be abrasive, exploratory, or raw.

Is a Knowing childhood leading us away from a defense of children on the grounds of innocence? Absolutely not. Though new images of childhood call into question children's psychic and sexual innocence by attributing to them consciously active minds and bodies, those images leave intact the concept of children's social innocence, including innocence of adults' socially formed psyches and sexuality. We are, however, being asked to redefine innocence along with childhood. We now have to consider whether a child has to be psychically or sexually innocent to deserve protection, or whether social innocence is all the justification we should ever need to shelter children from adult abuse.

Two daunting problems argued against writing this book. Many people care deeply about the image of childhood. It is not safe to analyze the sacred, especially not when the sacred has shown its fallibility. If the Romantic ideal of an innocence defined sexually and psychically still protects children, however partially or problematically, it will inevitably seem dangerous to undermine that ideal or even put it in historical context, and danger can provoke angry reactions. A book on pictures of children replays the risks of the pictures it is about. Despite my best intentions, no one, including myself, can predict or control how this book's arguments and illustrations might be used, or misused. It is possible that my argument will be caricatured, or not read at all, that the illustrations will be taken out of the context of my argument, or sensationally described. Everything the book is about could be twisted into positions I completely disagree with.

Meanwhile, my own academic field dismisses the subject of the child as being trivial and sentimental, good only for second-rate minds and perhaps for women. Moreover, this is not a book entirely about artistically exceptional pictures, the kind of object to which art history has been overwhelmingly devoted. It is instead a book about both exceptional and ordinary pictures, or about pictures whose exceptional popularity derives from widespread belief in their relevance to ordinary life. The book is not even so much about pictures themselves as about how pictures function in the real world, and especially about how their function may depend on the connection people feel they have to reality. Moreover, the subject of childhood demanded an understanding of how image types of very different esthetic status affected each other. It would be impossible, for instance, to comprehend the power of the photographs of children we take most for granted today unless we saw how they inherited, and subliminally refer to, the prestige and genius of elite paintings. It would be equally impossible to appreciate the commercial femininity of the subject unless we knew the constraints under which women illustrators worked on childhood at the turn of the century. And as to our own time, we cannot fairly judge the intentions or the content of some contemporary photographs with the highest esthetic ambitions unless we know how they grapple with ubiquitous mass media images.

Nor are the obstacles placed in the way of a book about many sorts of pictures all academic. Most of the people I contacted directly who make images outside the tightly restricted world called "art" ended up being extremely gracious and informative, but they tended to be initially baffled by my earnest queries, as well as by the visual context in

which I saw their work. When it came time to gather permissions to reproduce images, I met considerable resistance on the part of those who did not feel a prior allegiance to academic inquiry, notably corporations, celebrities, and some – though by no means all - photographers who are extremely successful commercially. Nonetheless, I persisted, in the belief that history matters, and that pictures matter to history.

Obviously I ended up willing to take my chances both publicly and professionally. I was attracted to the curious contradiction between the two arguments, general and professional, against writing on pictures of children. The subject was being tantalizingly pronounced at once too dangerous and too safe, too difficult and too silly. More importantly, a principle seemed to be at stake. I was simply not convinced that my silence could effectively prevent real danger to real children. Pictures are a form of ideas, not reality. Nor did I believe silence on the idea of childhood would be without costs. Public debate over crucial issues has always been considered a fundamental attribute of democracy, and I can think of fewer subjects more vital than the subject of childhood, which is essentially the subject of how we form and value our collective future. I could continue in this abstract mode, but the value of free speech to free societies is a familiar one, so let me conclude more personally. I don't want to raise my children in a world governed by fear, especially not fear of what childhood might mean.

So I wrote the book. It is dedicated to my sons: Constantin René, whose presence inspired its start, and Philip Alexander, whose arrival hastened its finish.

"Axioms of geometry are only definitions in disguise."

HENRI POINCARÉ

Sir Joshua Reynolds's painting *The Age of Innocence* still looks familiar, even though it was painted in the late eighteenth century (ill. 41). True to its title, the image presents an archetype of innocence, one which the late twentieth century continues to cherish. Also true to its title, the painting defines an age – not the child's age, but an age of childhood. *The Age of Innocence* might as well be titled the invention of innocence.

It is a pretty picture. Clever composition allows plants, land, sky and clouds both to show off a child prominently in the foreground and to make her seem reassuringly small. At once aggrandized and miniaturized, the child sits quietly close: face, throat, chubby feet and arms near to us in the picture's space, creamily painted, soft peaches and cream unctuously brushed in rounded shapes – big eyes, downy cheeks, dimpled hands. We the viewers are being encouraged to take visual delight in this figure, but not in the same way we would enjoy looking at an adult. The parts of the body so prominently displayed are exactly those least closely associated with adult sexuality, a difference reinforced by the child's clothing, which wafts in pure white drifts across what would be adult erogenous zones. This opposite of adult sexuality appears natural. The child belongs so comfortably in nature that she doesn't need shoes, as the picture insists by pointing tiny toes right at us.

Because it looks natural, the image of childhood innocence looks timeless, and because it looks timeless, it looks unchangeable. Yet that image was invented, and not so long ago, by Reynolds, among other British portrait painters. The Age of Innocence began only about two hundred years ago.

The image of the naturally innocent child, which I call the Romantic child, simply did not exist before the modern era. We forget this historical

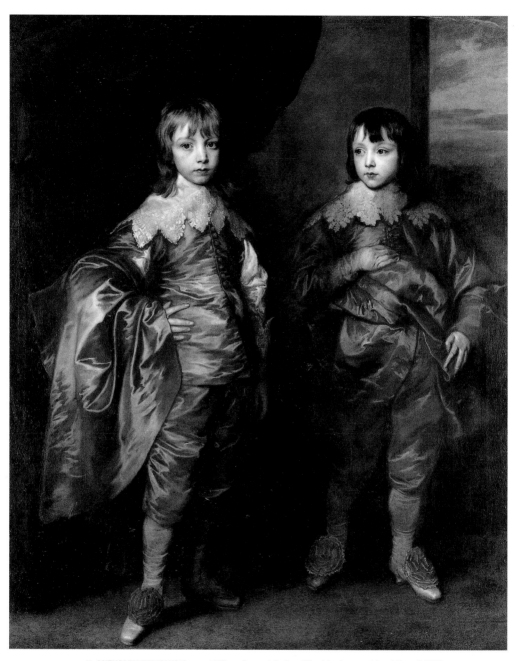

2  ANTHONY VAN DYCK George Villiers, Second Duke of Buckingham and Lord Francis Villiers 1635

fact because for the last two centuries the Romantic child has gradually permeated popular consciousness. Spreading from its elite origins in British academic painting, the modern image of the child moved into popular early and mid nineteenth-century painting, from there into mass-reproduced prints, and on outward through late nineteenth- and early twentieth-century commercial illustration into the photographic mass media of the present day. The images whose timelessness now seems axiomatic have a history.

Before about the middle of the eighteenth century, the bodies of children were basically pictured in the same way as adult bodies. With very few exceptions, children looked like small adults. They were dressed like adults, they behaved like adults, and they did not look innocent –socially, psychically, or sexually. Human children appeared in paintings and sculpture in order to indicate their future adult social status. Most of them were offspring of royal or aristocratic families, and the point of their portraits was to make that clear. Imperiously, these noble children gesture toward family lands or homes, lean benevolently from their thrones, or impassively stare in effigy, framed by captions that pronounce their rank. As late as the seventeenth century, little George and Francis Villiers, for instance, in their portrait by Sir Anthony Van Dyck, wear flame-red satin gleaming against stiff precious lace in the latest grown-up fashion, and adopt the pose that conventionally signalled adult masculine authority, hands on hips, toes turned out, one leg extended forward. Linked to their parents, either explicitly within a family portrait, or implicitly, the children in pre-modern art promise dynastic continuity and display wealth. Even in seventeenth-century Dutch art, which prefigures modern picture-making, the bodies of ordinary, not noble, children illustrate maxims and proverbs of adult life. In one ribald c.1650 scene by David Ryckaert titled *The Five Senses*, for instance, the boy present at his elders' carousing signifies smell; a woman pulls his shirt up from his bottom and the man nearby holds his nose.[1]

What about those frolicking winged babies and the adorable infants in Madonna and Child images? In the first place, none of them are human. The Christ Child represents the Christian God incarnate. Cherubs and cupids, too often confused, are very different creatures. Cherubs are Judeo-Christian divine angels who never were human. (At school I remember being sternly told by Catholic nuns that it was highly incorrect to picture cherubs with navels, since, being angels, they had no human mothers and hence no umbilical cords.) Cupids, quite the reverse of cherubs, are embodiments of Eros, pagan God of physical

love. Both cherubs and cupids in art before the eighteenth century wit-
ness or even incite bodily acts that are the diametric opposite of what
we in the twentieth century would call innocent. Cherubs lament the
sorrows, deaths, and tortures of Christian divinities. Cupids fill hearts
and bodies with lust, piercing their victims with arrows of desire. If they
ignite their targets successfully, then cupids cheer on courtship and
copulation of every sort, all in the name of classical mythology. The
ancient Greek theme of the "Rape of Europa," for example, which many
artists took a turn at, lets cupids flutter around the sight of a bull gal-
loping away with a woman in order to have sex with her against her will.

3  TITIAN Rape of Europa c.1560

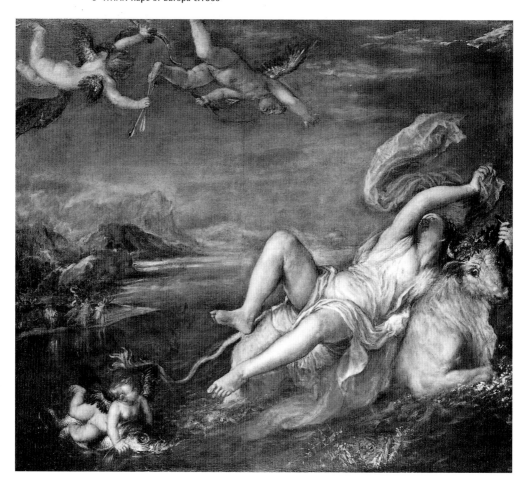

The display of the Christ Child's flesh once fulfilled a theological function. That function was specifically Roman Catholic enough for Madonna and Child images to be frowned on by Protestants until the late eighteenth century. In his wittily titled book *The Sexuality of Christ in Renaissance Art and Modern Oblivion* (1996), Leo Steinberg assembled dozens of Renaissance Madonna and Child paintings to prove how they consistently placed visual emphasis on Christ's vulnerably infant flesh in order to manifest the incarnation of God. If Christ were rendered at once visibly physical and physically visual, Steinberg argues, then Christians would be given tangible proof of a difficult concept, the concept of a God who was also a man. (Protestants objected to the reliance on visual proof, advocating individual faith instead.) Thus, Steinberg demonstrated, the Child's penis is at the center of most Madonna and Child images, whether exposed outright or covered, acting as the compositional fulcrum of gestures, drapery, and accessories. Even in a Madonna and Child at the edge of Steinberg's chronology, Raphael's tremendously famous *Sistine Madonna*, Steinberg's point holds good. The nestled heads of the Madonna and Child attract attention, but so does the presentation to viewers of the Child's entire naked body; His genital area is concealed from us by His raised thigh, but that area is marked by an intricate node of cloth, thigh, hands, and foot, at the very center of a strong equilateral triangle formed by the Madonna's and saints' heads.

Sexuality aside, the Christ Child is hardly psychically innocent. On the contrary, Madonna and Child images were intended to show that Christ, though humanly infant, already omnisciently knows his divine fate. So does his human mother. Crowns of thorns, sheaves of wheat, bunches of grapes, small crosses, and other devices symbolized Christ's acceptance of his future death by crucifixion. The Madonna shows her acceptance by her serious expression, as well as by the way she turns her child to us, beginning her sacrifice already. She knows her child must suffer, die, and be buried.

All rules have exceptions. Some children who look rather modern crop up from time to time in pre-modern art, though they were not understood then the way they are now. The children in Breughel's paintings, in Rembrandt's work, and perhaps Murillo's Spanish beggar children look familiar to modern eyes.[2] The faces of Van Dyck's children look more childlike than their bodies. Some exceptions can prove deceptive. French rococo art in the years just prior to the invention of modern childhood across the Channel produced scores of darling pudgy babies gamboling in the waves and clouds, frolicking among flowers

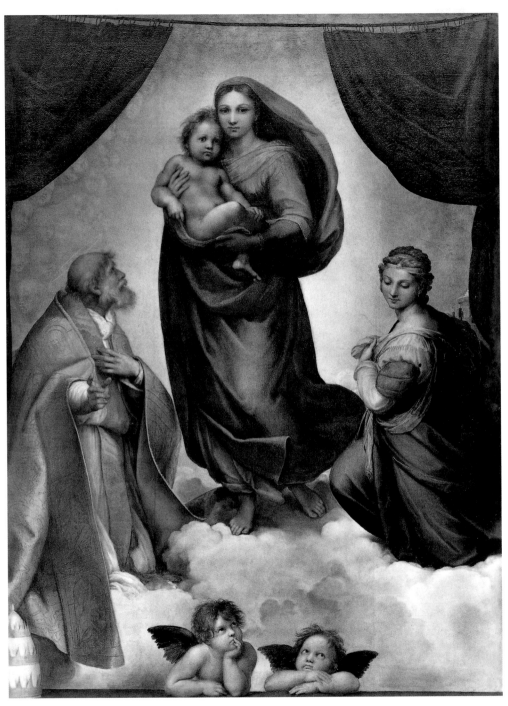

4  RAPHAEL Sistine Madonna 1513–14

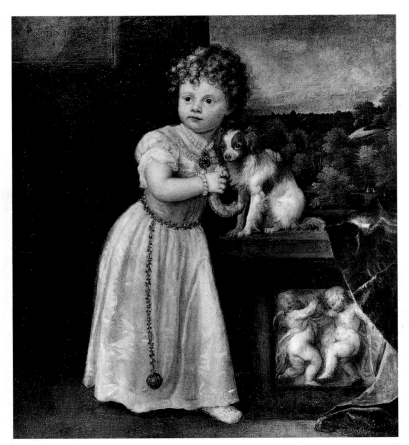

5 TITIAN Clarice Strozzi 1542

and ribbons, but their bodies were only one among many sensual invitations to adult rococo pleasures. Jean-Baptiste Greuze's semi-rococo sentimental children, so popular in the nineteenth century, provided the punch lines for moral tales, rather like children in seventeenth-century Dutch art, only the tales were more often sexual. Going much farther back, take the example of little Clarice Strozzi's portrait, painted by Titian in 1542. How novel, how fresh and spontanous, how childlike, exclaimed the great Renaissance pundit Aretino.[3] Yet the image sends an ambiguous message. The dancing cupid decoration, the offer of a tubular treat to that particular breed of spaniel, and the opulent jewelry at the child's waist, wrist and throat could all have been interpreted by contemporaries as slightly salacious puns.[4] Is Clarice only a delightful child or also a mini-woman, a Renaissance Gigi?

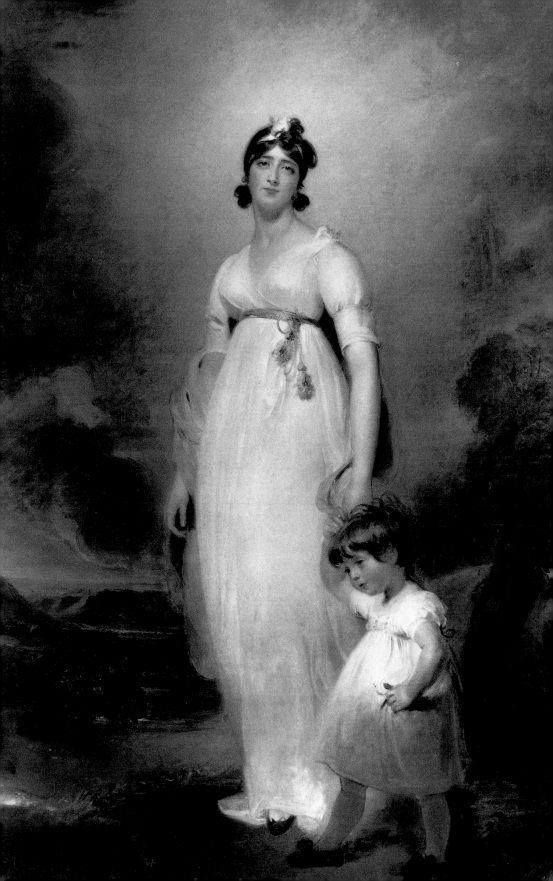

The Romantic Child

$A$ picture like Reynolds's *The Age of Innocence* adds up to more than the sum of pre-modern parts. Eighteenth-century British portraitists synthesized and altered art historical precedents to visualize a sweeping historical change in the definition of childhood. Unlike earlier scattered examples of pictures that look "childlike" to us, paintings by academic masters such as Sir Joshua Reynolds (1723-1792), Thomas Gainsborough (1727-1788), Sir Thomas Lawrence (1769-1830), Sir Henry Raeburn (1756-1823), and John Hoppner (1758-1810), created a consistent and sustained image of childhood, one which was perfectly in keeping with the latest social trends and written precepts of child-rearing.[1]

All of these new images of childhood revolved around an innocent child body, a body defined by its difference from adult bodies. Reynolds, adept at traditional as well as innovative modes of thinking, did produce some old-fashioned paintings of children: satires on adult life such as *The Infant Academy* (1782), scenes from classical mythology such as *The Infant Hercules* (1788), and religious subjects like his very popular *The Infant Samuel* (c. 1766). He also did paintings of children that lubriciously insinuate adult sexual pranks, notably *Cupid As Link-Boy* (c.1774). But it was paintings like *The Age of Innocence* that captured the modern western visual imagination and became the foundation of what we assume childhood looks like. Even the old-style subject pictures were quickly reinterpreted. By 1814 William Hazlitt was writing: "The one is a sturdy young gentleman sitting in a doubtful posture without its swaddling clothes, and the other is an innocent little child, saying its prayers at the foot of its bed. They have nothing to do with Jupiter or Samuel, the heathen god or the Hebrew prophet."[2]

What was so compellingly new about the Romantic child, as envisioned in Reynolds's *The Age of Innocence*, or Lawrence's *Portrait of Mrs John Angerstein and her son John Julius William* (1799)? Unlike most of their predecessors in Dutch and French art, these two Romantic children do not tell any story about adult life. On the contrary, these children deny, or enable us to forget, many aspects of adult society. Compared with Van Dyck's noble children at one end of the social scale,

and Murillo's beggar children at the other end, Reynolds's and Lawrence's children have no class. Or rather, they belong to a middle class that identifies itself discreetly with affluent cleanliness and absence of want. The child in *The Age of Innocence* may be barefoot, but her feet are pristinely clean, and both she and John Julius William wear immaculately white fragile dresses on their well-fed little bodies. Their dresses look remarkably alike, and so do their hairstyles, faces, and bodies, so much so that we can barely distinguish her from him. When we look at John Julius William alongside his mother, Mrs. Angerstein, their double portrait makes adult femininity and childhood look similar; in 1799 women's fashion veered close to the costumes invented especially for children: filmy white gowns with high waists, short sleeves, and sashes. But not so close. Mrs. Angerstein, monumentally and neoclassically statuesque (the portrait is life-size), appeals to the viewer sexually; both dress style and pose emphasize her full breasts, while she faces the viewer with a distinctly come-hither gaze, lips and eyes moistly glistening. In comparison, John Julius William isn't paying much attention to anything, and neither is his *Age of Innocence* counterpart. The Romantic child makes a good show of having no class, no gender, and no thoughts – of being socially, sexually, and psychically innocent.

Any idea as fundamental as a revision of childhood would affect many artists. One artist in a movement, though, can be more innovative and influential than the rest. A comparison between Lawrence's work and Reynolds's quickly shows Reynolds to be the more technically fluent, the more intimately persuasive, and the more formally imaginative of the two. In fact, Reynolds's vision of childhood was only one of the ways he dominated all British art. Ambitious, gifted, and tireless, he founded the English Royal Academy of painting, promoted grand history painting, made a fortune, and was rewarded with the presidency of the Royal Academy and a knighthood. He was the first professional English painter to behave as an equal to his patrons, daring even to keep a coach of his own. His patrons needed him, for he had the ability to make men look accomplished and women look beautiful. By the 1780s he had earned enough money to spend a significant portion of his time painting whatever he wanted.

Reynolds chose to paint children. Despite his official contempt for this minor, "genre" subject, Reynolds enjoyed doing what he called "fancy-pictures." He was busy and he was bossy, and for both these reasons he liked using models he picked from among the droves of London beggar children. He could tuck them into spare bits of time, hustling them out whenever a paying client arrived.

Reynolds cultivated a new kind of relationship with children that seemed unusual at the time, based on attention to, and enjoyment of, childish behavior. Reynolds's treatment of his young models reads like a passage from the latest child-rearing manuals, quite unlike the more traditional approach of, say, his rival portraitist John Hoppner. Hoppner had his wife whip children to keep them still, whereas Reynolds sought to amuse his child models while they sat for him, telling them fairy tales, playing tricks, romping and chatting. Reynolds's assistant James Northcote recalled: "He delighted much in marking the dawning traits of the youthful mind, and the actions and bodily movements even of infants; and it was by these means that he acquired the ability which enabled him to portray children with such exquisite happiness, truth, and variety."[3]

Many of Reynolds's pictures, like those of his contemporaries, send strong class signals.[4] Others, though, are quite ambiguous about class, principally because the children in them look so generically childlike. Who can easily tell, for instance, whether the child in *The Age of Innocence* is an aristocratic sitter, like John Julius William Angerstein, or, as happens to be the case, his own great-niece Offy, who lived in his household and modelled for the painting when she was about six.

Gainsborough's most famous portrait of a child, the *Blue Boy* (c.1770), is similarly evasive about class. The portrait seems to be formal, for the model wears a splendid satin outfit patterned on seventeenth-century clothing, exactly the sort worn by the young Villiers lords whose pose in Van Dyck's portrait Gainsborough adopts for his subject. Scholars, however, have discovered that behind the portrait's charm lies a socially equal relationship between the artist and a neighborhood child, Jonathan Buttall. They don't know for sure why Gainsborough made the painting, but it was not a commission, and Jonathan was not noble or even very wealthy.[5] Painters were paying less attention to the future adult social status of child models. Instead, they were treating children in a way that would convey another kind of distinction – their age.

Many factors converged to create a new appreciation of childhood. Luckily for art historians, their chronology is clear. Social historians deal with murkier evidence, because the representations on which they must rely do not necessarily reflect daily realities. Philippe Ariès, in his pioneering and influential *Centuries of Childhood*, first published in France in 1973, argued that adults cared rather little even for their own children before the seventeenth century, and that the idea of childhood as a distinct age to be treasured and protected emerged only in modern

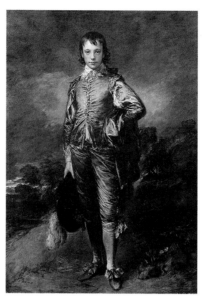

7 THOMAS GAINSBOROUGH The Blue Boy c.1770

times. Other historians have since disagreed with Ariès, arguing from other kinds of evidence that parents and children bonded long before the eighteenth-century Enlightenment.[6] Ariès may have relied too much on sporadic statistics, and too much on images, which he uses liberally as social evidence. In any case, by the time modern pictures of childhood began to appear in significant numbers, several concepts crucial to a new attitude were firmly in place: a private, nurturing middle-class nuclear family as the building block of society, a capitalist opposition between masculine public and feminine domestic spheres, and a political belief in the innate worth of the individual. Together, these concepts fostered a sheltered, mothering domain within which childhood could exist apart. Whatever the exact timing or rapidity of the change, an older concept of a child born in original Christian sin, correctible through rigid discipline, hard work, and corporal punishment, gave way to a concept of the child born innocent of adult faults, social evils, and sexuality.

Representations gave form to concepts. No written expression of the modern attitude to childhood was more coherent and eloquent than Jean-Jacques Rousseau's *Emile*, published in 1762, which declared in its third paragraph: "Childhood is unknown."[7] Like other Enlightenment philosophers skeptical of traditional religious teachings, Rousseau advocated raising children as "naturally" as possible, by which he meant

gently, with toys and play, in simple, light, loose clothing, outdoors whenever possible. Paintings by Reynolds, Lawrence, Gainsborough and their countless imitators look like illustrations of Rousseau's texts, and it may be no coincidence that Rousseau lived in England between 1765 and 1767, just before the British portraitists' vision of modern childhood swung into high gear. Those portraits, however, contributed something of their own to a modern concept of childhood, something specifically visual. Just as Renaissance paintings of the Christ Child made visibly manifest the theological concept of divine incarnation, so – by the same means but for the opposite purpose – modern paintings made visibly manifest the modern concept of childhood disincarnation. Images have always had a special power to represent the body, that is to present the body according to the concepts by which we understand our physical selves. The visual arts confront us physically, tangibly, with images of the physical, soliciting immediate empathy and projection. Nothing could make us understand the concept of an innocent child body better than pictures or sculptures.

A powerful paradigm overrides small inconsistencies. If children's bodies are so sexually innocent that they have no gender, then why do their eighteenth-century portraits subtly assign them masculine and feminine roles? Boys, apparently, quickly become men, while girls remain girls. Reynolds's little girl looks very much like Lawrence's toddler boy, but not nearly as much like Gainsborough's pre-teen *Blue Boy*. The *Blue Boy* stands commandingly on a hill; she sits passively. He stares right at us; she glances vaguely toward nothing. He has some distance from us; she is being proffered. Rousseau and his followers resolved this problem by claiming that femininity and masculinity were "natural" conditions, but if the *Blue Boy* is a natural child, then why the elaborate costume? More to the point, why does he seem, paradoxically, a more attractively natural child because he is costumed? Because what is more important than a logically consistent definition of nature is the separation of childhood from adult life, a separation dependent on a contrast between the child body and the adult body that exists in a desirous, experienced, and complicated present. Already in Gainsborough's time, the *Blue Boy*'s costume represented a bygone era rich in nostalgic associations.[8] Gainsborough made the associations of that clothing fit the concept of the modern Romantic child. The modern child is always the sign of a bygone era, of a past which is necessarily the past of adults, yet which, being so distinct, so sheltered, so innocent, is also inevitably a lost past, and therefore understood through the kind of memory we call nostalgia.

All Romantic children wear costumes, not just the *Blue Boy*. Reynolds's and Lawrence's children wear clothing that is supposedly "natural." It certainly fits less tightly and is made of less costly materials than contemporary adult clothing. Clothes, however, do not grow in nature. Societies design them, make them, and govern the conditions of their wear. Reynolds's and Lawrence's children are only more subtly and convincingly costumed than Gainsborough's *Blue Boy*. He masquerades as a seventeenth-century gentleman; they masquerade as Romantic children. The very difference between adult and child clothing first introduced by eighteenth-century fashion was an invention by adults.

Once the child is firmly differentiated from the adult, then a child can seem to be in masquerade even when wearing adult clothing. Ever since the eighteenth century, adults have reinforced this costume effect by dressing children in adult clothing which is too big for them. Take for example another extremely popular child portrait by Reynolds, *Penelope Boothby*. More than two hundred years after it was painted in 1788, *Penelope Boothby* still charms. The child's face is sweet, but the image is memorable because of the way the (ordinary) clothes are painted to make the child seem nestled in an over-sized fluffy cocoon. The mob cap, especially, looks amusingly too big and grown up. (Its puffy style was designed for the huge hairstyles then favored by adult women.[9]) Reynolds does not quite mock his model, but her youth, her smallness, is rendered as not-being-big-enough, as a discrepancy between her and her adult clothing, between her child body and an adult body that would fit these clothes correctly. Penelope Boothby has been endearingly miniaturized.

Like vanishing points on our chronological horizon, the Romantic child shrinks away to an unattainable distance from the adult present. According to Romantic pictures of children, innocence must be an edenic state from which adults fall, never to return. Nor can Romantic children know adults; they are by definition unconscious of adult desires, including adults' desires for childhood. The Romantic child is desirable precisely to the extent that it does not understand desire. So the image of the Romantic child is an unconscious one, one that does not connect with adults, one that seems unaware of adults. The child in *Penelope Boothby* is presented for us to look at, and to enjoy looking at, but not for us to make any psychological connection with. She glances ever so slightly aside; she is absorbed in childhood. We long for a childhood we cannot reach.

The image of the Romantic child replaces what we have lost, or what we fear to lose. Every sweetly sunny, innocently cute Romantic child

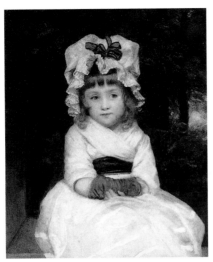

8 JOSHUA REYNOLDS Portrait of Penelope Boothby 1788

image stows away a dark side: a threat of loss, of change, and, ultimately, of death. Romantic images of childhood gain power not only from their charms, but also from their menace. That menace is both primal and actual. All children grow up, and some of them die. At the time the image of the Romantic child was invented, many of them died. Penelope Boothby, for instance. According to records, Penelope Boothby's parents doted on her. Already when they commissioned her portrait from Reynolds, they were trying to capture and preserve what they knew they were losing: the appearance of a three-year-old. Three years later, Penelope was dead, and her father tried again to make the visual arts compensate for her loss. Not only did Sir Brooke Boothby, who belonged to Rousseau's literary circle, publish a collection of verses titled *Sorrows Sacred to the Memory of Penelope* in 1796, but he commissioned the great Anglo-Swiss painter Henry Fuseli both to illustrate the verses and to make a painting of Penelope's soul. He also commissioned a marble funerary monument from the eminent English sculptor Thomas Banks. When the plaster model for the final sculpture was exhibited in 1793, the figure of Penelope moved viewers, including Queen Charlotte and the royal princesses, to tears. It was "drenched with sentimentality," an art authority wrote in praise at the time, "not dead but alive and sleeping ... the theme of Innocence is exploited to the full."[10]

The beautiful child corpse is one morbidly logical conclusion of the Romantic child image. Banks's sculpture was only one among earlier

acclaimed images of children ambiguously sleeping or dead. Countless mortuary sculptures or paintings, and, later, post-mortem photographs, were to follow. If the child's body appeals sensually to adults because it is unconscious, then the deeply sleeping, possibly dead body will be very appealing. The dead child's body is one that never did and never will know desire, that allows adults to project the full measure of their longing. In a more specific sense, these images of dead children deal with a terrible parental fear, the actual loss of one's own flesh and blood. Historians of childhood disagree most about this issue of the relationship between parental love and childhood death. Historians in Ariès's camp argue that the modern concept of the child could only develop once infant and child mortality rates declined enough for parents to invest their emotions in each and every one of their children from birth. Other historians argue that parents have always mourned the death of all their children, but that modern culture has allowed more outlets, like images, for their grief. Without taking one side or the other, I would say that the image of the Romantic child is haunted by death. A lowering vastness looms behind *The Age of Innocence*. Long before she actually died, Penelope Boothby's parents looked at her living beauty with death in their eyes. Images of the Romantic child have something profoundly in common with Madonna and Child images, though secular and thus different in their treatment of the child. Both image types lament the sacrifice of the child, so beautiful and precious, to a life that can only end in wrenching loss.

9 THOMAS BANKS Penelope Boothby 1793

Every Mother's Child

Banks's *Penelope Boothby* statue demonstrates how quickly the Romantic concept of the child spread through the arts. British portraitists gave the first push in the 1770s and 1780s. In less than two decades their visual example was taken up by artists like Banks, successful but not a genius. However different their gifts in degree, artists like Reynolds, Lawrence, Gainsborough, and Banks were all alike in kind: elite artists, intentionally working for the highest intellectual and social stratum of Europe. Their work could be directly known to a few thousand people at the very most, people who either bought paintings and sculpture, knew people who bought art, or saw it themselves in annual Royal Academy exhibitions – events which, though public, were still quite socially selective. By the middle of the nineteenth century, however, the visualization of the modern child initiated within the confines of an academic fine arts world had reached a very much broader audience.

Reynolds had led the battle in England to rank painting subjects. He adopted a hierarchy long enforced by painting Academies elsewhere in Europe. Reynolds identified himself with the grand history painting this system valued most highly, unaware, ironically, that his lasting impact on the history of images would depend more on the portraits and "genre" subjects his beloved system valued least highly. Genre painting depicted scenes from everyday life, present or past. Family life belonged to the everyday, and children became a sub-specialty within domestic genre. Until Impressionism rendered academic hierarchies obsolete for the avant-garde in the last quarter of the nineteenth century, genre continued to be considered a refuge for the least formally and intellectually ambitious artists.

On the other hand, genre painting sold well. The market for painting expanded during the early nineteenth century to include the newly monied middle classes. Not only did the demand side of this market ignore abstruse and archaic Academic precepts, but so, increasingly, did the supply side. Middle-class buyers might not know much, but the Academies learned to know what they liked. What middle-class buyers

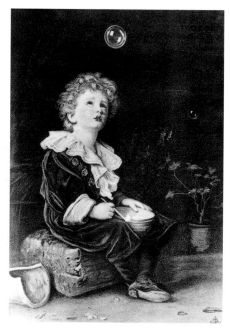

10  JOHN EVERETT MILLAIS Bubbles 1886

liked, not surprisingly, was to see images of themselves, or else to see versions of themselves set in their favorite historical periods. Once Impressionism had launched the concept of a rebellious avant-garde, mainstream middle-class taste became the province of the European and American Academies, the same Academies which, paradoxically, had earlier represented intellectual elites. During the second half of the nineteenth century, the most financially and institutionally successful artists were not the ones whose names art history remembers today, but artists who knew how to manage official careers, create work that perpetuated traditional moral standards, and also please a middle-class public.

All over Europe and the United States, paintings of children proliferated.[1] Some of the most socially respected painters made them. Sir John Everett Millais, for instance, was acclaimed a latter-day Reynolds. He began his career at mid-century as a founder of the controversial Pre-Raphaelite brotherhood, but soon after adapted his style and subjects to more conventional expectations. Constantly compared to Reynolds, he too was knighted and elected President of the Royal Academy. And he too painted immensely popular pictures of children. His French counterpart Adolphe-William Bouguereau also excelled in child genre paint-

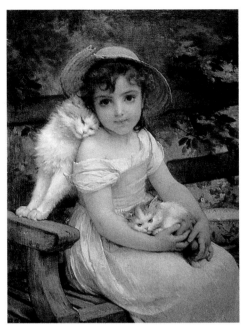

11  EMILE MUNIER Girl with Kittens c.1850–60

ing, especially updated Madonnas and cupid/angels: pictures, pre-
dictably, as influenced by the French rococo as by the eighteenth-cen-
tury English portrait tradition. Equally important, artistic mediocrities
painted children, indicating how widely a taste for the Romantic child
had spread by the middle of the nineteenth century. Who now knows
the career of Emile Munier or of Harry Brookner? But paintings like
theirs were the backdrop of Romantic childhood, the stuff of ordinary
budgets and households.

Whatever the price they commanded, the country they came from, or
the skill they demonstrated, nineteenth-century genre paintings of chil-
dren fell into subject types. Even though the types often overlapped
and, of course, are not totally inclusive, I will divide them, for the pur-
pose of quick reference, into five categories. Each of those types had
been invented or perfected in late eighteenth-century England, and all
of them centered on the child's body. Or rather, all five types in some
way proclaimed the innocence of the child, which meant concentrating
on the body in order to diminish its corporeality. Pictures of children
dressed up in special costumes, like Gainsborough's *Blue Boy* (1770)
and its descendant, Millais's *Bubbles* (1886), made the child seem time-
less. Children with pets, like Munier's *Girl with Kittens* (c.1850-60),

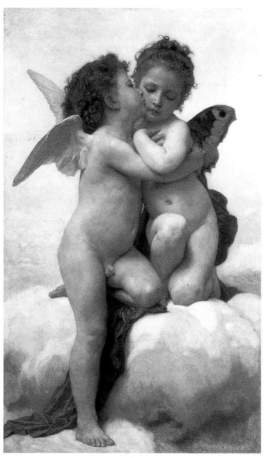

12 ADOLPHE–WILLIAM BOUGUEREAU The First Kiss 1890

liken children to animals, making the child seem less human, less conscious, more at one with nature; although we cannot see it now, the *Blue Boy* is also an ancestor of this type, for originally the boy was accompanied by a dog, since painted over.[2] Usually the pets are small and cuddly – kittens, puppies and bunnies were favorite choices – cueing the viewer's interpretation of the child; one 1851 picture by Alexander Hesler of a girl, a dove, and a rabbit was titled *Three Pets*.[3] Occasionally the pet is absurdly large, cueing instead the viewer's projection of his or her adult self into the image as the child's protector. The most popular way to present naked children past infancy was as a cross between an angel and a cupid. Merged and disembodied, cupids and angels became virtually indistinguishable from a new nineteenth-

century craze, the ethereal fairy child, as in Bouguereau's *The First Kiss* (1890). On the other hand, babies could be much more present, much more firm and hugable, especially when, if only to prop them up, they came with a mother attached. And last, often combined with other types, was the perennially popular genre of children unconsciously pre-figuring adult gender roles, as in Brookner's *Making a Doll's House* (1897).

13  HARRY BROOKNER Making a Doll's House 1897

Miniature adult, babe in mother's arms, winged tyke, kid with pet, dress-up fun – these five Romantic child types were adopted by artists of all abilities. Brookner's *Making a Doll's House* belongs to the low end of artistic production, yet it does its job. Today, the painting intones, he builds a house for her doll. Tomorrow he will build a home for her. And isn't she the real doll, so much more prominent than the sprawled toy on the floor? Even a picture as cliched as Brookner's deploys quite a few visual devices and cleverly appeals to both men and women. Examining the sub-sub-genre of paintings of famous men as children, art historian Susan Casteras has pointed out that gender roles are conveyed not only by the ostensible subjects of paintings, but also by the details of their composition.[4] In *Making a Doll's House*, the girl stands next to the hearth while the boy works near the window which offers the view onto an outside world. Two-dimensionally, her head is contained within lines. His head emerges from the domestic clutter. Casteras, an expert in Victorian painting, sees in such paintings a pattern that naturalizes adult gender roles by ascribing them to children. Of course the men like it. Patriarchy is justified. What about the women? Casteras suggests that women like this type of painting because it places boys, however provisionally, within feminine domestic space. Great men and great doings, these paintings promise women, begin in the home, a home which is securely women's domain.

At their most sophisticated, pictures of children's bodies evoke complexly ambiguous interpretations. Art historian David Lubin has devoted an entire book chapter to an American child genre painting, Seymour Guy's *Making a Train* (1867). A young girl stands facing the viewer in her lamp-lit attic room; as she holds some red fabric around her legs, letting it trail behind her, "making a train," her white shift falls down from her shoulders, exposing to us a completely androgynous little chest. Ostensibly, Lubin's research shows, the picture was intended to be seen, and was seen, as a tribute to childish innocence, heightened by its contrast to the adult feminine vanity the child so imperfectly mimics, just as the painting's organization around the sight of a childish chest dwells on a difference from adult women's breasts. Nonetheless, as Lubin astutely suggests, the child's body still triggers the viewers' adult sexual knowledge. Lubin decodes each of the many details in the painting, and every reference those details make to other pictures, in order to show that the painting's overriding message contains several messages, not all of them consistent. Are women so inherently vain that little girls play vamp? Is the lamp's shadow bringing darkness too close to the child? Lubin identifies the image pinned to the

14  SEYMOUR JOSEPH GUY Making a Train 1867

back wall represented in *Making a Train* as a print after Reynolds's *The Infant Samuel*. Does it mean that the image of a devoutly praying model child has slipped askew? Is the little girl sexy despite her innocence? Or, more troubling, is she sexy because of her innocence?[5]

The innocence of the modern Romantic child entails adult sexual knowledge. A polar opposition of values is also a binary opposition. If one value is defined mainly as the opposite of something else, then perceiving one value always entails thinking of the other value. Some nineteenth-century genre paintings keep the innocence-knowledge seesaw firmly settled on the side of innocence. Millais's *Bubbles* (1886), to cite an example dearly beloved in its time, is as clean as can be, beginning with its title. Upwards-gazing, the little boy is as light and airy as the bubbles he watches, at once mundane and magical. Yet the dubious overtones of paintings like *Making a Train*, *Girl with Kittens*, and *The First Kiss* let the innocence-knowledge seesaw tip back and forth, to

different degrees. Of course *The First Kiss* is meant to be cute, but both the image and the title are clearly also meant to allude to adult sexual behavior, regardless of the children's current innocence. Do the imagined girls in both *Making a Train* and *Girl with Kittens* mimic adult feminine flirtation a bit too well, providing viewers with the signs of sexual availability coyly grafted onto bodies coded with the signs of innocence? And what about the pussy in the little girl's lap? The unstable duality of images like these could call into question their entire lineage, for paintings like *Making a Train* and *Girl with Kittens* descend directly from paintings like *The Age of Innocence*. Looking from a twentieth-century vantage point on such eighteenth-century prototypes, art historian Marcia Pointon argues that they liken the girl child to the adult woman, at once infantilizing adult female sexuality and sexualizing the female child's body.[6] Importantly, Pointon alerts us to the vulnerability of the innocent girl.

Romantic innocence puts all children at a kind of risk. In an essential and brave book titled *Child-Loving*, literary historian James Kincaid warns against the dangers of the entire concept.[7] Defined as the opposite of adult sexuality, childhood innocence, according to Kincaid, runs the danger of becoming alluringly opposite, enticingly off-limits. Innocence suggests violation. Innocence suggests whatever adults want to imagine. If childhood is understood as a blank slate, then adults can freely project their own fantasies onto children, whatever those fantasies might be.[8]

Can we reconcile the dangers inherent in the idea of the Romantic child with late eighteenth- and nineteenth-century claims to cherish and protect childhood? We cannot, if we assume that all eighteenth-, nineteenth-, and early twentieth-century adults had the same relationship with children, relationships either actual or in fantasy. But of course Kincaid's point is that you never know. The concept of the Romantic child may render all children hypothetically vulnerable, but in practice adult projections onto childhood are bound to range from the predatory to the oblivious to the adoring. And here it becomes imperative to consider to whom images of Romantic childhood appealed. So far, the assumption has been that paintings of children were aimed at one uniform audience. That assumption becomes untenable as soon as the image of the child reaches a critical threshold of popularity. For when image types proliferated in the nineteenth century, audiences splintered. Never before had the prices and prestige of pictures fanned out so widely. Art historians of the nineteenth century have concentrated their attention on avant-garde painting and sculp-

ture, which on the whole was designed for patriarchal gazes, uses, and institutions. (A contested generality, to be sure, with many exceptions, but fair – on the whole.) Beside this dominant mode of art, however, sprang up many other image types with their own constituencies.

Already by the end of the eighteenth century, pictures of children were considered sentimental and therefore faintly feminine. In the decades just before and after the turn of the century, feminine sentiment did not necessarily taint pictures of children, nor was sentiment relegated to women only. The most ambitious and accomplished artists, writers, and audiences were all Romantic. But when Romanticism waned, childhood remained Romantic. The subject of childhood became intellectually marginal. Meanwhile, gender roles polarized; women became associated more closely than ever with domesticity. Childhood became a subject for women, a subject about women. The image of the child became increasingly associated with maternity, and pictures of childhood began to be designed for feminine audiences.

Placing the Romantic child image under the aegis of the mother altered its meanings. The best and most important example of that transformation is what happened in the late eighteenth and nineteenth centuries to Renaissance Madonna and Child paintings. In a superbly researched catalogue, David Alan Brown has shown how almost all Catholic theological significance was drained from Madonna and Child paintings and replaced by the meanings of a universal, non-denominational, maternity.[9] The two cherubs in Raphael's *Sistine Madonna*, to cite the most popular instance, were literally detached from their theological context, extracted from a religious painting and turned into single or double cherub portraits. Reproduced on their own, they were transformed from adoring sacral witnesses into adorable roly-poly babies.

In Benjamin West's *Mrs West and her son Raphael* (c.1770), he adopts the format, composition, and style of Raphael's *Madonna della Sedia* (1514), and therefore, ostensibly, its subject matter. But West doesn't purport to represent divinity. On the contrary, the title already tells us that West pictures his own wife and son (named Raphael after the artist he revered), and West confirms the painting's secular character by eliminating Raphael's ornate decorative details as well as his religious symbols: St. John the Baptist, haloes, and a tiny crucifix. Moreover, West emphasizes the physical bond between human mother and child by pressing the child's cheek more closely to his mother's and by letting the viewer see a tiny hand on the mother's shoulder.

15  BENJAMIN WEST Mrs West and her son Raphael c.1770 (detail)

Interpretations dear to mothers rewrote the history of art. Raphael
was considered in his time to be one of Europe's great artists, if not the
greatest, and his Madonna and Child paintings had always been
acclaimed. For art historians from Raphael's near-contemporary Vasari
to Reynolds, however, epic paintings of history and myth far out-
stripped in intellectual prestige any subject so simple as the Madonna
and Child. By the mid-nineteenth century, Madonna and Child paint-
ings, also known as Virgin and Child paintings, were re-ranked at the
top of the art hierarchy, and Raphael's greatness was re-located, with
the *Madonna della Sedia* and the *Sistine Madonna* consistently awarded
first and second prize for World's Greatest Paintings. In 1866, French
critic F.-A. Gruyer triumphantly concluded an entire book: "Raphael is,
in fact, above all a painter of the Virgin, and the Virgin is in art the
holiest incarnation of beauty."[10] Anna Jameson, England's first profes-

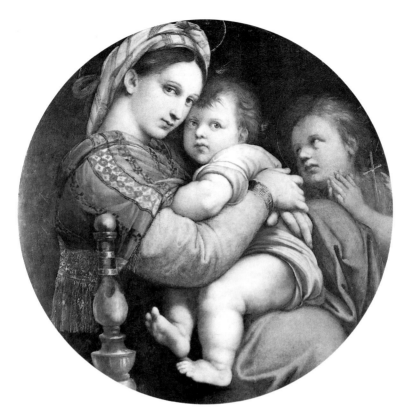

16  RAPHAEL Madonna della Sedia 1514

sional art historian, became a best-selling author by articulating this revision of Madonna images in the third volume of a book, abundantly illustrated with line drawings after dozens of paintings, called *Legends of the Madonna* (1852). For Jameson, the *Sistine Madonna* represented Woman: "at once completely human and completely divine, an abstraction of power, purity, and love."[11]

The effect was double-edged. Depending on your point of view, identification of women with the image of a mother worshipping her child could be either conservative or progressive, self-abasing or empowering, disembodying or erotic. In some ways, women denied their own bodies by identifying maternity with the Renaissance Madonna and Child image. Most obviously, they narrowed down female sexuality to maternity, which suited sexually conservative men perfectly well.[12] Rousseau, for instance, believed modern children needed mothers who

devoted all of their time to loving and nurturing them. Moreover, by identifying with the Madonna, also known as the Virgin, nineteenth-century women identified maternity with sexual renunciation. Catholic doctrine went so far as to maintain that Mary had been, as it is euphemistically put, immaculately conceived, a tenet even Protestants had difficulty with. God is the real Father of Christ, the missing member of the Holy Family in Madonna images, which might make the implied observer of Madonna images a man, the father, a godlike father. Certainly, there was plenty in all modern Madonnas for a masculine heterosexual viewer to relish, by identifying either with the absent father or with the baby. Nineteenth-century women consumers of Madonna images were acutely aware that the original paintings were virtually all authored by men. Indeed, nineteenth-century revisions of the Madonna image were divided between praise of a universally feminine maternity and praise of masculine artistic genius. The critic Gruyer, for example, praised both the Madonna and Raphael himself; in his study of the market for Raphaels in America, David Alan Brown has shown that the secularization of Raphael's Madonnas went hand in hand with soaring prices for his paintings.[13] Women, it could be argued, were doubly abasing themselves before the patriarchal institutions of Church and Art.

There are, however, other possibilities. Secularizing the Madonna image shifted its meaning from theology to bodies. Rather than looking like the Virgin Mary presenting Christ's redemptive future, Madonnas had come to look like a mother embracing her naked baby. In her 1875 *Christmas Carol*, for instance, the poet Christina Rossetti contrasted the spiritual adoration of angels with the physical adoration of a woman called "mother":

> Angels and archangels
> May have gathered there,
> Cherubim and seraphim
>  Thronged the air,
> But only His mother
>  In her maiden bliss
> Worshipped the beloved
>  With a kiss.[14]

If the Holy Mother was "mother," then all mothers must be holy. Reinterpreted Madonnas endowed all mothers' physical relationships to their children with a sacred aura. Motherhood became a holy calling. By 1891 the extremely successful academic English painter Lawrence

Alma-Tadema could paint an imposingly big picture of a decidely pagan classical Roman mother kissing the head of her decidely naked baby lying sybaritically on a couch among blossom-strewn silken pillows and title it *An Earthly Paradise.*[15]

By calling it "paradise," by identifying maternity with the sacred, the sensuality of the mother-child relationship was sublimated, which made it feasible within the strictest rules of proper femininity. Whatever was being physically enjoyed was also being denied physicality. And yet the enjoyment was there, masked in femininity. Precisely because it was so stiffly constrained by its religious and art historical origins, the Madonna image created a space of possibility within constraints, a space that allowed feminine viewers to desire the child's body maternally.

As Renaissance pictures of the Madonna acquired maternal meanings, modern remakes of Madonnas reinforced them. Even as early and close an adaptation as West's offered women something quite new. The relationship he depicts is one of pleasure, and not just his, but also a mutual pleasure within the image, and pleasure on the part of the viewer who identifies herself as feminine. Mrs. Benjamin West and her son are enjoying each other's touch, and their outward gazes as well as their postures solicit the viewer's participation in their enjoyment. If actual or potential mothers – namely, all adult women – were being told to identify with the Madonna, then they were also being allowed to enjoy what the (reinterpreted) Madonna was enjoying within her image: the physical pleasures of a child's body. The identification is with a biologically female maternal role, so the viewer has no problem identifying her female gaze with pleasure. Desire, however maternal, is nonetheless desire, and desire is by definition active. The image of the innocent child's body became a love-object women actively desired. The image of the child was less relegated to a feminine audience than actively claimed through identification by a feminine audience.

It was not just a question of what was represented within these new Madonnas – though the blessing of the Renaissance masters was crucial – but also the material forms they took. A modern maternal cult of the Madonna entailed not just the reinterpretation of original paintings, via words and illustrations, but the transformation of original paintings into reproductions of all sorts. The images were sometimes the same, especially in the case of Raphael's Madonna images, but the pictures were not, and neither were the functions of the new pictures. Some of the reproductions were relatively faithful to the original picture's physical qualities. Oil copies could be meticulously crafted and expensive.

17  O.G. REJLANDER Non Angeli sed Angli 1857

Henry James opens his 1876 novel *The American* in the Louvre with the hero meeting a young lady copying a Madonna and Child. He pays a very large price for her replica, 2000 francs – too high for her skill, but not for a really good copy.[16] Clever painters working in oil could afford to specialize in copying only one of Raphael's most famous Madonnas.[17] Some of these replicas survive in historic house museums, many in museum storage. Most reproductions of Madonnas, however, alter the details, the material, and the scale of original paintings, mutating into every two-dimensional medium: miniatures on ivory, porcelain, and cardboard, adaptations of whole or parts of compositions, prints of every size and technique, embossed, embroidered, and photographed. In 1857, for example, the eminent Victorian photographer O.G. Rejlander made a patriotic pun on the popular double detail of the *Sistine Madonna* cherubs, titling his version *Non Angeli sed Angli* ("not angels but English"). Prince Albert liked the picture so much that he put a copy in the personal royal family photo album.[18] In 1869 the reproduction dealer Prang was selling a photolithographic detail of the *Sistine Madonna* cherubs for twenty-five cents. He was selling a chromolitho-

graph of the entire painting, 22 inches square, for twelve dollars in 1891.[19] These cheap and easily available versions of Renaissance Madonnas did not require travel, or veneration, either in churches or in art museums. They could be bought or made, possessed, used, and lived with on a daily basis.

The cultural critic Michel de Certeau has written compellingly about a concept he calls "*détournement*," which translates only awkwardly from French as deviation, detouring, deflection, or cooptation: moves by which the original meanings invested in objects are transformed by new uses of the object or replicas of the object, often for the benefit of culturally marginal groups who could never have had access to the original objects or never participated in the original objects' intended functions. The phenomenon may remain marginal, but it creates an alternative pocket in culture's lining.[20] I would argue that the remaking of reinterpreted Madonnas into domestic objects was a massive and effective *détournement* of childhood's image by women. The *détournement* of Madonnas may have been double edged in effect, at once confining women to domesticity and glorifying that domesticity, but as a process it moved with spectacular energy. Isabella Stewart Gardner, wealthy art collector, was one of the few women who could speak of original unique Renaissance paintings when she wrote imperiously in 1905: "The Raphael I *want* is a *Madonna*."[21] (The emphasis is hers.) Yet what Gardner eventually did with her Madonnas and her Raphaels (alas no Raphael Madonnas) was fundamentally like what many ordinary women did with theirs. Unlike most of her masculine museum-founding counterparts, Gardner forced all her fabulous acquisitions into a spatial and semiotic context completely of her own design (the Isabella Stewart Gardner Museum), altering their meanings with her domestic meanings, imposing on art historical values her own values. What Gardner did with her masterpieces, other women did with reproductions. Sanctioned by the Madonna, women took possession of childhood's image through reproductions.

Precisely because Gardner worked with the most culturally prestigious pictures, by no means most of them Madonnas, and moreover on publicly institutional terms, her installation, her partial *détournement*, has survived. The much less prestigiously visible uses to which most women put their humbler pictures were almost all destined to disappear, which makes Kate Hayllar's *A Thing of Beauty Is A Joy Forever* a precious rarity (ill. 42). Within her painting, Hayllar vividly encapsulates the installations so difficult to reconstruct otherwise from fragmentary and dispersed evidence. Hayllar's artistic career is so obscure now that

the date of this picture is unknown; all the record says is that Hayllar was active between 1883 and 1900. Her painting is small, 12 1/2 by 9 inches, and in fragile watercolor. An unassuming material object, the picture moreover defers doubly to masculine genius, first by placing Raphael's *Madonna della Sedia* image at its center, next by being titled with a famous line of poetry by Keats. Yet something else is also happening. The image at the center of Hayllar's picture is authored by Raphael, but not the picture she inscribes within hers, for its black and white linear shading, so strongly contrasted with the rest of the picture's smooth, bright-colored volumes, as well as its wide border and multiple captions, announce that this is a print after Raphael. Thus remade, Raphael's image has been appropriated, and rendered, though central, controllably small in relation to its new situation. Placed on a mantlepiece next to a large decorative vase, behind a potted plant and a looming parlor chair, what the Madonna has come to stand for is ensconced among signs of middle-class domesticity. Hayllar situates the desiring maternal gaze within archetypally feminine space.

Maternal appropriation also seized other images besides Madonnas, images that did not include women but concentrated entirely on the child. Prints after eighteenth-century child portraits joined reproductions of Renaissance Madonnas among the most popular feminine items of image consumption. Reynolds, so canny in this respect as in others, had himself promoted the reproduction of his paintings in mezzotint prints, produced by skilled engravers.[22] One Reynolds scholar believes the painter may even have created some of his paintings for the express purpose of having prints made after them, taking advantage of a new export market for mezzotints that, from the 1770s, was quite profitable.[23] The market only got stronger with time, stoked by cheap print technologies and the increasing popularity of illustrated art history books, for example Sarah Tytler's *Childhood a Hundred Years Ago* (1877).[24] It was extremely plausible for a print after Reynolds's *The Infant Samuel* to appear on the wall of a girl's room in Guy's *Making A Train* (1867) because such prints were a ubiquitous ornament in both European and American children's rooms. As with Madonnas, the prints after eighteenth-century child-portraits generated all kinds of imitations, including actual outfits for children, a costume craze spurred by the fashion for children's "fancy dress balls."

By the end of the century the single most popular image of childhood was Gainsborough's *Blue Boy*, because it had been reproduced with such protean enthusiasm. By the beginning of the next century, the *Blue Boy* was widely known as the most famous painting in the world,

with the possible exception of Leonardo's *Mona Lisa*. Not the least reason for the *Blue Boy's* fame was that it became the world's most expensive painting when it was bought in 1921 from an English duke by the American collector Henry E. Huntington for more than $700,000. Why, however, had Huntington been so eager to buy it? Because it had become famous through reproduction. Some of Huntington's biographers think it may have been a print after the *Blue Boy* that sparked Huntington's interest in art in the first place.[25]

Mothers loved the *Blue Boy* look. The *Blue Boy* costume became synonymous with a mother's idea of how to dress a boy, especially after it acquired a black velvet look-alike in Reginald Birch's illustrations for Frances Hodgson Burnett's *Little Lord Fauntleroy* (1886). So much so that the costume became a symbol of maternal desire to keep sons androgynously childish. A boy's struggle to shed the *Blue Boy* look was therefore his struggle to leave the feminine domestic domain of childhood and enter the world of grown-up masculinity. This became a publicly discussed issue in the case of Burnett herself, who readily attributed the origins of Birch's illustrations to photographs of her costumed son Vivian. Burnett finally assured readers that she had cut her son's hair short and that he played heartily in sturdy masculine clothes.[26] One typically banal poem, published in a children's magazine in 1888 and illustrated with a drawing of a boy in *Blue Boy/Fauntleroy* pose as well as costume, describes: "A little boy in girlish frocks ... Has to learn his lessons,/ As he stands at Mamma's knee ... But it's hard for little Willie–/ So very, very hard–/ Who wants to scamper all the day/ About the sunny yard."[27]

Round and round the images went. Besides *Blue Boy* suits, another great dress-up favorite was a Penelope Boothby costume. In 1879, Lewis Carroll admired Xie Kitchen so much in her Penelope Boothby costume that he took her photo portrait wearing it. In the same year Millais painted Edie Ramage in a Penelope Boothby costume and called it *Cherry Ripe*. Millais adapted several other eighteenth-century images of childhood as well, including *The Age of Innocence* and the *Blue Boy*. Still more paintings, like his *Bubbles* (1886), were loosely patterned on the same kind of sources (ill. 10); the young *Bubbles* model wears the "skeleton suit" invented for little boys in late eighteenth-century England, which consisted of straight, loose pants buttoned to a short jacket, often worn over a white shirt with frilled or pleated collar.

Millais and others copied eighteenth-century images of childhood, but there was an important difference between the originals and the copies. Though the boys and girls in eighteenth-century portraits wore

" 'MY GRANDFATHER SAYS THESE ARE MY ANCESTORS,'
SAID FAUNTLEROY."

18  REGINALD B. BIRCH " 'My Grandfather says these are my ancestors,' said Fauntleroy" 1886

clothes that were newly invented, and therefore in a sense fashionable, they were already wearing costumes that set them apart from adult fashion. Having been set apart, children's clothing styles, especially in popular images, were cut adrift from adult clothing styles, whose fashions proceeded to change rapidly over the next century and a half, while children's fashion changed so little and consisted so much of revivals it could hardly even be called fashion. Or rather, children's clothing styles perpetually lagged, so that children often wore styles belonging to the past, whatever the past was in relation to a given present. Gainsborough had anticipated the future with his *Blue Boy* by dressing his model in clothing from the past, which may help explain why its popularity increased over the years. The *Blue Boy's* nostalgic sartorial undertow removed nineteenth-century portraits like Millais's doubly from the present, and by extension from adult life.[28] At any given moment, the child was clothed in signs both of not being like an adult and not belonging to adult time. Experience accumulates in time. Costumed timelessly, the child appears to exist before time began, before experience can begin. The great eighteenth-century child portraits equated childhood with innocence and with nature. The great nineteenth-century child portraits made the eighteenth-century naturally innocent child timeless.

19  After JOHN EVERETT MILLAIS Cherry Ripe 1879

A Golden Age

There was an important difference between Millais's *Cherry Ripe* or *Bubbles* and other adaptations of eighteenth-century child portraits. *Cherry Ripe* and *Bubbles* were both turned into prints reproduced in quantities so large that the image of childhood entered the mass media market. Reproduction rights to both paintings were bought by the Pears Soap Company, which used the images to illustrate advertisements and calendars. Pears made a safe investment, for when *Cherry Ripe* had been reproduced as a color centerfold in the *Graphic* Christmas Annual, soon after being painted, it sold about 600,000 copies within a few days.[1] Thanks to images like Millais's, mass marketing once again transformed the image of the Romantic child.

Millais may or may not have painted with an eye for commercial markets. His academic prestige certainly required him to deny any such motives. He professed, for instance, to be horrified when *Bubbles*, which was a portrait of his own grandson, appeared everywhere selling soap.[2] In any case, Millais's images began in a traditionally artistic way, as unique oil paintings (albeit modelled on other paintings). Millais's paintings bridged old and new ways of both producing and marketing images of childhood. The artist who took the next step was Kate Green-away, the great children's illustrator, whose work was designed for mass markets.

Greenaway employed the same kinds of images as Millais and others, but she gave those images a new style and new functions. Like other artists of her time, Greenaway too cited eighteenth-century portrait paradigms, dressed her children in Romantic children's clothing and set them in a perpetually pre-industrial English countryside. (It is often said that Greenaway's costumes and settings are contemporary but rural. This interpretation, however, ignores the eighteenth-century origins of rural clothing, and the nostalgia felt for a vanishing agrarian society by predominantly urban audiences. In other words, a quaint rural look was just another way of reviving mythic eighteenth-century values.) Unlike artists successful on traditional terms, Millais being the best example, Greenaway's career did not rest on the production of

unique, exceptionally valuable objects, and in that sense her work emerged from feminine consumer practices. Unlike the protean images circulating within feminine visual culture, however, Greenaway's work was the personal product of her imagination and skill, and she engaged her work in the public domain, not only in the professional art world, but also in the world of business. Greenaway's work was a kind of hybrid between paintings like Millais's and derived images like Hayllar's, like both and like neither: at once original and replicated, stylistically brilliant and formally simple.

Kate Greenaway shared Millais's genius for imagining popular children. She did not, however, share his artistic options. Because she was born a woman in 1846, she could hardly have hoped for professional training to become a painter at all, let alone a painter as institutionally powerful as the President of the Royal Academy. Instead, she was pointed toward a career in what were called, and treated as, the minor arts. Although she did complete her artistic education at the progressive Slade School, most of her school years were spent in a local art school and then at the National Art Training School at South Kensington, where endless exercises taught her to produce designs for commercial decorative objects.[3] When Greenaway managed to place a watercolor and some drawings of imaginary children in a show at the elite Dudley Gallery in Piccadilly, her success there led to illustrations for *People's Magazine*, as well as for other authors' children's books, and to greeting card design.[4]

The first greeting card was published in London in 1846.[5] New commercial image industries were taking advantage of expanding markets and rapid changes in printing technology, led by a new kind of art professional, the commercial art director, as well as by enterprising printers and publishers. The inventions of lithography and wood engraving at the end of the eighteenth century made possible larger editions of images at cheaper costs than ever before. Greenaway's father, for instance, was a wood-engraver, one in an army of hired workers which turned designers' drawings into engraving blocks of tough end-wood which could be run through a printing press along with type: one block for the outline, one for each of the three primary colors. The quality of the final printed colors depended on both the color printer's skill and the suitability of the design to the medium.

Greenaway worked fast and well at commercial illustration. Her first card, a Valentine, bought by the Marcus Ward Company in about 1873, sold 25,000 copies within weeks,[6] and the approximately 150 to 200 cards she designed during the following decade[7] were also extremely

popular. Greenaway worked almost anonymously for about six years. It didn't matter that her name was unknown, because the children she imagined had become her signature. More than a century later, Greenaway's work is still familiar and in print.

Greenaway, however unwillingly, was in the right place at the right time. She may never, in some hypothetical sense, have been able to be a painter, although the issue of her skill is bound up with the kind of training that directed and shaped her native gifts. Regardless, success in painting would have been a waste, because the reproductive media through which she achieved fame – a fame broader and more lasting than even Millais's – could not have been fully exploited by a dedicated painter. Academic painting precepts disdained the style Greenaway invented, which became the style of childhood.

Out of both inclination and necessity, Greenaway abandoned all the effects particular to painting and aptly called painterly. The work for which she is remembered began as pencil and watercolor sketches on small pieces of paper. Instead of calligraphic linear flourishes, rich, dense, blended colors, and complex layers of scumbled, glazed, creamy, scraped or flickering pigments, Greenaway used uniform short pencil lines and a small selection of diluted colors brushed in uniform bounded areas. The facial features of her children are abbreviated and are the same for every child (she managed to avoid drawing hands and feet in any detail), and the bodies of her children are imperceptible beneath their clothing. Her settings consist mostly of accessories, not three-dimensional space, and function as inert backdrops to the children placed front and center. In comparison with a painting like Reynolds's *Age of Innocence*, an illustration like Greenaway's for the nursery rhyme "Ring-a-ring-a-roses," done around 1880, is almost pathetically naive, simple, and – innocent (ill. 43).

Greenaway's images looked childlike. Her supporter, the great art critic John Ruskin, wrote of her work that Greenaway "lives with her girlhood as with a little sister."[8] Greenaway believed she made her images for children, and certainly she illustrated texts ostensibly intended for children. Whether or not this was entirely true – a middle-class child's allowance might afford a Greenaway item, but it was primarily adults who purchased things for children – she matched her style to the audience she believed was hers. This was a crucial move in the history of childhood's image. The signs that had previously belonged to a subject now also belonged to a style. The innocent child had become both a subject and a style. The great eighteenth-century portraitists and the great nineteenth-century Academic painters of childhood had both

made extremely sophisticated images of natural simplicity. Greenaway introduced stylistically "innocent" images of innocence.

Greenaway's innovation was the prerequisite for a booming market in images ostensibly geared to children but in fact pitched to the adults who would buy images that corresponded to their idea of childhood. At the heart of the Greenaway commercial phenomenon were her books, beginning with *Under the Window*, published in 1879. The first printing of 20,000 copies sold faster than it could be supplied to stores. In Greenaway's own lifetime the book sold more than 100,000 copies.[9] *Under the Window* was quickly followed by more illustrated books and almanacs, all of them internationally published and pirated. In 1905, shortly after her death, her biographers wrote that "the published works of Kate Greenaway are known, and ought to be found, in every house where children live and are loved."[10] Differentiating Greenaway from her prominent peers in illustration, her biographers also stated: "She was the Baby's Friend, the Children's Champion. Randolph Caldecott laboured to amuse the little ones; Mr. Walter Crane, to entertain them. They aimed at interesting children in their drawings; but Kate Greenaway interested us in the children themselves."[11]

Greenaway was able to remodel the image of the child's body so effectively because her style lent itself not only to printing, but also to easy reproduction. The formal simplicity of her watercolors allowed Greenaway children to appear on every conceivable printed or stamped commodity: tea towels, embroidery kits, china figurines, wallpaper, stationery, dolls, doilies, soaps etc. And then there were the Greenaway clothes, which swept the children's fashion world. Little future dance iconoclast Isadora Duncan wore them. Little future Kaiser Wilhelm of Germany wore them.[12] If imitation is the sincerest form of flattery, then Kate Greenaway should have been one of the most flattered women in the western world during the 1880s, even though most *Greenawisme*, as it was known in French, was illicit and Greenaway received no direct financial profits from it. The tie-in was born. Greenaway's work was possibly the first internationally successful example of original work that generates an array of commercial products based on the originals but not necessarily replicating them. In a sense, this phenomenon had been pre-figured by feminine visual culture's versatile adaptations of paintings, and thus *Greenawisme* had a market waiting for it to happen.

Among all forms of commercial image-making, book illustration is the most traditionally prestigious, perhaps because books seem like a relatively uncommercial commodity, or perhaps because book illustration has a long history going back to the days of handwritten books

illustrated with unique images. Intellectually ambitious, Greenaway clung to the vestiges of that traditional prestige, but the connections she tightened between illustration and commercial reproduction could override connections between illustration and what was called art. In this respect, too, her work was unlike Caldecott's or Crane's, artists who carefully fostered their links to (masculine) movements that were decorative arts movements – notably the Arts and Crafts movement – but whose emphasis remained original authorship and unique objects. Of course book illustrations remained the partners of book texts, and the success of illustrations as images and of the story or poem as text could reinforce each other. Nonetheless, the relationship between the images and the text of children's books was arbitrary enough so that the images could develop a life of their own beyond the book they had first been made for. (Conversely, a long-term best-seller like *Alice in Wonderland* could go through several editions with a new set of illustrations in each.) Even when, as in Greenaway's case, the artist laid out or drew the text as an integral part of a decorative page, the images could be plucked from the page and transformed into highly salable commodities. The mass market into which the Romantic child image had entered was much bigger than the book market.

As long as art and commerce were cast as each other's enemies, commercial success was only a consolation prize for creatively ambitious image-makers. Greenaway, for example, could not reconcile herself to the conditions of her own success. She longed to be a fine artist and show paintings in galleries. By 1890 she had almost given up illustration to pursue her impossible goal. Insecure, she let herself be bullied by a succession of male mentors, of whom the most famous was Ruskin. Greenaway died unhappy and frustrated. Commercial illustration was potentially lucrative, popular, and influential, but in the nineteenth and early twentieth centuries it could not escape high art's allegations of triviality and sentiment. Illustration was indeed subject to more obvious constraints than were the fine arts: constraints of commercial viability, technical reproduction, and editorial supervision. The fine arts were arguably also constrained by many factors, but avant-garde artists not only believed they could shed social and economic rules, but took the rejection of all convention as a proof of talent. Hierarchies of subject matter atrophied, but hierarchies of medium persisted. Painters and sculptors looked down on decorative or illustrative artists, and their disdain became a self-fulfilling prophecy by which art authorities – teachers, critics, juries – assigned students to media according to talent.

Or so the authorities believed. Class, race, or gender could and did

fool them. Not surprisingly, given its recent history, the subject of child-hood was most affected by the gender factor. Faced with demands by a growing number of women for access to artistic careers, art establish-ments could easily respond by claiming that women had a "natural" inclination to the decorative or commercial media of middle-class domestic life, along with a "natural" affinity for the subject of mothers and children. At the turn of the twentieth century it was difficult for a woman illustrator to work for anything but magazines and books aimed at women and children.[13] In 1900, a female art critic wrote: "Indeed, many publishers hold that certain qualities of pictorial interpretation are distinctly the faculty of women's delicacy and insight to portray, and especially is this true of the studies and compositions depicting child life."[14] The more women represented childhood, the lower the artistic status of the subject sank. The more illustrative the subject of the child or maternity became, the more women were encouraged to specialize in it. Beginning in about the 1880s, commerce and feminini-ty together entwined the subject of childhood.

The pressure on women to picture children for commercial publica-tion was strong. Alice Barber Stephens (1858-1932) was one of the most successful women illustrators of her generation. Stephens pre-ferred to be a painter who dealt with many subjects.[15] She enrolled in the prestigious Pennsylvania Academy of Fine Arts as soon as women could, in 1876. Three years later, she celebrated women's new artistic opportunities with a painting, *Female Life Class*, that pictured her fel-low women students doing what they had not been allowed to do before: paint from a nude female model. *Female Life Class* was chosen by her teacher Thomas Eakins to illustrate an article in *Scribner's Monthly* on his teaching methods. For the rest of her long and produc-tive career, Stephens wanted to paint but felt obliged to illustrate. She began to earn her living in 1880 by engraving other people's designs, then, around 1885, turned to her own designs. In the field of illustration she could hardly have done better. Recognized nationally, her work appeared regularly in most of the top magazines: *Collier's, Cosmopoli-tan, Country Gentleman, The Delineator, Frank Leslie's Illustrated Weekly, Harper's Young People, Harper's Weekly, Harper's Monthly, Harper's Round Table, Home Companion, Ladies Home Journal, McCalls, McClure's, New Idea Woman's Magazine, Scribner's, The Reader,* and *Woman's Home Companion.* Stephens was also awarded some of the most coveted book illustration commissions, notably, in 1901, that feminine children's classic, Louisa May Alcott's *Little Women* (1868-9). Despite her fine arts training at the Pennsylvania Academy

and later, in Paris, at the Académie Julian and the Académie Colarossi, and despite her fine arts teaching at the Philadelphia School of Design for Women, her numerous prizes, and her co-founding of the Plastic Club (an arts organization for women), Stephens felt trapped. Wistfully, she wrote at the end of her life that when she had visited the eminent English Academic painter Alma-Tadema: "He knew the simple domestic subjects of mine coming out in *Harper's* and said he was glad someone was content to do them. The fact was, however, that I longed for a greater flight of fancy, even a decorative opportunity."[16] She concluded her account of herself: "During the latter eighties and into the nineties, I painted out of doors during the summers, being interested to get the out-of-doors pitch of color, in the swift impressionistic manner. I got a few results that I feel are the best I have done."[17] Stephens had been typecast. In 1905 the reference book *Women in the Fine Arts* described her as: "An illustrator whose favorite subjects are those of every-day home life – the baby, the little child, the grandmother in cap and spectacles, etc."[18]

Feminine and commercial pressures on women's work were strong enough to be felt even by the most successful women fine artists, as evidenced in the career of arguably America's finest late nineteenth-century woman painter, Mary Cassatt (1845-1926). Cassatt's early work was an integral component of the French avant-garde Impressionist movement. Both formally and thematically, Cassatt's early paintings experimented with the representation of women's roles, showing strong women who thought, read, looked hard, and controlled space. Then, after about 1885, responding to a changing cultural climate, Cassatt shifted her attention to the subject of mothers and children. Her earlier work may be the more significant art historically, but it is the late work that has captured popular approval. At an exceptionally high formal level, Cassatt's late mother and child paintings fulfilled all the Romantic child expectations built up since the eighteenth century, and more. Cassatt's work delivered the intimate maternal pleasures of reinterpreted Madonnas, updated and attributed to the middle class. In fact, Cassatt's women were often called "Modern Madonnas" by contemporaries. One of her most famous works, *The Bath* (1891), is equal measures of Renaissance Madonna and Japanese print, scrubbed with a bit of eighteenth-century English portrait and sweetened with a dash of Greenaway. The newest ingredient is the consciously-felt influence of Japanese Ukiyo-e woodblock prints, evident in the shallow picture space and use of contrasting, subtley colored patterns – striped dress, flowered rug, bowl and jug shape – and also in Cassatt's choice of an

20  MARY CASSATT The Bath 1891

ordinary feminine domestic moment. Cassatt's subject is the everyday
comfort a mother and a daughter take in each other's bodies; contacts
between maternal flesh and child flesh create the central axis of the
image. Tender and reciprocal, this is a picture of love, quiet and tender,
woven into feminine domestic routines.

Women artists' subject matter was affected by a demand for moth-
ered childhood, as was the interpretation of their work, including
women artists' own interpretation. Bessie Potter Vonnoh (1872-1955),
for instance, was yet another American woman who successfully spe-
cialized in the subject of children and their mothers.[19] Potter Vonnoh
chose to work in sculpture, of all media the one then considered the
most masculine, but on a very small scale, which allowed her to repro-
duce her work easily and sell multiple copies. A (male) critic wrote in
1897: "Hitherto there has been little about the sculptor's profession that
suggested its adaptability to feminine hands, ... but in the case of Miss
Potter," he went on to say, "the results are different."[20] Neither the
woman nor the children of her 1903 statuette *Motherhood* seem to have

bodies at all, they are so amply clothed; still, the theme is physical bonding, as the two small girls and a baby emerge only partially from the mother's form, as if growing out of her. Like many other women artists who pursued long, demanding careers – Cassatt, for instance – Potter Vonnoh never became a mother biologically. Yet she, like other women artists, used the language of maternity to describe her work: "I have only my bronze and marble babies, but I love them as much as if they were flesh and blood."[21]

A great deal of talent and energy was being invested in the subject of childhood. Artists like Stephens, Cassatt, and Potter Vonnoh reinvigorated the subject formally, finding new devices to express the beauty of the innocent child body and the maternal love it inspired. Like other artists, they made the sight of the human body the main theme of their work. Unlike artists who represented adult bodies, however, turn of the century women artists were assigned a body-image whose innocence, thematic and stylistic, severely curtailed expressive possibilities. Even Cassatt, an artist of the first rank, only represented the most lyrical, elegiac sides of childhood and maternity. Many more women artists, like Stephens and Potter Vonnoh, were additionally constrained by commercial considerations. All passion, and reason, had been leeched out of the image of the child, leaving sentiment. Paradoxically, it was these

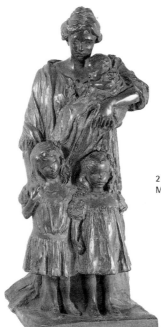

21 BESSIE POTTER VONNOH
Motherhood 1903

images devoid of passion to which a feminine audience was passionately attached. It was the sentimental images of the innocent child that women felt able to use, own, admire, adapt, share, and, increasingly, to produce. If the first century of the Romantic child was dominated by men like Reynolds and Millais, the second century was led by women like Greenaway, and, as we shall see, Jessie Willcox Smith and Anne Geddes. If only because women were not allowed to identify themselves so fully with any other type of image, the innocent child had gained an audience deeply invested in it socially, emotionally, and sensually.

Around 1900 the audience for the innocent child became exponentially larger. Stephens's career indicates why. Between 1860 and 1900 the number of magazines published in the United States multiplied five times. At the turn of the century, a thousand magazines reached millions of Americans, and not only were their articles, essays, serialized novels, short stories, poems, and editorial pages illustrated, but so were their advertisements.[22] In 1902, a writer ruefully remarked: "A learned editor said to me not long ago, 'You know I want enough text to carry the pictures.' Illustration has outstripped its parent and makes the pace."[23] Harper's Weekly had led the way during the Civil War with illustrations that helped swell its weekly press run past 150,000.[24] In 1893, the new McClure's magazine entered the market at half the price of the established giants Harper's, Century, and Scribner's. A scramble for advertising revenue and higher circulations had begun. With 60,000 readers The Cosmopolitan charged $60 for an advertising page; with 100,000 readers it could demand $200 a page.[25] Magazines could lower their prices and still provide more illustrations because technology was also on their side. Already in the 1870s line drawings could be reproduced photomechanically. In 1881 the American printmaker Frederick Eugene Ives patented the halftone black-and-white process whose photomechanical technique supplanted wood engraving. The halftone process reproduced tonal values, so that illustrators could now submit their work to publishers in the form of paintings as well as drawings. They could even work in color once the four-color halftone process was adopted, beginning, slowly, in the 1890s.[26] Advertisers and book publishing houses benefited from magazine innovations, and often employed the same illustrators. What is widely known as the Golden Age of American Illustration had begun. It was also the Golden Age of the Illustrated Child.

New publishing markets gave talented women huge incentives to specialize in the subject of mothers and children. Friends called Jessie Willcox Smith (1863-1935) "The Mint." For one magazine cover alone,

Smith could command as much as $1,800.[27] Commissions streamed in from every major magazine and publisher, as well as from parents for oil portraits of their children, once she had become famous. Already as a student, Smith was illustrating advertisements and then books. She went on to illustrate many of the books on which the great Golden Age children's book illustrators successively tested their mettle: *Little Women*, *Mother Goose*, Charles Kingsley's *Water Babies*, Robert Louis Stevenson's *A Child's Garden of Verses*, Clement C. Moore's *'Twas the Night Before Christmas*, Johanna Spyri's *Heidi*, and more. Praise came from every quarter.

Understanding Greenaway's use of evocative accessories, nostalgic settings, and detailed costumes, Smith depicted children within lifestyles. Better trained for illustration than Greenaway, perhaps more gifted formally, Smith used line vigorously, creating an enchanting illusion of coherency and containment by binding all the elements of her composition into a decorative whole. Smith had been influenced, like Cassatt, by the way Japanese prints elegantly control form in graphic black and white. Especially in her best early work, Smith had an uncanny knack for harmonizing physical charm with cool style. Her images are organized around modelled faces, hands, and limbs, surrounded by details that distract from the body but anchor it in attractive places replete with gorgeous things.

Smith's style lent itself to advertising, which at the turn of the century demanded much the same formal quality level as magazine illustration. Some companies, like Proctor & Gamble, would even offer

22  JESSIE WILLCOX SMITH Ivory Soap Advertisement 1902

enlarged copies of color advertisement inserts as premiums: "without printing [words], on enamel paper, 14 x 17 inches, a suitable size for framing."[28] In a 1902 image by Smith for Ivory Soap, our attention is divided between the few broad graphic forms that define the body and the many smaller forms that define things and place, between a girl bending forward into the picture, and shoes, pitcher, towel, commode, mirror, and wallpaper. We do not ever see the soap being advertised; instead, we imagine the soap being used in front of the body whose bottom and legs would be what we were looking at if we were not looking at flawless stockings and starched white fabric. Despite the first line of the ad's caption – "The sweetest thing on earth is the face of a little child" – the child is almost anonymous, because the head and shoulders we see reflected in the mirror are dim, and the child seems completely unaware of us. Neither the face nor the soap matter; what matters is that an innocent, metaphorically clean, child uses the soap in a cozy and very pretty middle-class home. The child is the prime object of our looking, but the desire we might feel is diffused into her surroundings. Lest there be any doubt in our minds, the picture is bordered with soap bubbles blown from pipes. The innocent child, as Millais too showed, is like a soap bubble: all beautiful surface, shimmering and empty. Do not touch.

Smith liked representing children. She said her favorite illustrations were the ones for Kingsley's *Water Babies*, which gave her the opportunity to depict lots of little bodies free in nature.[29] Shortly after her death, a critic wrote: "What other artist would select this line as a text for an illustration of *Water Babies*: 'He felt how comfortable it was to have nothing on but himself?'"[30] Smith could feel comfortable representing child nudity because she had found a way to make the child's body look like no body. A fairy theme helped, of course, but it was the pretext for silhouettes by moonlight, dark foliage patterns camouflaging a little boy, his delicately incised form set intimately close to us, yet turned away, looking at the moon, so that we too can look long and longingly.

Smith and her critics masked her accomplishments with a rhetoric of nature. Critics repeatedly praised Smith's empathy with her child subjects, compared her children with flowers, described her pictures as being alive, told stories of Smith working and living in the fresh countryside. "Simplest and most winsome,"[31] was a typical accolade, and so was a comparison of the artist with a child: "That paradox which genius is – a grown person who retains the frank sweetness of a child – is Jessie Willcox Smith."[32] Smith described herself and her work the same

23 JESSIE WILLCOX SMITH, illustration for Charles Kingsley's *The Water Babies* 1916

way, disclaiming skill and minimizing her professional training. Smith wrote that: "Children had always attracted and interested me and I naturally turned to them when selecting my life's work," which was teaching kindergarten. Glossing over her dislike of that first calling, the origin-myth spins on with Smith just happening to attend drawing lessons and then slipping unconsciously into a specialty: "and ever since it has been one long joyous road along which troop delightful children."[33] Smith declared that her children "unconsciously" took "the positions that I happened to be wanting for a picture," and that she hated "a paid and trained model ... an abomination and travesty on childhood – a poor little crushed and scared unnatural atom, automatically taking the pose and keeping it in a spiritless, lifeless manner."[34]

At the same time, her contemporaries understood that Smith was leading an important cultural trend. They could see where her images were coming from, and how influential they had become. One anonymous critic who wrote an article titled "Mother-Love in Jessie Willcox Smith's Art" called Smith's images "modern Madonnas" and compared them with Madonnas in "European picture galleries." The critic commented: "The world-wide fame of Raphael and Correggio is closely associated with the enormous popularity of the Madonna picture. ... In this revival of interest in the artistic portrayal of childhood, Jessie

Willcox Smith has taken a dominating part."[35] Another critic who titled her article "The Age of Innocence" wrote that Smith "has been called the modern Kate Greenaway" and that her "style is distinctly in the English tradition," specifically naming Reynolds and Gainsborough. She concluded: "The ideals of Jessie Willcox Smith have been woven into the fabric of contemporary thought, and her forms are impressed upon the consciousness of innumerable mothers, who hope that their children will look like the children she paints."[36]

Smith appealed to an enormous audience, composed primarily of women. Contemporary articles about her work noted this, but the same conclusion could be reached just by looking closely at Smith's images. For one thing, her images often include mothers, mothers who are usually touching and looking at their children, cueing viewers to see the children likewise: with a caressing, haptic, maternal gaze. For another, the children thus sensually presented occupy domestic settings and engage in domestic activities that, historically, we know were common for women and very much less common for men. And finally, the overlap in Smith's imagery between book, magazine, and advertising imagery allows us to know with some certainty who her images were being pitched to: 88% of all American magazine subscribers were women.[37] Advertisements succeed or fail by pitching their product clearly to the right consumer. Who was likely to be buying soap? By the turn of the twentieth century, women were overwhelmingly the consumers of all household goods, not to mention items for children. It seems unlikely that children actively disliked book illustrations by someone who sold as well as Smith, but it was their mothers who not only bought the books, but shaped the tastes of the children who received the books.

Many advertisements from this period similarly designate a feminine audience, for instance a 1909 advertisement for Mennen's Toilet Powder. This is a clumsier cousin of Smith's lovely Ivory Soap ad image, and is also descended from pictures like Munier's *Girl with Kittens* or Guy's *Making a Train*, and through them, distantly, from Reynold's *Age of Innocence*. Not content with shoulders and limbs, Mennen's puts almost an entire dimpled toddler on display, skimpy shirt slipping coyly off the shoulder closest to us, golden ringlets curling down a nearby cheek. The body's pose, oriented to viewers, pulls our gaze in its direction. Where is the child looking, and where, by implication, are we? At home during the day, next to a nicely furnished room complete with baby-nurse, so we must be women. The ad's strategy dates its moment. On the left of the 1909 picture we see the original 1889 Mennen shaker-

top box; it, too, shows a baby, but a far less delectable one – twenty years make a difference. Like Smith's Ivory Soap image, the 1909 ad primarily pictures a child's body, rather than a product. We are supposed to imagine how delightful it would feel to put powder on such adorable flesh. The selling point is the child's body.

At whom is the ad aimed? Not to the person the baby commands: "Hurry up with Mennen's." The baby-nurse may be a surrogate mother, but the ad reassures us that we are the real mothers. Servants in Romantic child imagery never hold children the symbiotic way mothers do, or look at them with the same loving eyes. If nurses or nannies are shown touching children, then they hold their charges stiffly, distantly. In one 1894 child-portrait by Cecilia Beaux, the painting is so centered around the little girl that the nurse gets cropped out entirely, leaving nothing but the hand that holds the child's, and an identifiable bit of uniform.[38] Even when they appear in images of the Romantic child, the working classes and people of color are made effectively invisible. Maternal pleasures depend on someone else's labor. Precious children require plenty of protection. Happy mothers hire help.

An expanding feminine market made room for plenty of feminine talent. Smith played a "dominating part," but only a part in the "revival of interest in the artistic portrayal of childhood." Smith herself lived and worked with two other prominent women illustrators, Violet Oakley and Elizabeth Shippen Green.[39] Oakley (1874-1961) soon turned from

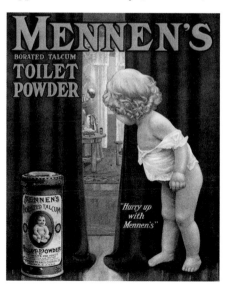

24 "Hurry Up with Mennen's" Mennen's Toilet Powder advertisement 1909

magazine and book illustration to stained glass design and mural paint-
ing, but Green (1871-1954), whose style was often compared to stained
glass, became one of the most successful illustrators in America. An
illustration for the December 1905 issue of *Harper's* shows why.

Green managed to make pictures that were all about looking at a
child, and yet were all about not seeing his body. A young boy sits
cross-legged directly in front of us on a window seat. Dressed in bright
red, he is presented so close to us in picture space, so frontally and cen-
trally, that we cannot avoid staring at him, especially since our sight of
him is secured by the horizontals running behind the head and by the
strong floral pattern of the bench upholstery. Moreover, the rushing
view pulled out the window by dramatic perspective to a dense inter-
play of textured shapes reminds us that looking is the order of the
moment. Yet the boy is oblivious to us, and his body has been de-mate-
rialized, smocked and shielded by a drawing-board. Out the window
goes our gaze.

Like Smith, Green started a prolific, well-paid career even before she
finished her training. Green went on to become the first woman staff
member at *Harper's*, a coveted and powerful job. Most of her work
between 1901 and 1924 was therefore done for *Harper's*, but she also
illustrated more than twenty books, designed posters, advertisements,
and the Metropolitan Museum of Art's magazine for children. By 1910 a
number of articles had appeared on the three friends, sometimes known

25  ELIZABETH SHIPPEN GREEN Making A House 1905

collectively as the Ladies of the Red Rose or the Cogslea family, hailing their contribution to American art.[40]

One man also played a key role in the sudden rise to prominence of women illustrators. Howard Pyle (1853-1911) was perhaps the single most important figure in the Golden Age of Illustration. Pyle was himself an extremely successful and innovative illustrator. It was his teaching, though, first at the Drexel Institute in Philadelphia between 1894 and 1900, then at the Howard Pyle School of Art in Wilmington, Delaware, and during summer sessions at Chadds Ford, Pennsylvania, that galvanized an entire generation of illustrators.[41] Known as the "Brandywine School," Pyle's students included Smith, Oakley, and Green, as well as artists such as Maxfield Parrish and N.C. Wyeth. Pyle gave his best students a professional head start by passing on jobs to them and lobbying for them with publishers. Historian James J. Best has conducted an impressively thorough survey of illustrations in *Harper's*, *Scribner's*, and *Century*, the three magazines that dominated magazine illustration, if only because they carried so many full-page color pictures: the best-paid, most challenging illustrations. His survey proves that the elite of the Brandywine school overwhelmingly dominated *Harper's*, controlled a disproportionate share of *Scribner's* color pages, and made an impressive showing in *Century*.[42]

Pyle treated his women students well. He allowed his classes to be almost half filled with women, and he did not restrict their ambitions. There is some evidence that he placed little faith in women's talent or career potential,[43] but faith seems to have deferred regularly to evidence. He obtained commissions for his best women students that were every bit as good as the ones he got for his best men students. One female student recalled: "after one of his composition lectures feeling I could hardly wait until the next morning to get back to work and start being a Michelangelo, which I felt I would have no trouble doing."[44]

Several factors had converged to create a movement. Alice Barber Stephens had been a somewhat isolated female success in her generation, but even in that first generation she was not alone. Maud Humphrey (1860-1940) was making $40,000 a year when she married a Dr. Bogart in 1898.[45] She continued to work after her marriage, eventually supporting the entire household. She illustrated magazine covers (*The Delineator* and *Buttrick's*, for example), magazine stories, books, calendars, cards, and advertisements for products like Mellin's Baby Food. There was such a thing as a "Humphrey Baby," an instantly recognizable and widely beloved popular type. Devotees must have been delighted to see a portrait sketch of the "real Humphrey Baby," seven-

week-old Humphrey Bogart, published in 1900.[46] (Incidentally, Maud Humphrey Bogart was one of those mothers who dressed her son in the dreaded *Blue Boy* outfits.)

The next generation of American illustrators was packed with women. Besides Smith, Oakley, and Green, Pyle launched other prominent women illustrators, notably Sarah Stilwell Weber (1878-1939) and Charlotte Harding (1873-1951). Women also built careers without Pyle foundations. Florence Scovel Shinn (1869-1940) was famous for her humorous drawings of street life; Fanny Young Cory (1877-1972) worked for *Century* and *Harper's* and illustrated *Alice in Wonderland*; May Wilson Preston (1873-1949) was a key member of the Ashcan School, for several years the only woman member of the Society of Illustrators, and an exhibitor in the notorious 1913 Armory Show. There were others. All these women tended to follow a pattern. They trained professionally, sometimes did stints in Paris art schools, worked commercially for decades, won prizes, showed in exhibitions – and pictured children. In 1912, a reference book on American artists summarily described Sarah Stilwell: "Illustrator, is known as the delineator of fully clothed little girls."[47]

Jessie Willcox Smith's and Elizabeth Shippen Green's closest competitor was Bessie Pease Gutmann. Like her peers, Bessie Pease (1876-1960) trained professionally and was quickly tracked into commercial illustration. In 1903 she was invited to join Gutmann and Gutmann, a "fine art print" and advertising business. During the next three years, Pease illustrated popular books (including *Alice in Wonderland*), magazines, and calendars. In 1906 she married one of the Gutmann brothers, and began to turn her career toward prints modelled by their three children, as well as by the children of her relatives and friends. Some work continued to be commissioned; between 1906 and 1922 Pease Gutmann signed twenty-two covers of major magazines such as *McCall's* and *Woman's Home Companion*. It was her prints, though, that really made Pease Gutmann famous. She could take themes already done by artists as successful as Jessie Willcox Smith and sell more of her version. Pease Gutmann's biographer estimates that her *A Little Bit of Heaven*, modelled in 1909 (while sleeping) by her two-month-old daughter Lucille, published in 1916, has sold "millions" around the world. Despite World War I, orders for thousands of copies poured in from around the globe when the image first appeared.[48] In both the original charcoal drawing with watercolor shading, and in the published print, Gutmann concentrated on the infant's flesh, her round face and tiny hands, leaving her clothes and blanket sketchy, her setting almost invisible. We the viewers

26 MAUD HUMPHREY BOGART
A Young Humphrey Bogart 1900

27 BESSIE PEASE GUTMANN
A Little Bit of Heaven 1916

are situated intimately close to this charming baby, as if nothing else in the world existed for us. More than any of her peers, Pease Gutmann represented children's physical appeal. The cheeks are irresistibly round, the limbs swelling out from their shoes and sleeves, dimpled and firm, the lips exquisitely rosy, full, and rounded. These are chidren to be hugged and squeezed, stroked and kissed. Yet despite the sensual appeal of Gutmann's images, they are not, in the end, much more passionate than Smith's or Green's. Intense but bland, the sensuality of Gutmann's images is monotone, a thick and very sweet vanilla cream.

So much work of such high quality was being devoted to children that it seemed as if the image of the child had a new lease on life. In 1904 a critic wrote: "The illustrative work done by women in America, in recent years, is noticeable for its brilliant effect and sympathetic touch. Especially is this true among those artists who devote their talents, more or less, to the portrayal of child life."[49] "This is the age of the child," pronounced Sadakichi Hartmann in 1907.[50]

During the 1920s and 1930s, several English illustrators of children (as opposed to illustrators of children's books) also acquired huge followings. Mabel Lucie Attwell (1879-1964) was the English analogue to Jessie Willcox Smith and Bessie Pease Gutmann. She designed a whole range of child-images, for books, posters, cards, calendars, wall-plaques, handkerchiefs, biscuit tins, chinaware, and even three-dimensional items such as figurines and soft toys. Like Pease Gutmann, Attwell was often inspired by her own child, her daughter Peggy. Her popularity peaked in the 1920s, spurred by her first children's annual in

1922.[51] Attwell was joined, notably, by two women born slightly later, Margaret Winifred Tarrant (1888-1959) and Cicely Mary Barker (1895-1973), who were close friends, and who both became famous for their depictions of fairies.[52] Barker had been popular since her first set of postcards designed at age fifteen, and became internationally known with her *Flower Fairies*, published one season at a time beginning in 1923.

The flower fairies are both botanically correct and sensually unworldly, hothouse hybrids of floral bounty and childish beauty. Each page imagines a different flower-child, human, but with a face, body, ornaments and clothing like the bloom it holds. The Rose Fairy of *Summer*, for instance, is round-cheeked, fair, and rosy, dressed in a tunic of petals and with pearly, petal-like wings sprouting from her shoulders. She offers her bud, inviting us to inhale its scent, to inhale, by analogy, her own sweet self. The child is being represented as a metaphor: a body is like a rose. Barker's images take a basic strategy, common to many images of children, and execute it perfectly. The metaphor is seductive but it avoids attributing desire to the child itself. The child's body does not exist because it is something else: a flower, a star, a fruit, whatever.

Despite the great and enduring success of many English child-illustrators, the energy balance had shifted decisively to the American side of the Atlantic by the turn of the century. Many explanatory factors could be invoked, among them the sheer size of American audiences, the leadership of American advertising agencies, and a widespread American cultural emphasis on youth. American illustrators, moreover, had confidence in themselves. Regardless of their own vestigial longings for fine arts careers in painting, they seem to have felt that their kind of work was suited to a young, realistic, economically booming, democratic country. The author of an article on Howard Pyle didn't hesitate to title her essay: "The Founder of an American School of Art," claiming that "his American type of mind shows itself in that strongest characteristic of his art – its practical value. ... It is no wonder that modern illustration, including such strictly commercial work as advertisement drawing, useful certainly, and capable of the finest treatment, appeals to Mr. Pyle as the unassuming foundation on which may be erected a 'school' of American art."[53]

Nonetheless, subsequent American generations of illustrators, including child-illustrators, dwindled in number and so did their publishing opportunities.[54] Maud Tousey Fangel, for instance, produced very popular pastel pictures of babies for products like Carter's infant wear, Cream of Wheat, and Squibbs Cod Liver Oil during the 1920s and

1930s; she also worked for the leading women's magazines. Yet the very fact that her dates are unknown indicates how quickly the status of the illustrator was declining.

Photography was replacing illustration – technically speaking. Ironically, the medium that put illustrators of childhood out of business preserved the consequences of their creativity. Far from replacing the imagery of the Romantic child that illustrators had ingrained in the popular imagination, photography fossilized it. Photography sealed all the conventions of child imagery honed and shaped by illustration, as if photographic emulsion were like amber, preserving precious child specimens. American women illustrators of the Golden Age had brought the image of the Romantic child right up to the verge of its present form. Refined over a century and a half, beloved by a committed constituency, and present in every western household, the image of childhood innocence was poised for the final phase of its history. All that remained was for the Romantic child to be transposed into photography.

28  CICELY MARY BARKER The Rose Fairy 1925

29  US POST OFFICE Love stamp 1995

Innocence Inherited

Like a landscape left by ancient seismic movements, today's most popular photographs of children were shaped by forces long forgotten, yet without which they would not look the same. All the visual signs of childhood innocence invented and refined by painting, prints, and illustrations from the eighteenth to the early twentieth centuries were transposed into photography, which rendered them nearly invisible, not because they are not there to be seen, but because photography's reality effect is powerful enough to make the cleverest devices look natural.

By the beginning of the twentieth century, the Golden Age of Illustration was giving way to the age of the photograph. In 1907, the eminent American critic Sadakichi Hartmann guessed that photography would bring the image of the child, and of maternity, into every home: "the artistic photograph – which answers better than any other graphic art to the special necessities of a democratic and leveling age like ours."[1] Anyone who could push a button could use a camera. During the 1920s and 1930s it became increasingly easy and cheap to reproduce both black-and-white and color photographs in magazines. Yet as far as the image of childhood was concerned, photography did not so much replace illustration as relay it.

Sadakichi Hartmann practiced what he preached when he hailed photography as the new force in child imagery; his illustrations include roughly equal numbers of paintings and photographs. Looking through Hartmann's article, it is hard to tell one medium from the other. The paintings convey spontaneity and innocence, and the photographs have been posed and printed to look like the paintings. In a "before" and "after" photograph pair, the "after" photograph has even been altered to achieve an eighteenth-century English portrait "Romney effect."[2] In 1928, the prestigious Bachrach studio advertised its photographic portraits of children by comparing one with Gainsborough's *Blue Boy*: "Thus it is sometimes given to the lesser to speak the language of a master."[3] Already in 1857 when he punned on Raphael's *Sistine Madonna* cherubs, O.G. Rejlander was paying photographic tribute to painting's influence on the pictorial imagination (ill. 17).

The great, and sometimes not-so-great, old images of childhood continue to retain their grip on the late twentieth-century visual imagination. If anything, they have recently become more popular than ever. Admittedly, prints after eighteenth-century English portraits of children are not as common as they were before the Second World War. The *Blue Boy*, though still famous, is no longer the most famous painting in the world. Nineteenth-century genre paintings of children, though, are perhaps more widely reproduced now than they have been for decades. Finding the genre paintings discussed earlier did not require obscure research. They appear on greeting cards in local drugstores and card shops, in the mail-order pages of magazines such as *Victoria* (note the title), in embroidery and paint-by-number kits. Bouguereau's nineteenth-century *The First Kiss* is relentlessly marketed in Italy as a local souvenir, even though it is French (ill. 12). Madonna images have never declined in popular appeal, if only because of Christmas. Madonna images appear on all kinds of Christmas items, including stamps (the U.S. Post Office uses a different one each year). In 1995, the U.S. Post Office did not even need a Christmas pretext. Each of the cherubs from Raphael's *Sistine Madonna*, already reproduced just about everywhere else in North America and Europe, appeared on a stamp, one for 32¢ and one for 55¢, both labelled "LOVE." Each time anyone buys one of those cherub stamps and sticks it on mail, they re-enact the nineteenth-

30 CLARA BURD *Woman's Home Companion* cover, January 1911

31 ANNE GEDDES Hanging Baby 1993

century feminine cult of Raphael's Madonnas. Mary Cassatt's babies embraced by their mothers turn up on refrigerator magnets, calendars, little inspirational books designed for Mother's Day, puzzles, all kinds of trinkets. Potter Vonnoh's *Motherhood* (ill. 21) graced the cover of the spring 1994 "Museum Collections" catalogue, #13S244; it was available by mail order in cast stone replica form, "finished in a flattering antique white," for $99. All the great turn-of-the-century illustrators are still in print, and selling briskly. The jacket flap of a 1990 edition of Cicely Mary Barker's *Flower Fairies of Summer* claims, rightly, that the charm of her illustrations "has captivated both children and adults alike for nearly 70 years," while the caption of a 1990s greeting card says of Pease Gutmann: "Her work today is as popular as it was in the 20's and 30's when it was almost required nursery decor."

No wonder, then, that so many successful contemporary commercial photographers emulate old favorites. Occasionally, the affinities between handmade images and photographs can be quite clear. For example, Clara Burd's 1911 cover illustration for *Woman's Home Companion*, and Anne Geddes's 1993 photograph called *Hanging Baby* are remarkably similar in their subjects and their compositions. The 1911 and 1993 babies hang in identical cloths at the same distance and height from us, allowing us to see the same amounts of darling chubby face, fingers and feet. The resemblance between the images is all the

more striking because in 1993 babies no longer hang from hooks for the banal reason they used to. In 1911, babies were weighed by being hung in cloths from scales, albeit not scales in trees.

The point is not that one artist copies another but that the archetypes of the nineteenth century are alive and well. They reappear over and over in all kinds of commercial photographs. It is no exaggeration to say that today's commercial photographs of children almost all fall into the same five categories that characterized nineteenth-century painting and then were passed on to illustration: 1) children dressed up in special costumes, 2) children with animal pets, 3) angels/cherubs/fairies, 4) Madonna and Child, and 5) miniature adults. Look through any card rack or any magazine that has anything to do with families and you will find modern variants on the five types. The cover of Blooming-dale's 1994 Christmas catalogue pictures a charming blond ringletted child wearing a vaguely wing-shaped bunch of feathers. The caption asks rhetorically: "Do you believe in angels?" (Permission to reproduce withheld by Bloomingdales.)

Any of the nineteenth- or early twentieth-century paintings, prints, or illustrations discussed earlier can easily be matched to 1990s photographs. Consider only three pairs among the infinite possibilities. The cute little girl with two kittens, sitting right in front of us showing us her arms and shoulders, in Munier's *Girl with Kittens* (c.1850-60; ill. 11), reappears, updated, in a 1995 ad for OshKosh B'Gosh children's clothing. Just as Cassatt used the theme of bath-time to show loving

32 "Preferred by kiddies since 1895" OshKosh B'Gosh advertisement 1995

contact between a mother and her child in her 1891 painting *The Bath*, so do ads like one for Kotex published in 1992 and captioned: "Kotex understands what it means to be a woman." (Permission to reproduce withheld by Kimberley-Clark.) Anne Geddes's *Cheese Cake* (1993; ill.15) is certainly more ribald and intentionally humorous than Barker's *Rose Fairy* (1925; ill.28), but the idea of the girl child as rose-bud persists.

Most of today's photographs remain consistent with their Romantic precedents. The overwhelming majority of commercially successful photographs centered on children's bodies make those bodies look innocent. We are being offered visual pleasure, but only on the condition that we perceive children's bodies in terms of their utter difference from adult bodies, or even that we perceive them as beings who hardly inhabit the present physical world at all. The child's flesh is what grabs our attention – those dimpled limbs and knuckles, those round cheeks, silken hair, that absolutely perfect skin – but our attention is being guided by the child's accessories, clothing, companions, settings, metaphors, or captions. Angels are not real; toddlers are like domestic pets; a mother's love is sacred; babies are like flowers. Most of all, these children belong to the past, or else belong to forever, not to real time, but to a timeless utopia (no place). Just as Gainsborough's *Blue Boy* referred childhood back from the eighteenth to the seventeenth century, and just as Millais and Greenaway referred childhood from the nineteenth century to the eighteenth century, so our ads and greeting cards and catalogue covers and posters refer childhood back from the late twentieth century to any time that looks quaint, or to a past we call tradition. The OshKosh ad reads: "Preferred by kiddies since 1895 ... Celebrating a Century of The Genuine Article." "What it means to be a woman" has no qualifiers, as if it didn't matter whether the year of the Kotex ad was 1992 or not – or whether, for that matter, the century was the twentieth.

One might reasonably assume that photographs are supposed to record a particular real moment, and that photographs of bodies are supposed to document real bodies. Apparently not quite, in the case of children. The most popular images of children today are photographs, because people want to see real children. But, at the same time, people don't. Photographs of children that appeal to a large consumer audience have to accomplish simultaneously two contradictory goals. They have to make children look physically charming, but not intentionally. They have to provide child bodies to their audience without making those bodies enticing or even available. They have to allow us to enjoy the sight of children and think "cute," not "desirable," let alone "sexy,"

and maybe not even "beautiful." Basically, successful commercial photographs have to make children seem there and yet not there, which is quite a feat in the realistic medium of photography. So the most popular photographers of children both exploit their medium and undermine it.

If all that sounds difficult to accomplish, then one can begin to understand why some photographers' work does better on the market than others. To realize just how perfectly designed best-selling photographs of children need to be, look carefully at work by two of the 1990s' outstanding professionals: Betsy Cameron and Anne Geddes. Both Cameron and Geddes, each in her own way, turn the difficulties of photographic innocence into brilliantly successful strategies. Cameron makes children's bodies belong to an unreal world; Geddes makes children's bodies themselves unreal. Cameron's and Geddes's pictures are exceptionally smart, and reward close looking, but these are the exceptions that, proverbially, prove the rule. The two strategies they have mastered inform all ideal – and idealizing – photographs of children.

For seven years in a row, Cameron's *Two Children* was one of the best-selling posters in the world.[4] Cameron is reputed to be among the best-selling photographers of children, though precise comparative statistics are virtually impossible to obtain. At first Cameron's photographs look like innocent images of innocent subjects, very much in the tradition of Kate Greenaway, Jessie Willcox Smith, and Bessie Pease Gutmann. *Two Children*, for instance, appears charmingly simple. Technically, it is a simple image. Any reasonably competent photographer could have shot and printed it. Nor does the concept seem too complicated: two hugging children seated on a beach looking out to sea, seen from behind. Like many of Cameron's photographs, however, *Two Children* only seems simple. The genius of *Two Children* is in the details. We feel we occupy the same beach space as the children because we see nothing between them and us; the children's heads are placed just at the horizon line, their elbows right at the line between surf and sand, so that they seem at once to dominate the elements and be united with them. Change any of the details, as the many imitations of *Two Children* do, and the effect is more or less lost. It has to be a boy-girl couple, they have to be placed just so by the sea, and the composition has to be exactly the way it is: children photographed close-up from behind and below so that they look permanently monumental, placed so that earth and sky extend in front of them from side to side, going on forever. Because the children are seen from behind, they seem innocently unaware of our presence, and they become not so much individual

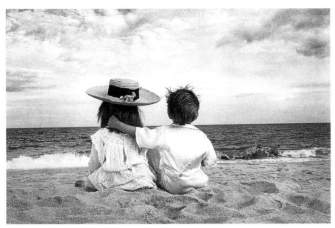

33 BETSY CAMERON Two Children 1987

children as generic children. "As timeless as childhood itself," reads the caption on the back of Cameron cards.

Cameron presents her work as if making it were simple, merely a natural extension of her relationship to real children – again, just as the great women illustrators of children did. Most of Cameron's photographs represent her own three children, and the rest depict her children's close friends. Her settings are all chosen within a tiny radius of home. Cameron lets her work and maternity blend together. Children's games suddenly turn into photo shoots when mother/photographer and children/models are in the mood. Leafing through a book of Cameron's photographs next to one of her children, I asked her daughter which of the pictures of herself she preferred. She liked all of them, she instantly answered, as if none were exceptional, including the ones that have made her mother famous. Seeing a picture of one of her friends, the little girl suggested to her mother that the friend might enjoy a copy, as if it were any photograph of a friend, and Cameron agreed. Cameron works in a seemingly domestic space; the same large open area that holds her painting easel, her filing cabinets, business desk, costumes, accessories, and camera equipment also serves as a children's play area merging imperceptibly into the rest of her house. She insists that her photographs are easy to print and hand-tint. In Cameron's home, her best-selling images play two roles; in her work area, though they are almost as accessible to her children as other people's albums, they still are destined for professional publication; in the rest of her house her photographs hang everywhere, framed, pinned, or stuck on the refrigerator door, in exactly the same way other parents surround themselves

with photographs of their children. She says she began photographing her children to make albums for their father, and says of her future work that if it doesn't succeed commercially, she will be satisfied to fill more family albums. Cameron's house, grounds, children and Cameron herself are all radiantly beautiful, and when I met her on Long Island in 1994 I felt as if I had walked into a "real" Cameron picture.

I quickly learned, however, that Cameron is a very smart woman who leaves nothing to chance or nature. "I firmly believe you can get what you want, but you have to work very, very hard at it."[5] Cameron first encountered photography as a top fashion model; when she started taking fashion photographs, her subjects were children as "typical" as Brooke Shields. Then Cameron accepted a commission from the United Nations High Commission for Refugees to produce photographs of some 3,500 Cambodian children. The purpose of the photographs was to give parents a better chance to identify and reclaim children from whom they had been separated. Cameron refuses to discuss exactly what she learned from the children she engaged in conversation, just as she shies away from discussing her own childhood; all she will say is that she decided parents would recognize their children more easily if the children were pictured smiling. Metaphorically, this is what Cameron has been doing ever since. She is acutely conscious that there are many kinds of photographs of children being produced now, and she thinks carefully about how they are interpreted. She has decided to reinforce one vision of childhood. She has been quoted to sound disingenuous: "I think the images are full of hope, full of optimism. They reach out and say 'Oh, what a beautiful world! You can be a part of it!'" Cameron knows full well the world is not beautiful. She wants us to believe it could be.

Cameron stages an imaginary world for children to inhabit. Serene, sunlit, edenic, idealized, nostalgic, mythic, innocent, beathtakingly fragile, are all words that have been used to describe Cameron's effects.[6] The children in Betsy Cameron's photographs wear what are clearly costumes: clothes made long ago or in archaic styles, miraculously (for the 1990s) free of logos, labels, or neon. Cameron's children instead wear eyelet lace, straw hats, angel wings. They inhabit an idyllic rural world like Greenaway's, in which the passage of time seems halted, in which people stay young and beloved toys remain in use: no polyester plush or garish plastic, only a gentle pastel haze. Cameron paints her black-and-white prints by hand with watercolors after they come back from a developer. We want to know the images are photographs, so we can see something "real," but we also want to see photography's modernity denied by painting's traditional aura.

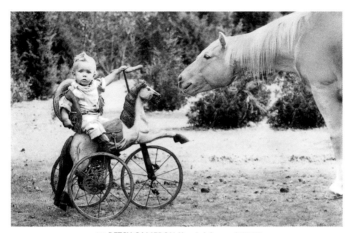

34 BETSY CAMERON Horsin' Around 1994

We are and we aren't fooled by Cameron's photographs. In her best work, Cameron plays with our belief in photography's realism. Look closely again at *Two Children*. Doesn't the girl look stiff? And notice that you cannot see a bit of her flesh. I wonder if "she" isn't a mannequin, which puts some spin on the "natural" quality of the photograph. In *Horsin' Around* (1994), fake meets real, toy comes almost nose to nose with animal; danger animates a narrow gap between two opposing sides. The child wears a cowboy costume, perfect for riding a toy horse, but this isn't quite the "right" fake, not quite western enough for the outfit, too antique. And what if we compared *Horsin' Around* with another Cameron photograph done the same year, *Baby Blue Eyes* (ill. 44)? It is the same child. If a costume is enough to convince us the child in *Horsin' Around* is a boy, who knows for sure whether the child in *Baby Blue Eyes* is a girl? I don't think Cameron's photographs sell well despite her jokes. I think they sell because of her jokes. It is not just that we, a consumer public, like a heavy dose of unreality in photographs of children. We also like to be reminded humorously that the unreality isn't real, if only subconsciously. We enjoy jokes about photography's realism.

Cameron's jokes about reality are gentle; Geddes's jokes are stronger, because they involve children's bodies themselves. Daringly, Geddes concentrates entirely on children's bodies, yet cleverly manages at the same time to turn those bodies into something else, something completely different and as imaginary as Cameron's settings.

Almost anywhere cards are sold, you will find pictures of kids by Anne Geddes, an Australian born in 1956 who now works in New

Zealand. Her photographs appear on cards, posters, note-pads, calendars, and in children's books: 11 million Geddes items had been sold by the fall of 1996.[7] At my local book store-café in 1995 and 1996, Geddes's products occupied both sides of the cash register, and sales clerks told me that they sold them all day long. At another local store I was told that Geddes's cards accounted for about of quarter of all card sales. I have asked Geddes's fans why they love her pictures so much, and they all answer that they are "cute." But what does "cute" mean?

Geddes rachets up the conventions of childhood so high they become funny. Perhaps the conventions are simply old and established enough for them to have become a game, a set of references we want both to repeat and to play with. If Geddes's enormous popularity is any indication, we – a buying public – enjoy the tension between knowing and not-knowing, between believing and denying the visual conventions of childhood. Geddes's work turns the signs of the old Romantic child into new jokes.

Geddes's children rarely appear in open outdoor space, the way Cameron's do. Instead, they obviously have been posed under lamps in studios against plain backdrops or in shallow sets and photographed at close range. The clear bright colors of Geddes's sets and costumes shine, drawing attention by contrast to the sweet curves and sparkling eyes of her young models, to their perfect, glowing skin. Lighting has been controlled to maximize both color and surface texture. Geddes does some work similar to what other photographers of children, past and present do: angels, twins, tutued girl ballerinas shyly kissing cello-wielding boys, etc. Like Cameron and others, Geddes occasionally hand tints black-and-white prints. Her most memorable work, however, is in a more personal style.

Geddes's best photographs are not supposed to look natural. Quite the contrary. They re-represent nature. The child in her *Bunny in a Crate* (1995), for instance, doesn't look like a rabbit, or even a rabbit-child. It looks like a child wearing a white rabbit costume, posed in a pink crate matched to a bunch of pink tulips and a pink paper backdrop. Cameron's *Baby Blue Eyes* is also wearing a costume. Unlike *Bunny in a Crate*, however, *Baby Blue Eyes*'s costume flatters its model's human charms, however innocently. Very much in the vein of Sir Joshua Reynolds's late eighteenth-century *Age of Innocence* or *Penelope Boothby*, and also very much like Millais's late nineteenth-century *Cherry Ripe* and Kate Greenaway's little girls, Cameron's late twentieth-century *Baby Blue Eyes* dresses a girl in filmy white puffs that enhance femininity while proclaiming ethereal purity. Geddes's *Bunny in a Crate*

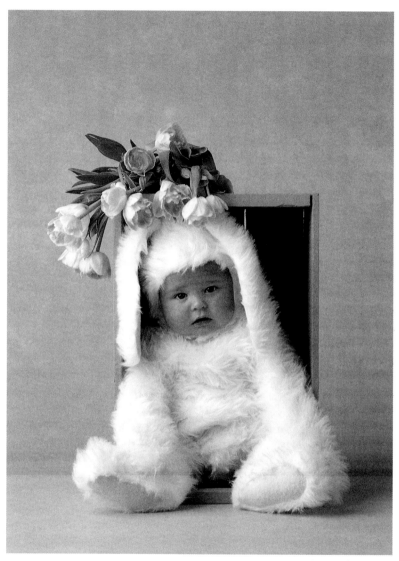

35  ANNE GEDDES Bunny in a Crate 1995

purposely maintains a discrepancy between the child and its costume. We are meant to notice the fake fur bunching in fabric folds at the stomach, the candy-pink oval soles turned up at us, and the edge of the hood all around the baby's face. The idea of comparing children with animals, bunnies in particular, has as venerable a pedigree as Cameron's *Baby Blue Eyes*, going right back to another classic and

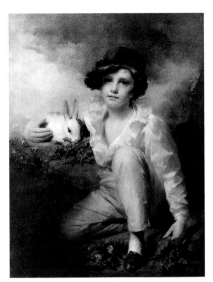

36 HENRY RAEBURN Boy and Rabbit 1786

ubiquitously reproduced late eighteenth-century child portrait, Sir
Henry Raeburn's *Boy and Rabbit* (1786). Yet however distinct from the
costume, Geddes's baby is not separate from it. Unlike a picture of a
child with a bunny, such as Raeburn's painting, *Bunny in a Crate* is a
picture of a child literally in a bunny, or rather a bunny costume. The
costume makes us look directly at what we do not see: the child's body.
Geddes takes an old metaphor – a baby is like a bunny – and renews it
by simultaneously making the metaphor look more and less real. We
know children aren't bunnies, but we enjoy pretending we think chil-
dren are bunnies. Genially glossing on his psychoanalytic theories,
Jacques Lacan advised his patients: "Enjoy your symptom." Geddes
allows us to thoroughly enjoy an irrational attitude toward children.

Our irrationality is both loving and self-serving. *Bunny in a Crate*
looks cute to adults, but don't children have to look slightly ridiculous,
by adult standards, to seem cute? Geddes has a keen sense of humor,
both visual and verbal. She often makes what could be called word-
image puns, where the punning is not between two verbal meanings,
but between words and pictures. *Small Change* (1994) puts a black
infant into an enormous pocket. Jokes both confess and deny, reveal
and disclaim. Geddes turns an image like Cicely Mary Barker's *Rose
Fairy* into a joke, into Geddes's *Cheese Cake* (1993; ill. 45). Once again,
as in *Bunny in a Crate*, a child's body is both the subject of the photo-
graph and what the photograph denies. Instead of seeing just nudity,

we see roses. Of course the two are connected, again by a clever visual pun. Flowers, particularly roses, have long been used in art to symbolize femininity, and the photograph's title refers to a tradition of photographs that put adult women's sexy bodies on display. Successfully pulling against that current might be the picture's evocation of the saying "life isn't just a bed of roses," and certainly the disarming expression on the baby's face, all gummy smile and eyes squeezed shut, defuses with its silly charm any pretentious academic theorizing. We get to see the baby's body and not see it. We get to take pleasure in the sight of the child, and not take our pleasure too seriously. We get to have our cheesecake and eat it too.

Over and over, Geddes invents fresh variations on her basic concept. Dressed in down and seated on a rock, one infant becomes *Baby Bald Eagle* (1994). Seven tykes in stripes and antennaed hoods seated in a honeycomb have turned into *The Bumble Bees* (1993). Two babies peek out from among gigantic green balls – *Two Bods in a Pea* (1993); two more impersonate cabbages, sitting inside cabbages and wearing cabbage leaves on their heads. Even her *Zac and Georgina Close Up* (1993), a closeup of two children's faces cheek to cheek, one very dark-skinned, the other very blond, is about an idea as much as it is about two children; despite the title, and despite the beauty of the children, the photograph is governed by the concept of racial difference reconciled.

The sets and costumes of Geddes's photographs obviously require a great deal of planning, skill, time and money. Getting small children to sit still in those sets and costumes, moreover, must be quite a job, and the more children involved the more daunting the task. *123 Pots*, admittedly an exceptionally elaborate Geddes photograph, pictures 123 infants in clay flower pots on the floor of a warehouse. How long do you think it would take to set up such a shot, and what are the chances that so many babies would all spontaneously stay seated in their pots at the same time, let alone seated and smiling? (The answer is three weeks of preparation plus one hour of shooting time.)[8]

More recently, Geddes has begun using computers to combine and alter photographs. To create the images for her latest book, Geddes chose models under the age of four weeks in order to increase the chances they would sleep through elaborate photo shoots. Plenty of food and heat helped. Behind the scenes, Geddes's studio includes facilities for feeding, diapering, and playing. "People haven't thought seriously about babies photographically. I'm trying to take them out of the cliché and make them into an art form."[9] The book, titled *Down in the Garden*, made the *New York Times* best-seller list for over twelve weeks

in late 1996, despite a price, $49.95, that almost always precludes such strong sales. By 1997, more than 650,000 copies of *Down in the Garden* were in print.[10]

In another sense, too, Geddes thinks quite consciously about her photograpic subjects. Like Betsy Cameron, she wants her work to serve a purpose. In 1991, she founded Next Generation Enterprises, a company that donates a share of the proceeds from her calendar sales to the New Zealand Child Protection Trust: some $350,000 since 1991.

In 1994, Portal Publications, which publishes Geddes's work, began putting a photograph of Geddes hugging a naked baby on the back of her cards, with a caption that includes a typical child-photographer's sentiments: "Her pleasure and pride is obvious, as is the necessary patience, timing, and sympathetic communication needed with her favorite models." I don't doubt it. Within the space of trust a good photographer of children orchestrates, she or he waits for the "right" moments to capture, and what makes those moments right is that they conform to visual expectations of childhood. Children, starting at birth, learn the "right" ways to please adults and to act in ways that adults think are "cute." The photographer waits, or makes the right moments happen. Some moments happen randomly, many more are staged. Professionals have the skills and resources to choose film and lighting according to the effects they plan to achieve, as well as to make right moments look righter in the darkroom by selecting among shots, altering negatives, cropping prints, and now, using powerful computer programs to manipulate everything about a photograph.

The signs of Romantic childhood can be as effectively marshalled for the camera lens as they were previously painted or drawn. By the time photography came to dominate the representation of children, the image of the Romantic child had been so completely perfected and so often reproduced that it would not even have to be consciously summoned up in the minds of photographers. It had become a visual habit, an assumption, a pattern expected, looked for, and replicated. Great modern photographs of children succeed for the same reason that the great paintings and illustrations of children succeeded in their time and still appeal to us now – they show us what we want childhood to be. Before photography, paintings and illustrations made ideals believable by allowing us to see them. Paintings and illustrations of children allowed us to really see perfect innocence; commercial photographs do the same thing one degree more convincingly. Photography guarantees the existence of what we decided we wanted to see two centuries ago.

Snapshot Families

Pictures of children seem to be everywhere, made by everyone. According to various estimates, about half of all photographic film processed in the United States today features the very young. Since the Department of Information and Communications of the Photo Marketing Association puts the number of photographs made each year in the United States alone at 25 billion,[1] about 12$^{1}/_{2}$ billion new American pictures of children appear each year. Adults make pictures of children almost as much as they look at them, and they use them as a part of their daily lives.

According to the 1992 *Wolfman Report* on the United States photo industry, of the 17 billion or so photographs taken each year by amateurs, 37.9% of the ones important enough to their owners to be framed are of children, and another 19.6% are of families. Of those surveyed for the report, 63% listed "family events" as one of their favorite subjects, and 49% listed "children."[2] Fond relatives click away incessantly, filling album after album, sending copy prints to all their friends, restocking their walls, wallets and desktops with the latest favorites. Every holiday, every party, trip, event, or new outfit warrants a shot, or even an entire roll of film. No one needs any technical expertise any longer to make casual snapshots, and the relatively low price of a camera, film and developing makes photography very widely available throughout the western world. Although, according to the *Wolfman Report*, 44% of all United States camera sales were to households with incomes of $35,000 and over, 41% were to households with incomes of $10,000 to $34,999.[3]

So snapshots of children get taken for granted. After more than a century of hand-held box cameras and cheap commercial processing, we are completely accustomed to seeing childhood photographically. The odds are strong that you have seen snapshots of your grandparents when they were young, stronger that you know snapshots of your parents as children, and almost overwhelming that you yourself were repeatedly photographed. If you have children, you probably photograph them. By now it seems perfectly normal to take family snapshots, and then to display or preserve them. Who thinks twice about getting or

sending a photograph of children as part of a holiday greeting card? Or about having a family photo album? Or about the snapshots scattered on refrigerators, framed on mantles, tacked to bulletin boards? And yet, consider the enormous value placed on those seemingly innocuous pictures. People fleeing from sudden disaster have been known to abandon all kinds of objectively valuable items in favor of the family photographs. Two sociologists asked a large group of families in the 1970s which of the objects in their homes meant the most to them. The third most frequent response among all age groups was family photographs, ranked just behind "visual art" and furniture.[4]

Entire family identities are built around photographs. As the written word cedes pride of place in late twentieth-century culture to pictures, the family photo album replaces diaries, letters, and other verbal records. Pictures of children are sent as holiday greetings to identify the sender as a family defined by its children, a family that is both stable (same children year after year) and changing (my how they've grown). The pictures on the refrigerator, in the wallet, on the walls, are chosen to convey an image of family. When young children want to know where they come from, they look in the family album. When families are begun or extended, new albums begin. Two people may even inaugurate themselves as a couple by starting an album. Family memories are woven around the album's photographs.

"You've recorded the most memorable moments of your life on film. Photos of family holiday celebrations, birthdays, graduations, special vacations ... even the snapshots you took of the kids one rainy Saturday afternoon ... are the memories that cannot be replaced." The phrase sounds ordinary enough, and indeed it comes from a brochure put out by a plastics company advertising photo storage sheets: "Century-Poly pages protect your photos, slides and negatives for a lifetime of viewing."[5] The hackneyed proposition, however, is based on some culturally crucial assumptions, and draws some equally fundamental conclusions. First of all, note that the subjects of the photographs described pertain overwhelmingly to "family" and more particularly to children. Secondly, what about the blithe equation of photographs with memories? And lastly, consider the suggestion that, for the rest of your life, the only memories you will have are photographs: "memories that cannot be replaced." These are the assumptions and conclusions on which an utterly ubiquitous practice of photography is based, and which, therefore, seem both ordinary and normal. Ordinary and normal, however, are not exactly the same. A norm is a standard, and a standard has to be defined in relation to the ideal on one side and the forbidden on the

other. Standards, moreover, always need enforcing. A norm doesn't just automatically happen, especially not inside a camera. Photographs of family are not born but made.

"Start making the most of your moments."[6] Catchy Kodak photo company advertising slogans play cleverly on what we assume but rarely articulate: we use photographs to create positive identities, and especially to create family and childhood values. "Pick your best shot," Kodak urges us.[7] In the film *Bladerunner*, an android cherishes fabricated snapshots of a childhood past that never existed. When photographs supposedly become memories, their identities have convinced us. Our childhoods were not like the photographs that picture them, in any absolute, hypothetical sense. Photographs record how we choose to represent our origins, both individually and collectively as a society. I am not saying anything new about photography in general. The relationship between photography and memory has been eloquently investigated by many writers, notably Susan Sontag in her famous 1977 essay, "On Photography."[8] Sontag cogently asked whether we remember the events of our past themselves, or whether we remember photographs of them. I only want to emphasize how extremely closely photography is tied to the "memory" of childhood. "Making Memories," a 1996 Nordstrom winter holiday mail-order catalogue called itself, and with the title went a photograph of a smiling mother and child. Whoever designed that perfectly ordinary catalogue (of adult women's clothing) assumed all their customers would understand that photographs of children "make memories."

To what extent do we remember our own or our children's childhoods as a succession of photographs? When I was pregnant, several colleagues and friends asked solicitously if I was prepared – to take plenty of pictures. Or consider the wording of one mother's account of a special episode in her girls' lives, which appeared recently in *Working Mother* magazine: "... and my first reaction – after racing for the camera – was to wonder ..."[9] Taking the photograph has become so essential to the way we imagine childhood that it happens even before a "first reaction." Precisely because our sense of childhood depends so heavily on photographs, their making and use is anything but random, automatic, or natural. On the contrary, even the most casual snapshotter is highly selective, consciously or unconsciously choosing "Kodak moments" from among the infinite possibilities presented by chance. All it takes is a quick glance through your photo albums to realize how remarkably consistent they are. And have you ever wondered why most family photo albums bear an uncanny resemblance to each other? Or why your

eyes glaze over when proud relatives start pulling those school pictures out of their wallets? Tolstoy observed that happy families are all alike (while unhappy ones are all different). Because we pattern snapshots after an image of the happy family, our family photographs all look alike.

Start with individual photographs and an exercise of the imagination. You could think of the family snapshots taken of any child or group of siblings: yourself, your children, someone you know. Just for the sake of specificity, let me present two examples, both of which were sent to me by friends or relatives. Admittedly, the children are unusually attractive, and the photographs are technically better than average. (I did have to consider how the pictures would reproduce.) Still, they are amateur snapshots taken by parents of their children. The children have been photographed at a moment when they were happy, attentive, clean, well-behaved, and healthy. Typically, the single child has been pictured during a sunny vacation idyll, while the pair are getting along affectionately with each other. If we don't happen to see what we're looking for, we can alter things, fix them, arrange them. Look at me, smile, stand up straight, give Grandma a kiss, it's time for a picture, this would make a great picture. Then the rolls of film come back from the lab and we sort again, picking out the "good" shots, the ones that fulfill our expectations. Who would take, let alone keep, any other other kind of snapshot, you may respond. But that's the point. Unspoken rules govern snapshots. No tantrums, tears, or bruises, no mess, no pleading, no failures, no conflicts, no resistance, few if any expressions except smiles. Not even much effort. In other words, the child in typical "normal" snapshots corresponds exactly to the Romantic innocent ideal invented in the eighteenth century, perfected over the next century in paintings and illustration, and inherited by photography. What child does not experience less-than-Kodak moments, every day? Whatever those less-than-ideal moments might be, they are excluded from photographic memory. The photographic moments we associate with childhood range from the selected to the outright staged. Kodak moments picture Romantic children.

Our idea of the normal is heavily influenced by our inherited ideals. It could hardly be otherwise, considering how popular the most successful commercial images of children are, and how pervasive ordinary professional photographs of children have become. We encounter highly crafted and idealized photographs of children all the time. Photographs by artists like Betsy Cameron and Anne Geddes don't just exist in the abstract. Once they are bought, they get hung on people's walls,

38 KRISTIN HODGKINS Hodgkins/Macomber
family Christmas card 1995

37 Vranos family Christmas card 1995

sent to friends, scribbled on as notepads. You can't avoid photographs of children unless you never turn on the television and never leaf through a magazine. Put aside editorials and articles, which often picture children, but not necessarily idealizing images of children, and think about the advertisements. In addition to billions of amateur snapshots of children plus photographs of children sold as such, we are surrounded by photographs of children that market a stunning array of goods and services. According to some industry estimates, about a third of all advertisements now feature photographs of children, and the proportion is rapidly rising.[10] Flipping haphazardly through adult general interest magazines – not parenting or children's magazines – I recently found advertisements organized visually around photographs of children for the following: Macintosh computers, Purina Puppy Chow, Northwestern Mutual Life, Elizabeth Arden perfume for women, Soft-Sense hand-lotion for women, Guerin decorative hardware, Nuveen Tax-Free Mutual Funds, Evian mineral water, Ford's Windstar automobile, American Express Financial Services, sofas by Baker, the Breast Cancer Research Foundation, British Airways, Goldstar electronics, and the entire IBM company. None of these goods and services are either exclusively or necessarily relevant to children; certainly none of them require the body of a child to convey factual information about what is being advertised. But of course factual information is not what ads tend to be about. Ads associate the image – in the broadest sense – of an

ideal with a product. Photographs of Romantic children that exude physical charm have become one of our culture's most ideal ideals, and so ads use photographs of attractive children relentlessly. Ordinary consumers therefore encounter the photographic Romantic ideal of childhood ceaselessly.

Conversely, commercial ideals are also influenced by "normal" photographic standards. The look of the amateur family album snapshot has infiltrated professional practice. Precisely because advertisements must appeal to unprofessional sensibilities, a "personal" style of photograph now makes frequent professional appearances. When I first saw the Guerin company's ad, I couldn't figure out what its product was; a toddler and a baby in fancy clothes occupied the largest surface area on the page, while decorative hardware had been shunted off to the sides. Moreover, the largest explanatory caption announced: "Our Greatest Masterpieces," while directly underneath the children's picture I read: "A family tradition in its fifth generation. Libby Marguerite Ward and Andrew Francis Ward II."[11] Was the image advertising Libby and Andrew? Or were Libby and Andrew already working in the family business? Does producing cute kids guarantee good drawer knobs? I'm still not sure, but obviously the intention had been to identify the Guerin company with "family values" through a photograph of children, linking the commercial to the domestic, the public to the private. Sometimes ads even pretend to incorporate anonymous personal snapshots. One Holiday Inn ad I spotted in 1995 cascades three snapshots, complete with shadows behind their curling edges, above the caption "Wonderful Winter Escapes"; the top picture shows a smiling boy held forward to us by his parents.

Ordinary amateur snapshotters use photographs of children, in a sense, to market a particular idea of "family" to themselves and to each other. If the initial taking of family snapshots is already a highly selective and even orchestrated practice, how much more so are the ways those photographs subsequently get used. Unlike the meanings of most commercial photographs, the meanings of family snapshots continue to accrue long after they are made. When people choose among snapshots, frame them, arrange them in their homes or offices, send them as cards, and stick them into albums, they are creating meanings for their photographs.

Consider the function of the two family snapshots I discussed earlier. They came in the mail during the 1995 winter holiday season, tucked into printed paper frames. Like all the similar cards I receive, and you receive, they sent a message at once bigger and more personal than

"Happy Holidays." To begin with, they identify the senders as family members. Do you get any cards with separate photographs of the adult people who actually sent the card? Do you get as many cards with photographs of adults together with their children as you do of the children alone? Almost certainly not. Inside the card with the pair of boys on the front, I found a photograph of the friend who had sent me the card together with her husband and children, accompanied by the astute comment: "This is a bonus photo for those who might have forgotten what we grown ups (how did *that* happen?) look like." Reaching even farther into the realm of the unlikely, have you ever received a greeting card with a photograph of adults at work, or even of children at school? Do you think as many people assert their professional identity at home by putting photographs of their colleagues on the mantle, bulletin board, or refrigerator as assert their family identity by putting photographs of relatives on their office desks? Apparently, normal individual identity = family = innocent children.

The pull of a standard is very strong. Of course I became quite self-conscious about the holiday cards I sent while I was researching this book. I wanted to prove to myself that my research had given me some kind of critical edge, some historical perspective. So with a photograph taken by my child's beloved care-taker I put together a collage card I

39  RAPHAEL, US POST OFFICE, ANNE HIGONNET and VIRGINIE ROLLET
Higonnet/Geanakoplos family Christmas card 1995

hoped would be just a bit different. The result is superficially a visual joke about my work, and also my tribute to the popular cult of Raphael's *Sistine Madonna*. Fundamentally, however, the card isn't any different from the cards I receive. In my heart of hearts, deluded like all fond mothers, I do believe my child is a masterpiece, and a photograph of him seems to me the most perfect image I could show anyone of myself.

The larger the collections of family snapshots get, the more alike they become, regardless of how unique the individuals involved might be. According to snapshots, the normal modern family is harmoniously nuclear, anchored to society by collective rituals yet basically private, and relatively affluent. Special events and leisure activities, along with parents, grandparents, and other close relatives or friends, constitute a cocoon within which the snapshot version of childhood is sheltered. Smiling, embraced, celebrated, dressed up, cute and cuddly, the Romantic child plays the central role in photography's performance of family. Needless to say, every family plays its own variations on the theme. Some give extra space to aunts, uncles or cousins. Some insist on family trips, parties, weddings or graduations. Grandparents often excise their own children from their snapshot pantheon in favor of the grand-children. On the whole, however, the theme remains quite consistent. Adults may claim they take, keep, and display so many pictures of chil-dren because kids are photogenic, but what do we mean by photogenic? Technically speaking, a child is not an inherently good photography subject, if only because children wiggle and squirm at the speed of light. Photogenic means our society treasures the image of childhood innocence and the identities Romantic childhood anchors.

What matters is not just what the photographs themselves represent, either individually or as groups. What matters is also the practice of taking, accumulating, and preserving snapshots of childhood. The prac-tice itself, as a process and an attitude, replicates the function of the paintings and illustrations of childhood that precede it. The great eigh-teenth-, nineteenth-, and early twentieth-century images of childhood represent a lost past, an irretrievable innocence beyond adult time and place. The practice of representing childhood through snapshots does the same, at once inflicting and veiling loss with the beauty of the innocent child. Nowadays adults enact the image of Romantic child-hood, as well as produce and consume it. Looking has turned into an activity involving adults more thoroughly in the ideal image of child-hood than ever before. No one snapshot, made or kept, contains the longing for edenic innocence compressed into single images by great

paintings or illustrations; now snapshots perform a serial function, one by one warding off the inevitability of loss.

Everyone knows they cannot capture childhood with snapshots, but most people persist anyway. The more snapshots get taken, the more obviously time and life slip through all photographic nets. The camera, the frame, and the album deny fate. When we mourn the passing of childhood, we are really mourning our own passing, the inevitable end of all lives in death. We fend off death's terrors, snapshot by snapshot, pretending to save the moment, halt time, preserve childhood intact. We never succeed, of course, so we have to keep on trying, caught in what Sigmund Freud called repetition compulsion. The critic Jean Baudrillard has written that all collections defend their collectors from the fear of death.[12] All collections, Baudrillard argued, are idealized images of the self, idealized but insecure, compulsively reinforced through repeated acquisition. There may be no more common form of collection than the collection of childhood snapshots, and none so hopefully wedded to the illusions of eternal life.

We treasure our own childhood snapshot identities. They give testimony to an imaginary time when we were perfect and innocent, when we were, we would like to believe, our original and therefore real selves. Any fall from grace can be measured against the child snapshot standard. In the last scene of *Philadelphia*, a film about the decline and death from AIDS of an adult man, his bereaved family and friends gather to watch home movies of him as a child. Because in the fiction of the film this man's (redefined) family chooses to close his life with a vision of him composed by childhood photographs, we the viewers are also left with that vision, one which gradually takes over the whole screen to close the film. The tragedy of adult death, we are being shown, is that every adult was once an innocent child. Against the stereotypes about AIDS has been pitted the truth-value of the childhood photograph.

All photographs may seem more or less real, and therefore true, but no photographs seem truer than snapshots of childhood. Take for example the cover of Shere Hite's 1995 book *The Hite Report on the Family: Growing Up Under Patriarchy*. Behind the title and author's name we see a photograph of Hite as a small girl. The image conveys a connected group of messages: 1) the child is the essence of the family; 2) the author was already basically herself by the time she was about eight, and remains true to that childhood self; 3) the author therefore speaks the truth, since, as the proverb assures us: "truth comes from the mouth of babes." And, most pertinently, 4) a photograph is the kind of image that proves messages 1, 2, and 3. Whether Hite knew consciously or

40 MARTINE FRANCK Shere Hite holding a photograph of herself as a young girl 1995

unconsciously that her cover would convey these messages, or whether she realized that images of cute girls with pigtails help sell commodities, the point remains the same. Playing on Wordsworth's famous Romantic line: "The child is father to the man," a *Ms.* magazine article promoting Hite's book included a photograph of Hite's hands holding the snapshot used on her book cover, captioned: "The child is mother of the woman: Hite holds an early photo of herself."[13]

Hite uses the private connotations of her childhood snapshot publicly, just as the movie *Philadelphia* does, just as advertisements use those same connotations in publicly commercial ways. All of these photographs are making arguments about the nature of the family, and some are taking on issues – like patriarchy, family abuse and AIDS – that did not formerly seem to be family matters. Paradoxically perhaps, the private values of the "normal" family so convincingly carried by snapshot photography have become deeply ingrained in a public mentality. As the character and functions of the family seem less and less predictable at the close of the twentieth century, as the family becomes a controversial social issue, it is therefore inevitable that snapshot photography, which stands for the family, will continue to function as a form of public argument, and be increasingly subject to public vigilance.

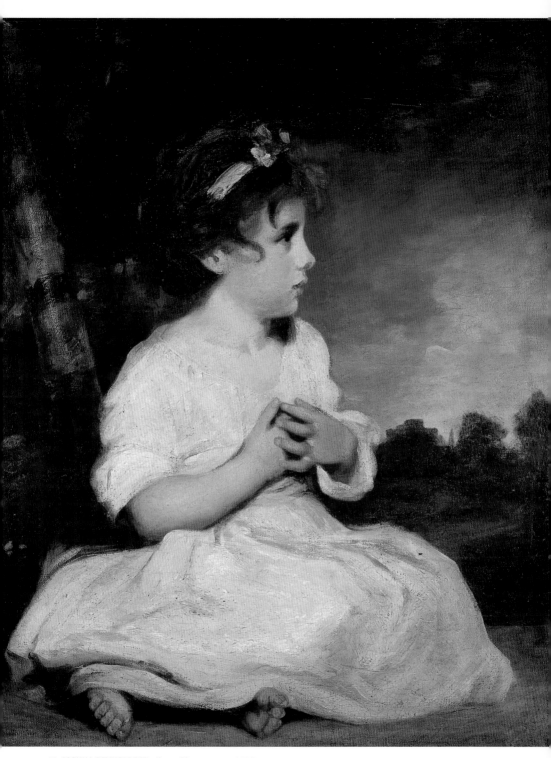

41  JOSHUA REYNOLDS The Age of Innocence c.1788

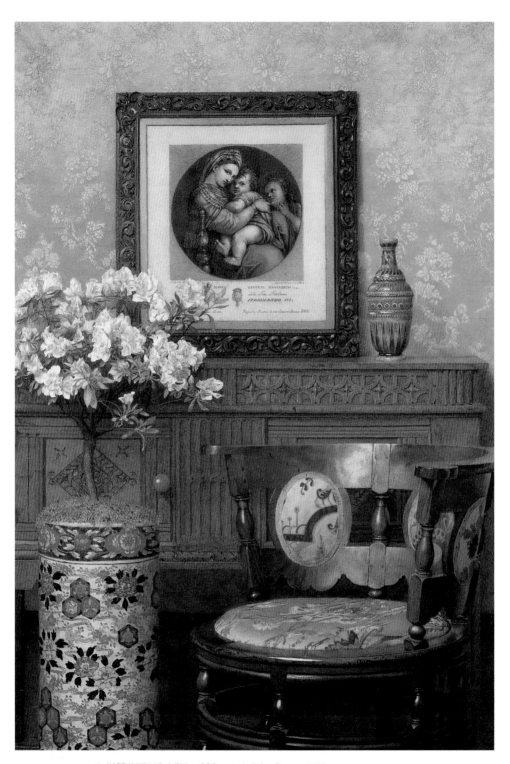

42  KATE HAYLLAR A Thing Of Beauty Is A Joy Forever 1890

Ring-a-ring-a-roses,
A pocket full of posies;
Hush! hush! hush! hush!
We're all tumbled down.

43  KATE GREENAWAY 'Ring-a-Ring-a-Roses' 1881

44  BETSY CAMERON Baby Blue Eyes 1994

45  ANNE GEDDES Cheesecake 1993

46  SHEILA METZNER Stella on Fire 1982

47  NAN GOLDIN Io in Camouflage 1994

48 GLEN WEXLER and VAN HALEN *Balance* album cover 1994

"You can observe a lot by watching."

YOGI BERRA

The 1994 rock music album cover *Balance* takes over where Reynolds's *The Age of Innocence* leaves off. *Balance* disrupts the same established expectations of childhood it taps into. Because it threatens the ideal of childhood innocence, it has provoked resistance as well as change.

Like many unusually thoughtful photographs of children, *Balance* raises issues basic both to photography and to childhood. Using the latest computer image technology, *Balance* exploits a tension between artifice and realism, the tension good photographers have always manipulated, no matter how firmly convinced they and their audiences might be of the camera's mechanical neutrality. Could those Siamese twins be real? Or are they one imaginary monster? It is a photograph, but it cannot be true. On closer inspection the image turns out to be photographic, and also fake. The two torsos fuse at a pixel shadow, not an organic join, and the eerily crisp, chemically tawny tone of the whole picture defies nature. Moreover, both the twins and their seesaw pointedly illustrate the concept of duality announced by the album's title.

An artist named Glen Wexler combined and altered parts of several photographs to create the image in 1994, taking off from an initial suggestion by Alex Van Halen, and granted an unusual degree of freedom by Jeri Heiden, a Warner Brothers records art director. Wexler used a computer to work with two photographs of the same four-year-old boy, a photograph of his own daughter, who was present at the studio session, and photographs of the studio set, in addition to a photograph of sky in the artist's files.[1] Rationally, we know this image is fabricated, yet somehow it does still feel like a real picture of children.

Realism certainly enhances the *Balance* picture's impact, an impact which has been considerable. The picture was designed to be striking.

Now that recording packages have been reduced to five square inches, it takes a strong image to compete successfully for attention in a retail space filled with thousands of other images, all of them in plastic boxes. Yet despite its realism, and despite the album's strong sales in many different countries, neither the quantity nor the quality of reactions to the image were possible to predict or control, in large part because it did not look the same to everyone who saw it. In Japan, for instance, the image was perceived in a way quite particular to Japanese history. Prior to the album's release, the company planning to distribute the record in Japan reminded Warner Brothers of the extreme Japanese sensitivity to any photograph depicting human deformity. Another cover image, of a single child, was therefore created for the Japanese market.[2]

In the United States, the original *Balance* picture met with opposition for quite another reason. Seeing obscenity, some major retail outlets, notably Walmart, Kmart and Sears, would only stock the album when stickers were placed over the sewsaw handle area of the picture.[3] Whatever the *Balance* picture actually showed or did not show, it was being seen in the context of anxiety over revelations of rampant child abuse, especially sexual child abuse – not as an isolated picture, but as part of a much larger visual culture, a culture which includes an increasing number of troubling images. In the eyes of many people, photographs can pose a dangerous threat to real children by sexualizing them. Attitudes to photography have changed dramatically over the last few decades. The conditions in which the photographs for the *Balance* image were taken, for instance, conformed to laws, once inconceivable, which required the presence of a licensed social worker at all commercial studio sessions.[4]

Because photographs originate in a real encounter between actual people, concerns for children's welfare govern the making and marketing of photographs more strictly than in the case of any other representational medium. At their most forceful, controls over images on behalf of children's safety take the form of child pornography law. Over the last two decades, the scope of child pornography law has gradually broadened. The law now attempts to control the interpretation of photographs as well as the conditions of their making, and can be construed to affect all pictures of children, including those belonging to the commercial mainstream once exempt from scrutiny. Now all pictures of children – clothed, unclothed, documentary, altered or completely artificially generated, artistic, commercial or taken by their own parents – are implicated by child pornography law provisions.

Even within the United States, however, there is no consensus over

the meanings of any image of a child. Returning to the *Balance* case, for example, Van Halen held its ground amidst controversy, insisting on its intentions. A statement issued by the group about the cover concluded: "Our intention was to provoke thought, discussion and reflection. As parents, we consider children our most precious resource, never to be exploited or demeaned."[5] Or as group singer Sammy Hagar put it: "It's kind of deep and it's kind of twisted, but it says a lot."[6] He also commented: "To be honest with you, I don't care what you do these days, somebody is going to be offended."[7] Evidently, many somebodies were not at all offended: *Balance* has sold exceptionally well. To its intended audience, young in spirit if not in fact, comfortable with computer imaging, and concerned with the earth's ecology, the album obviously struck a congenial chord.

What can we presume the *Balance* album cover looks like to millions of Van Halen fans? Perhaps simply an illustration of its title. According to such an interpretation, the child represents twinned though opposite qualities: innocent and experienced, serene and angry, spiritual and carnal, cute and shocking. Like Romantic images, Van Halen's posits the child as the essence of humanity. Here, however, the vision is not of a reassuringly pure origin, but of a volatile situation always liable to tip out of control. The image's maker, its art director and several Van Halen members have all said the image was supposed to warn against losing balance, which in its largest sense they understood as an ecological consequence visually implied both by the idea of environmental causes for genetic mutation and by the "post-apocalyptic" setting.[8]

*Balance*'s image appeals to so many people because it taps into a growing movement. In every branch of the media, whether ostensibly commercial or artistic, new images of childhood are appearing. The children represented by these new images are much more physical and challenging than the ones Romantic imagery accustomed us to, so much so that the entire Romantic definition of childhood is being called into question. This reinvention of childhood is hardly simple. On the contrary. As *Balance* warns us, the forces at play are complex and even contradictory, at once fascinating and disturbing. Yet they are forces which can no longer be denied or suppressed, only reckoned with.

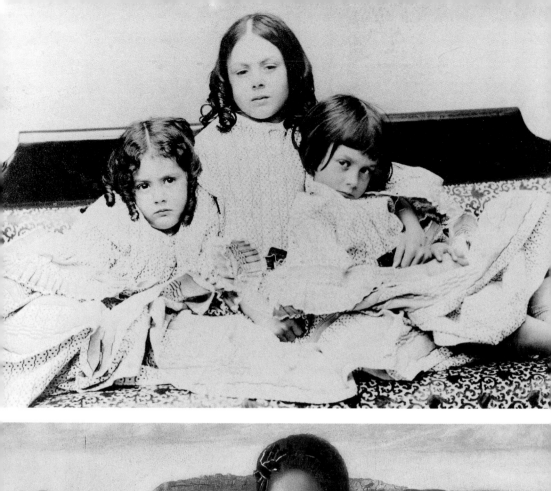

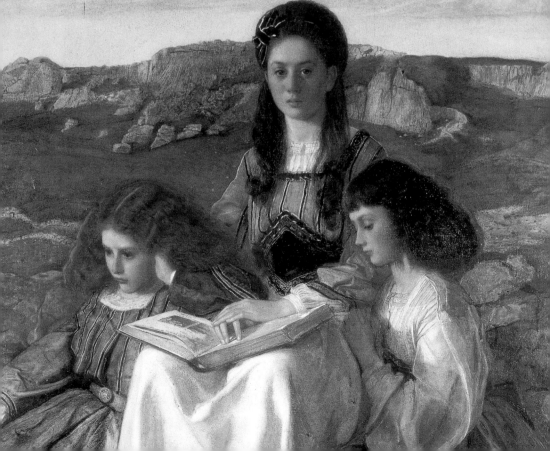

Through the Looking Glass

Romantic childhood never quite completely swept its visual field. Though the pictures discussed in Part I rallied popular consensus, alongside them persistently emerged alternative visions of the child's body and that body's symbolic significance. The most important of the alternatives have not been conscious violations of the Romantic ideal, but, on the contrary, pictures that sprang from that ideal itself, and which in so doing have therefore revealed the tensions, limitations, and contradictions of Romantic childhood. Among those important alternatives, photographs have had the greatest impact. While painting, sculpture, and printmaking continued to produce challenging images of children, only photography with its claim to objectivity would have been able to shake the Romantic ideal at its core.

Photographs of children have appeared in surprisingly wide variety. Some of them may hardly have been known to a general public when they were first made, but are nonetheless classics in the history of their medium. The most prominent and gifted photographers turn out to have had quite different ideas about how to represent the innocence of children, differences tied to radical disagreements about the validity and purposes of photographic realism. Whatever photographers intended their work to mean, serious photography critics and historians may think otherwise. Interpretation attributes meanings to photographs of childhood which their makers, even their era, would never have consciously recognized. It all adds up to a rather wild instability.

Going back to photography's first heroic age, consider the dramatic differences between the approaches of Lewis Carroll and Julia Margaret Cameron. Both took great photographs of children in the middle of the nineteenth century, for opposite reasons.

Lewis Carroll was among the first to understand how photography and the image of modern childhood could be allied. As many people now know, Carroll, besides writing *Alice in Wonderland* (1866), taught mathematics at Cambridge University under his real name, Charles Dodgson, and also quietly took hundreds of photographs of little girls between the late 1850s and the late 1870s. At the end of his *Alice in*

49, 50  CHARLES DODGSON (LEWIS CARROLL) Alice Liddell and sisters Edith and Lorina c.1859 and below, WILLIAM BLAKE RICHMOND Edith, Lorina and Alice Liddell 1864 (detail)

*Wonderland* manuscript, he originally drew the face of Alice Liddell, the girl for whom he wrote the story. Then he changed his mind. He covered his drawing with a photograph of Alice he had recently taken. Photography had replaced drawing as his preferred way of representing childhood visually.

Carroll's photographic portraits of girls, Alice Liddell only one among them, do look convincingly childlike, in a Romantic way. It is easy to see why Helmut Gernsheim, the photography historian who introduced a twentieth-century public to Carroll's amateur pictures of children, praised them for what he perceived as a natural insight into childhood that dispelled stiff studio conventions.[1] A student of mine in a graduate seminar, Diane Waggoner, showed me how Carroll achieved his effect.[2] Carroll's images, especially those of his favorite "child friends," artfully convey artlessness. The girls' poses are ever so slightly asymmetrical, tilted, or off-center, wisps of hair drift astray, clothes wrinkle or bunch up, and some "wrong" prop or background testifies to the spontaneity of the photographic session. Compare a photograph Carroll took of the three Liddell sisters in 1859 with a painting made in 1864 of the same girls by W.B. Richmond. While Richmond tries to make a pyramid of girls look compositionally lively, Carroll succeeds in capturing the look of casual slouch, fleeting glance, and hasty sprawl. Richmond uses a "natural" landscape background which appears every bit as contrived as Carroll's cropped sofa and blemished wall appear unplanned. Richmond's style, in "Pre-Raphaelite" fashion, tries to seem pure and simple. It was Carroll, however, who understood what would convey the values of purity and simplicity to his contemporaries.

Carroll's fresh look occurs over and over again, and the signs of his spontaneity obey a pattern. Carroll staged the "natural" image of the "natural" child, all the while sincerely believing cameras recorded reality. Carroll was absolutely convinced that the innocence of the child was a natural quality, just as he was convinced that the truth of the photographic image was an automatic quality. No wonder childhood and photography seemed to him to go so well together.

At the same time as Carroll was making his great photographs on the assumption of photography's mechanical neutrality, his peer and acquaintance Julia Margaret Cameron was making great photographs of children on the opposite assumption. Cameron could, like Carroll, be called an amateur genius, because, like him, she received no formal training and worked at her own pace. Unlike Carroll, however, Cameron courted public recognition for her photography.[3] She actively campaigned against the idea that photography was necessarily a mechani-

cal process in order to claim artistic status for her images and for herself. In 1864 Cameron wrote: "What is focus – and who has the right to say what is the legitimate focus? My aspirations are to ennoble photography and to secure for it the character and uses of High Art by combining the real and the ideal and sacrificing nothing of Truth by all possible devotion to Poetry and beauty."[4]

In addition to her bids for publicity and payment, Cameron inscribed her claims in her photographs themselves. Images like her 1865 *Devotion* (sometimes called *My Grandchild*) obviously refer to the iconographic, compositional, and lighting devices of traditional Christian religious painting. We know this woman and child are real, or were once real, but Cameron also intended us to see them as the visual archetypes of Madonna and Christ Child. Cameron, cannily, was tapping into the contemporary feminine cult of the (reproduced) Madonna image, into the associations renewed by prints of the great Renaissance masterpieces and reverential tributes to those classics like Kate Hayllar's *A Thing of Beauty Is A Joy Forever* (ill. 42). Contemporary estimations of Cameron's success varied, but they all recognized her intentions; one

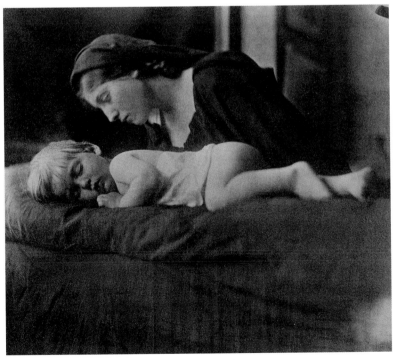

51 JULIA MARGARET CAMERON Devotion (My Grandchild) 1865

critic wrote in 1868: "No person that we know of has ever photographed children as Mrs. Cameron has done. Raffaelle [sic], Correggio, and Sir Joshua Reynolds have been painters of children *par excellence*; and what they did with the brush Mrs. Cameron has done with the camera. Some of her child pictures might easily pass for copies of paintings."[5]

Carroll, among others, criticized Cameron precisely because she refused to treat the camera as a mechanical instrument. Cameron focused when she felt like it, and ignored the chemical craft of clear, sharp, clean prints. She preferred atmospheric blurs, moody smudges, and other-worldly glows; she tolerated cracked negatives, torn film, fingerprints and even traces of hair. Artifice was her objective, not realism. Cameron thought the subjects of her photographs should pose in costumes for long periods of time. Nor did she hesitate to splice negatives, in preparing *Devotion*, for instance. At first we think the mother gazes at her beautiful child's body. Then we realize she bows behind the child, whose scale is almost imperceptibly larger than hers; the two figures once belonged to different negatives. Far from being a mistake, Cameron's manipulation of her negatives subtley reinforces her message by making the mother small in relation to the object of her adoration. Cameron is also insisting that her image is not found but made, and made for an audience. We are the ones to whom the child is ultimately presented for adoration; face, torso, and chubby limbs are turned toward us, filling the breadth of the image. The mother's role is not so much to engage with the child, but to cue our visual engagement.

Carroll and Cameron occupied opposing positions in the perennial photography debate. Is it mechanical representation or is it art? From the very start of the medium, there had been two basic camps encompassing infinite gradations of opinion. In 1859 Charles Baudelaire might rail: "I am convinced that the badly applied advances of photography, like all purely material progress for that matter, have greatly contributed to the impoverishment of French artistic genius,"[6] but as early as 1840 Edgar Allan Poe lauded photography's "most miraculous beauty," adding that "the source of vision itself has been, in this instance, the designer."[7]

The debate continues. Everyone, no matter how logically rigorous, worries about the effect photography's connection to reality has on them. Cultural critic Roland Barthes, who famously called that effect photography's "reality effect," devoted many essays to photography's artificial rhetoric. Yet he clung, however vestigially, to what semioti-

cians call indexicality: the sameness of a sign and what it represents. Barthes contracted photography's connection to reality into a viewer's uniquely personal and subjective reaction to some aspect of the photograph, which might be merely an insignificant detail, one Barthes called a "punctum" (point or puncture), and whose impact he conveys with his charged language: "The photograph is literally an emanation of the referent. From a real body, which was there, proceeds radiations which ultimately touch me, who am here ... A sort of umbilical cord links the body of the photographed thing to my gaze: light, though impalpable, is here a carnal medium, a skin I share with anyone who has been photographed."[8] Barthes speaks of photography's realism with the language of the body, reinforcing the visceral – not rational – effect he attributes to the medium. He likens the punctum to an "umbilical cord," and Barthes's most important book about photography, *Camera Lucida*, revolves around his meditations on his umbilical relationship to his mother.

By contrast, Umberto Eco, a semiotician, intransigently classifies photography among representational signs, and does so with technical language. Yet even he admits that photography's connection to reality requires discussion "at greater length": "The theory of the photo as an *analogue* of reality has been abandoned, even by those who once upheld it – we know that it is necessary to be trained to recognise the photographic image. We know that the image which takes shape on celluloid is analogous to the retinal image but not to that which we perceive. We know that sensory phenomena are *transcribed*, in the photographic emulsion, in such a way that even if there is a causal link with real phenomena, the graphic images formed can be considered as wholly arbitrary with respect to these phenomena. Of course, there are various grades of arbitrariness and motivation, and this point will have to be dealt with at greater length. But it is still true that, to differing degrees, *every image is born of a series of successive transcriptions*."[9]

It is extremely difficult to locate a boundary between the realistic artifices Eco calls "transcriptions" and what Barthes calls the "emanation" of reality. Whatever seems to emanate directly from reality tinges an entire photograph with realism. Barthes's sharp "punctum" induces belief in all the esthetic and cultural choices that constitute a photograph, starting with the choice of its subject matter and ending with the place where it is shown. The more the choices that go into making a photograph have become habits or conventions, the more thoroughly we will be convinced of that photograph's reality. Photography critic Allan Sekula has written: "Every photograph's image is a sign ... of

someone's investment in the sending of a message."[10]  The greater the investment in the message, the more intensely we desire it to be true, and the more we will want to believe in the message's reality. Those who make the photographs are as susceptible as anyone else.

Photographers have put beliefs in the realism of their work, however, to very different purposes. Even among photographers committed to the camera's mechanical optics, and reluctant to orchestrate subjects, alter negatives, or crop prints, any one photographer's work will still be strongly affected by changes in cultural climate. Skipping now from some of the great mid-nineteenth-century photographs of children to those of the early twentieth century, from a comparison between Carroll and Cameron to a comparison between Edward Weston and Dorothea Lange, we can see how rapidly and visibly attitudes to the reality of a child's image do change.

During the 1920s, photographers all around the world joined an avant-garde Modernist movement toward abstraction. Edward Weston emerged from this movement to become one of the greatest artists in the history of the medium. Out of Weston's modernism, his belief that the camera could distill the essence of the visible, came some of the most highly acclaimed photographs of a child ever taken. Shot in 1925, the *Neil* series includes six printed images (out of nine Graflex negatives) representing Weston's son Neil Weston, nude.[11]  One image includes Neil's face and torso, two the front of his torso and thighs, two

52  EDWARD WESTON Neil (from behind) 1925

his torso alone from the front, and one his torso from the back. All of them are lovely, but the back view is the most exquisitely abstract. Pulling toward the left, a lithe contour divides misty grays from flat black into an undulating pattern of poured light, of live surface against the dark.

Edward Weston kept diaries during this period, which, published as the *Daybooks*, have become standard reading in the history of photography. The beauty of his images, Weston wrote, resided in what he called "my vision," and in the purely formal quality of the prints he made from his negatives. On 6 January 1926, he wrote in his diary about the *Neil* series he was printing: "If I am ever temperamental as story book artists are, it is while printing. The reason is based on economics. The first print must be perfect, which is of course expecting the impossible.[....] One nude of Neil is 'almost right.' Should I reprint it? or is it 'good enough?'"

Next entry, 7 January: "Printing of yesterday yielded five more prints, the most pleasing, another nude of Neil, though I must say that I am not happy with the rendering of deep black in the white stock, which seems to solarize more easily than the buff. The deepest blacks are not clean – they have a chemical quality – yet Neil's whitest of white bodies should be printed on white."[12] Later in the same entry, he repeats with pride the Mexican muralist Diego Rivera's praise: "Your work leaves me indifferent to subject matter."[13]

One decade of social and artistic change can alter the photographic climate altogether. In 1923, during an early phase of her work, Dorothea Lange had produced *Torso, San Francisco*, an image closely related to the Modernist intentions and effects of the *Neil* series (ill. 77). By 1936 she was making pictures like *Damaged Child, Shacktown, Elm Grove, Oklahoma*. Not only do Lange's two images evoke very different cultural moods – the replete 1920s as opposed to the desperate 1930s –but also radically different concepts of what reality means in a photograph.

When Dorothea Lange took her famous WPA (Work Projects Administration) photographs in the 1930s, faith in the social purpose of photography's realism reached one of its highest tides. The whole WPA photography project rested on the assumption that photography could not only record reality, but also that, through visible reality, photography could reveal the reality of social conditions. The director of the project absolutely forbade any of his photographers to alter their negatives in any way, on the assumption that artifice would diminish not just their credibility, but the credibility of all WPA social programs. Through

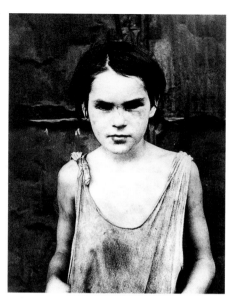

53 DOROTHEA LANGE Damaged Child, Shacktown, Elm Grove, Oklahoma 1936

the body of one girl, Lange wanted to show how all poor rural children were affected by the Depression. She was not alone. Denouncing poverty by exposing the suffering of a child's body was a strategy other photographers of the period also relied on, among them Walker Evans in his very famous *Bud Fields, Cotton Sharecropper and Family, Hale Co., Ala.* (1936), with its little boy naked from the waist down as pathetic center of a destitute family group.

To believe Lange's message, we need Barthes's "punctum": the shock of seeing that there once was a real child who was really so hungry, dirty, and, as the title insists, really so damaged by the Depression. Then again, it is Lange's formal choices, what Eco would call her "transcriptions," that make this image thought-provoking and memorable. Honed in on a closed, luminous human form pinned against a plain dark background by intersecting rifts, the simplicity of the composition lends its figure a dignity that commands our respect as well as our pity. How beaten and yet defiant the child's stance, how angry and also pathetic the charred abyss of her gaze. Darkness corrodes a mottled and uneasy light. No one finds an image like that by chance, least of all Lange, who carefully posed her subjects, and who was finally evicted from her WPA program because she couldn't resist altering the negative of her famous *Migrant Mother* photograph.[14]

Lange's images of children come out of what was by her time a tradition of photographic social protest. All along, positively Romantic photographs of children have made possible negative images capable of evoking pity or outrage. Because the "normal" image of the child was Romantic innocence, any sign of deviation from innocence could be understood as violation. Signs of want, of brutality, of labor, of filth, of sexuality, of any physical or emotional trauma, would appear as a forced, social ban from natural innocence. Lange's *Damaged Child*, for instance, signals wrong because photographs like Carroll's and Cameron's signal right. Carroll's and Cameron's friend and colleague O.G. Rejlander made photographs of suffering poor children, and he was only the beginning of a lineage that extends on to labor law reformers like Lewis Hine at the turn of the century, through WPA work, and on to photographers such as Sebastian Salgado and Mary Ellen Mark in the late twentieth century. The children in protest photographs are necessarily perceived negatively, as the deformation of a standard, and moreover they tend to be poor or not white, or both, in other words socially subordinate to their audience. Social protest photos, therefore, can sometimes verge on exploitive objectification.[15] Either way, photography has always included pictures of children whose realism is supposed to lead beyond bodies toward social conditions, and whose conscious intention, at least, is hardly to abuse real children, but, on the contrary, to use photographs of their bodies to achieve reforms in children's favor.

Helen Levitt's documentary work on children, for instance, is exceptionally humane and tolerant, as well as keenly aware of children's less than ideal aspects. A photograph such as her famous *New York* (1942), draws our attention to what Romantic images exclude. Six boys congregate around a frame whose mirror has shattered in our direction, a scene redolent with evocative allusions to sight. Echoing the edges of the photograph, the emptied frame now surrounds one small boy bicyling toward us. Two boys hold the frame upright, while two more pick up dangerously splintered fragments of glass with their bare hands. Though their smooth, rounded, exposed limbs proclaim their youth, and though the boys are linked to each other by their common interest in the broken mirror, Levitt's apparently random but in fact brilliantly selective journalistic style situates their childhood in an adult urban world, out on the grimy commercial street. On this street, all kinds of bodies can be seen: old and young, affluent and ragged, white, black, and racially mixed. In Levitt's image, distinctively childish bodies and occupations exist in a world where damage and diversity must be reckoned with.

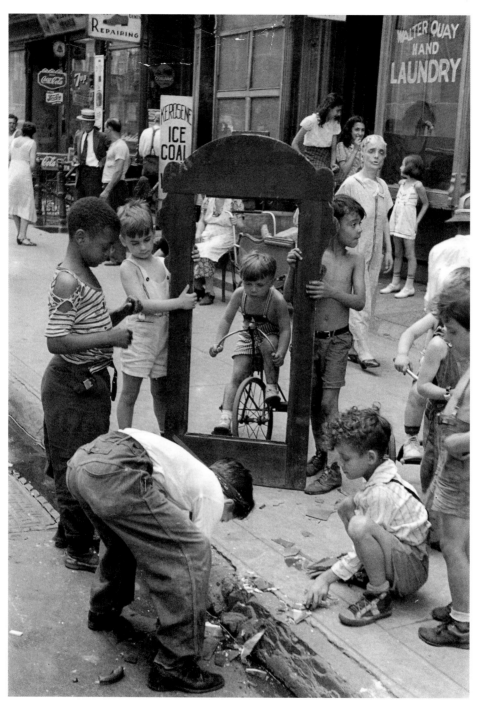

54  HELEN LEVITT New York 1942

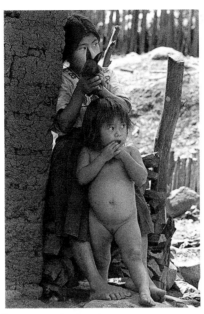

55  JOSÉ ANGEL RODRÍGUEZ Los Chorros, Chenalhó, Chiapas 1981

   In the shadows of ideal childhood we have been confronted with the
issue of race. How very white the Romantic child has been, so domi-
nantly white that race did not even seem to be an issue. Nonetheless,
one variant on photography's realistic impulse has brought many
racially different child bodies to public attention. Ethnographic pho-
tographs of children from non-western peoples have long been items of
mass consumption, notably through popular family magazines such as
*National Geographic.* First cousin to social protest photography in the
documentary family, ethnographic photography has produced countless
photographs of children, photographs whose realism is complexly cele-
bratory, exploitive, informative, and derogatory. Ethnographic pho-
tographs of naked children purport to show to a curious civilized
audience how picturesque primitive people "really" live. The conde-
scension implicit in such an attitude allows a double standard of inno-
cence. In an ethnographic context, a child's nudity or near-nudity can
reinforce stereotypes of primitive nature and cultural hierarchy. Not all
innocences are alike, or equal.
   In 1981 a book titled *Vidas Ceremoniales* published José Angel
Rodríguez's *Los Chorros*, a photograph taken in Chiapas, Mexico, and
reproduced as a commercial postcard. I chose this image among many
for two reasons. First, because it was not taken by a foreign ethnogra-

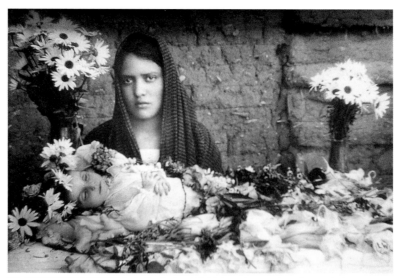

56 JUAN DE DIOS MACHAIN Portrait of a Dead Child, late nineteenth–early twentieth century

pher – academic or commercial – nor under colonial conditions, thereby leveling the playing field somewhat by eliminating the worst motives for ethnographic photography. Second, because it can be usefully compared with pictures discussed in earlier chapters, especially Raeburn's *Boy and Rabbit* (1786) and Anne Geddes's *Bunny in a Crate* (1995). From a cheerful point of view, the naked little girl facing us in the center of the image, as well as her older companion holding a bunny behind her, are just so "cute." Dressed and undressed girls are equally comfortable in their pre-industrial setting, rhymed with the primitive wall and post that frame them. The older girl substitutes for a protective mother, and the toddler seems alert, well-fed, and clean. Looking at the photograph more cynically, however, these children's oblivious innocence confirms a long western tradition of seeing anyone who isn't western as an innocent savage, a savage who remains perpetually a dependent child. The signs of these girls' innocence are simultaneously the signs of pathos. They wear exotic costumes or nothing at all out of necessity, their mother is away struggling for a living, they walk with bare feet in a destitute built environment, and their rabbit is more likely to be dinner than a pet. Nudity here signals the innocence of childhood, and also a quaint tourist attraction.

The Romantic child belongs to the modern affluent west. To anyone outside our culture or not influenced by it, the ideal meanings we have attached to the child's body would be odd if not incomprehensible. And

57 E. THOMAS GILLIARD Melanesian Girl with Pandanus Specimens 1950

vice versa. How, for instance, would a rural Mexican have photographed a small child a century ago? In ways that might shock us, or at least seem strange. One of the most characteristic Mexican photographic traditions of the nineteenth and early twentieth centuries was the infant mortuary portrait; among the most beautiful were those made by Juan de Dios Machain. Typically, these mortuary portraits show a gorgeously dressed and formally posed tiny corpse, crowned and adorned with massed flowers, laid out along the picture's width for us to see, in front of a witnessing adult, the mother or other members of the family. In an age of steep infant mortality rates, North Americans and Europeans too sometimes had photographs taken of their dead children as final keepsakes, but the ritual, watchful, solemnity of the Mexican tradition, coupled with its lavish, almost sensual, presentation of the child's corpse, strikes its own note. Such photographs might seem ostentatiously ghoulish (or even necrophiliac) to anyone unaware of the deep spiritual meanings evoked for Mexicans by the tiny dead children they call *angelitos*, sinless little angels whose worldly trappings are only material reminders to their loving mourners of the celestial beauty *angelitos* have already attained.

Culturally-determined differences of interpretation cascade from the sublime to the ridiculous. Take, for example, an unusually comic recent academic debate, over a *National Geographic* photograph published in 1951. The photograph represents a Melanesian girl holding a plant in

each hand and wearing flashbulbs hung from ribbons around her neck. In her 1990 book *Gone Primitive*, art critic Marianna Torgovnik denounced the photograph. Claiming that the "palm fronds ... evoke a fertility or initiatory ritual," she continued with an analysis of the flashbulbs, which "suggest, on the young girl, the forms of breasts she does not yet have, replace them in a metonymy both verbal (bulbs/boobs) and visual. The bulbs may have come – probably did come – from the camera taking the picture. Is this 'culture contact' or 'cultural hegemony,' 'sexual politics,' even, at the most extreme view, 'child porn'? The photograph suggests an uneasy crossing of all four."[16] In 1995, art critic Denis Dutton retorted in the professional magazine *African Arts* that Torgovnik had no idea what the circumstances surrounding the photograph had been. American Museum of Natural History Bird Curator E. Thomas Gilliard had asked many children to search out plant specimens for him. Gilliard offered a coveted camera flashbulb in exchange for each find. According to Dutton's interpretation, both the many flashbulbs the girl wears and the young pandanus trees she holds signal the girl's hunting prowess. "There is a real human joy in Gilliard's wonderful image," Dutton asserts.[17]

Everyone interprets. Many people could agree on an identification of objects or people or places in a photograph without being able to agree at all on what any of those identified features meant. What you genuinely feel you see in a photograph depends on who you are, where you come from, what culture you belong to, where you see the photograph, and with whom you see it. This instability of meaning, caricatured as a decadently contemporary moral relativism, is actually only common sense, as Goethe wrote in 1798: "A glance at the surface of a living being confuses the observer; here, as elsewhere, we may adduce the proverb 'We see only what we know'... perfect observation really depends on knowledge."[18] Of course Goethe was writing long before photography was officially invented, yet there could be no better description of people in photographs than "the surface of a living being." The only reality a camera can record is light bouncing off surfaces. Knowledge supplies the rest. And perhaps the least reliable knowledge of all is sexual. What could be more personally subjective than an opinion about what is sexual and how it is sexual, especially when the sexuality is all in an image?

Over time, wide publics as well as individual art critics and historians have seen very different sexual meanings in photographs of children than their makers intended, and each successive reinterpretation has been the genuine product of a different situation. Among photogra-

phers of children, none have known more dramatic reversals of critical fortunes than Carroll and Cameron. Once again, the two great Victorians appear as each other's mirror opposites, one cast from acclaim into ignominy, the other raised from disdain to awe.

When it became common knowledge, not long ago, that Carroll had made photographs of naked little girls like Evelyn Hatch, suddenly his pictures of dressed little girls looked different. Confident that Carroll had always been seeing through clothes, late twentieth-century viewers followed suit. Faced with a photograph like Evelyn Hatch's, it is indeed difficult not to wonder what Carroll's motives were, if only his subconscious motives.[19] Then, of course, there is the business of whether he proposed marriage to an underage Alice Liddell, a controversy that has never been resolved, but does continue to affect our understanding of all of his photographs.

Carroll's photographs tapped into Victorian conventions ranging all the way from pedophilia to innocence, and back again. Photographs like his nude study of Evelyn Hatch would not have been ambiguous to Victorian audiences. Then as now, her reclining odalisque pose clearly signalled adult and available feminine sexuality. At the other unambiguous end of the spectrum, his portraits of fully dressed girls appeared utterly innocent right up through Carroll's rediscovery as a photographer in the middle of the twentieth century. But what about photographs in between, like his portrait of Alice Liddell as a beggar girl? Having once seen Carroll's nudes, Alice's bare calves and shoulders, her soliciting gesture, and her ripped rags, all provoke suspicion.

58 CHARLES DODGSON (LEWIS CARROLL) Reclining Nude 1879

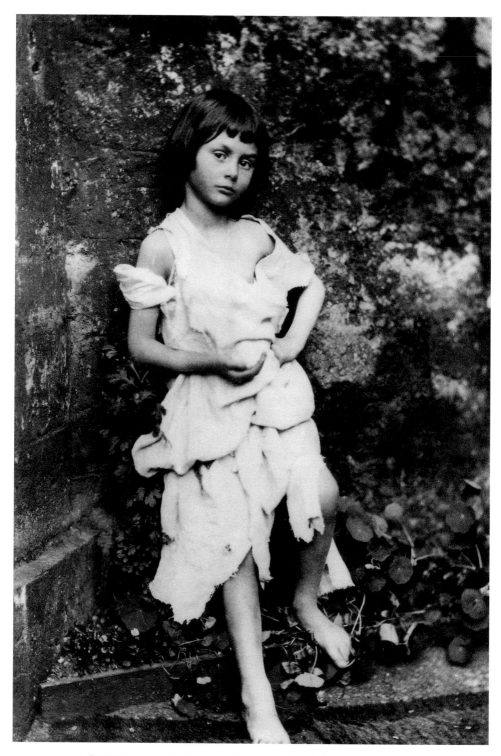

59 CHARLES DODGSON (LEWIS CARROLL) Alice Liddell as The Beggar Maid c.1859

The whole beggar pretext seems dubious, since Alice exudes health, wealth, and the arrogance of privilege. To Carroll's contemporaries, however, Alice's beggar portrait did not look prurient at all. No less an eminent Victorian than the British poet laureate Alfred, Lord Tennyson said it was the most beautiful photograph he had ever seen. If Tennyson's estimation seems surprising, or naive, or repressed, then we should carefully compare *The Beggar Maid* to popular genre paintings being made at the same time, images like Bouguereau's *The First Kiss*, Munier's *Girl with Kittens*, Guy's *Making a Train*, and Millais's *Cherry Ripe*, or to earlier inspirations like Reynolds's *Age of Innocence* or Banks's *Penelope Boothby*.[20] The differences among all these images are differences of degree, not kind. In their time they were all consciously seen as being of one kind: images of natural innocence and therefore naturally innocent themselves.

Meanwhile, if latent sexuality now seems reprehensible in pictures of children by men, especially if the children are girls, it can seem empowering in pictures by women. Since late twentieth-century photographers like Sally Mann have brought issues of mothering, sexuality, and photography into controversial contact with each other, the work of Julia Margaret Cameron looks different. Until very recently, Cameron's portraits of adults were recognized as classics, but her images of children were dismissed for their sentimentality. George Bernard Shaw, for instance, had this to say: "While the portraits of Herschel, Tennyson and Carlyle beat hollow anything I have ever seen, right on the same wall, and virtually in the same frame, there are photographs of children with no clothes on, or else the underclothes by way of propriety, with palpably paper wings, most inartistically grouped and artlessly labelled as angels, fairies or saints. No-one would imagine that the artist who produced the marvellous Carlyle would have produced such childish trivialities."[21]

Now those "childish trivialities" look erotic, and not just to one person. Unbeknownst to each other, two gifted art historians were working at the same time on a revision of Cameron's child imagery, and published their ideas at almost the same time. Both Carol Mavor and Carol Armstrong argue eloquently for a maternally erotic meaning in photographs like Cameron's.[22] Cameron's peers might have looked at such pictures with eyes sugared by confusions between cherubs and cupids, glutted, perhaps, by the infinite reproduction of Raphael's pudgy putti, but both Mavor and Armstrong look at such pictures with the eyes of their time, which happen to be the eyes of loving and feminist mothers. Reinterpreting Cameron's technique, they explain her cracked nega-

60  JULIA MARGARET CAMERON Cupid (The Adversary) c.1866

tives, hair shadows, and chemical blurs as signs of tactile presence which, far from spoiling the images, reinforce their haptic immediacy. These are photographs of children, Mavor and Armstrong contend, as much about touch as about sight. To them, Cameron's esthetic privileges the feminine, and represents an alternative to both patriarchal sexuality and patriarchal art history. Mavor's and Armstrong's historical, professional, political, and maternal circumstances intersected at a point of view that allowed them to see the sensuality of an image like Cameron's *Cupid* (*The Adversary*) (1866), with its yielding, dreamy gaze, luminous folds of flesh against soft fabric folds, and streaming hair. Right at the front of the picture, a glowing round thigh presses against curving calf and little heel. Cupid looks heavy-lidded at us, grasping a trembling bowstring, with a quiver full of love arrows gliding off his shoulder, his whole body sliding toward us.

These new, sexualizing interpretations clustered around the Victorian greats render visible a persistent strain in the history of photographs of children. Right through the nineteenth and twentieth centuries winds a tendril of what has to be called photographic passion for children's bodies, passion all the more disquieting because it cannot be treated as a simple perversion of the Romantic ideal, but rather seems to be an intensification of it, visions of innocence heightened by parental and naturist fervor.

At the same time Carroll and Cameron were imagining children photographically, Lady Clementina Hawarden was devoting herself to the representation of her many daughters. Hawarden's photographs now appear ripe with sensual promise, dreamily evoking mysterious relationships and longings. In one of these photographs, *Daughters on a Balcony*, made in about 1865, two young women are embraced by the photographic gaze of their mother just as tenderly as they clasp each other. Hawarden's images remained completely private in her lifetime, but if they had been more public, they would not have seemed so unusual to Victorians or Edwardians. Yet to historian Lilian Faderman, or perhaps to her publisher, the image seemed appropriate for the cover of her 1981 history of lesbian love, *Surpassing the Love of Men*.

Both mothers and fathers once revelled respectably in the sight of their children's bodies. Not only did Prince Albert, paragon of Victorian virtue, personally place O.G. Rejlander's photographic version of the *Sistine Madonna* cherubs (ill. 17) in the photo album of the royal fami-

61  CLEMENTINA HAWARDEN Daughters on a Balcony c.1865

62  CALDESI Prince Albert 1857

63 ALICE HUGHES Pamela, Countess Lytton with her son Antony, Viscount Knebworth 1904

ly, but with it he put photographs imitating those same cherubs using his own son Prince Arthur as model, taken in 1857 by Caldesi. A mother's pleasure in her child's body was a standard feature of photographic portraiture at the highest echelons of society. Take, for example, a 1904 portrait by Alice Hughes of Pamela, Countess Lytton with her son Antony, Viscount Knebworth. Anthony is stark naked. His mother smiles at his naked, wriggling warmth, holding him gently and proudly, enjoying the touch of his little hand on her bare shoulder. Perhaps the intimate mood of the double portrait owes something to the gendered empathy of the photographer, but nothing about the subject is out of the ordinary.

An association of beautiful child bodies with primordial innocence was a central theme of the entire Pictorialist photography movement at

64 CLARENCE WHITE Two Nude Figures and a Statue in a Wood 1905

the turn of the century. As photo historian Patricia Gray Berman has shown, Pictorialists both male and female celebrated children hedonistically, often their own children.[23] Clarence White's *Two Nude Figures and a Statue in a Wood* (1905) sums up the many lushly lyrical and atmospheric photographs of children by prominent Pictorialists such as Alice Boughton, F. Holland Day, Gertrude Käsebier, Imogen Cunningham in her earliest phase, and Alfred Stieglitz. A tree, a naked boy, a wreathed Pan sculpture, and another naked boy form a continous sweep through a dappled forest, united with their setting by the treatment and printing of the photograph's negative, removed from the here and now within their velvet haze. Art, nature, and nudity are together being designated as eternal forces. Along the way, incontrovertibly, the child's body receives its share of hommage.

Decades later, Nell Dorr made perhaps the last great Pictorialist parental statement in her 1954 book titled simply *Mother and Child*. An elegy to her dead daughter's maternity, and also a tribute to what Dorr

thought of as the universal foundations of life and love, the book includes many tender and intimate images, among them one that startles. The mother seems almost like a vampire, inhaling her baby's life, face removed in shadow as she is removed from us, utterly absorbed in her love, strong fingers between us and her child, trying to hold as much of its tiny wrinkled body as she can. Her embrace fills the image, fills her being.

Do our modern eyes see what the Victorians and Edwardians could not, or would not? Do we have the advantage of hindsight? In Carroll's case, the incontrovertible fact of his nude photographs, as well as biographical evidence, not to mention his children's books, do add up to what, at the least, was an extreme preoccupation with girls. On the other hand, we are witnessing at the end of the twentieth century a tendency much more widespread than Carroll-mania to see sexuality, if not pedophilia, in many Victorian images of children. Now not even the most universally beloved of Victorian pictures escapes academic vigilance. In 1991, art historian Laurel Bradley revived interest in Millais's

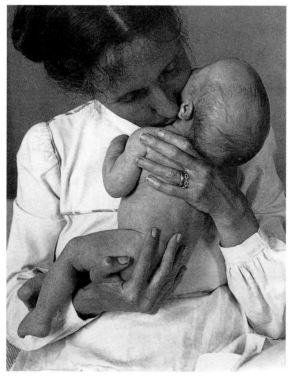

65 NELL DORR VND With Nude Baby c.1940

best-selling painting-turned-print *Cherry Ripe.* Her meticulously researched and reasoned article demonstrated that in its time *Cherry Ripe* looked like the quintessence of pure English innocence.[24] Whereupon, with an alacrity rare in academia, not one but two literary historians wrote rebuttals to Bradley's argument, claiming that Bradley, like the Victorians, had overlooked *Cherry Ripe's* sexual innuendo.[25] Arguing that the Victorians thrived on a (barely) repressed pedophilia, both latter-day interpreters read a sexual metaphor (hymen) into the title of the image, and saw curvaceous adult female forms in the child's billowing dress. Most importantly, they saw female genitalia beneath pubic hair in the child's hands below black wristlets, pressed palm to palm between her thighs.

The Romantic image of childhood runs deeper than it seemed. Apparently innocent images may be fraught with sexual overtones; sentimental images may conceal passion. In *Child-Loving*, James Kincaid proposes a way to understand how the Victorians' and Edwardians' consciously upright motives produced images that to us look at least latently sexual. Because the Victorians believed children were categorically different from adults by virtue of their innocence, Kincaid argues, children seemed other than adults yet better than adults, and by being at once other and better, irresistibly desirable.[26] Children could only become desirable if they were genuinely believed to be innocent. Innocence itself became the object of desire. This paradoxical desirability of innocence put an irresolvable tension at the heart of Romantic childhood. Tension held the whole construction of childhood in place for a while, but by the late twentieth century its strains had become apparent. We now live with the consequences of Romantic innocence. Retrospectively, we see the consequences in the premises. Exceptional photographs like Carroll's and Cameron's show with sharp clarity the difficulty in all Romantic images of children. Their children appear desirable not despite their age's concept of childhood innocence, but because of it.

Trouble was brewing in Eden. The Romantic ideal itself was producing photographic signs of dissent, and those signs were beginning to accumulate. Whether because it was in the pictures themselves or because it was in the eyes of their beholders, the meanings of children's bodies seemed to be heading in one direction – the direction of a dangerous sexuality.

Private Pictures, Public Dangers

Interpretation threatens to bring real consequences in its wake. An attribution of sexuality to pictures of children cannot simply be tucked away on the bookshelf along with other exegeses. Real children seem to be endangered when photographs imply, however ambiguously, that children are not completely sexually innocent, or when photographs allow predatory adult sexual projections onto children. For the last two centuries, the social protection of children has been based on the assumption of their innocence, an innocence whose sexual component turns out to be crucial, and whose credibility turns out to depend rather more on images than we had realized. The slithery subjectivity of sexuality puts it in the realm of the imaginary.

Abstract interpretation is all very well for the past, but the images with which today's real children must contend require more caution. Nor are we only dealing with isolated cases of sedition on the artistic margins, but much more mainstream photographs, pictures whose commercial distribution circuits reach millions of viewers. While pictures intended for the art world are being held accountable to popular cultural standards in unprecedented ways, images intended for mass consumer consumption now elicit the fiercest opposition. Rightly or wrongly, the belief has become widespread that we live in a contemporary media culture whose images sexualize children, and put children at real and unacceptable risk.

By their own interpretive tendencies, art critics and historians have introduced previously immune pictures into danger zones. As long as pictures called art were defined only on esthetic terms, they were safe, but once they became involved in socially controversial sexual issues, they became vulnerable to social attacks. Take the example of Weston's beautiful 1925 *Neil* series, which has been hailed as a "virtual icon of photographic modernism."[1] Since they were made, the *Neils* have been brought into interpretive territory far more fraught than Weston could ever have imagined, territory none of his other photographs have ever had to contend with. No subject is as publicly dangerous now as the subject of the child's body.

66 EDWARD WESTON Neil 1925

At first, art historians and critics followed Weston's consciously Modernist lead. Nancy Newhall, one of the architects of Weston's Modernist reputation, described his nudes in 1952, carefully contrasting them with documentary photography: "The light he loves best is almost axial with his lens – the same light-angle at which a news photographer's flash bulb flattens faces and collapses space with its fake shadows. Here the luminous flesh rounds out of shadow; the shadow itself, from subtle recession to deep void, is as active and potent as the light. In the torso of his little son Neil, where he indicates how that long-neglected theme, the Male Nude, might be approached, sinuous shadows give life to delicate whites. In these, as often in Weston's work, the beholder sometimes recognizes, with a tingle down his spine, the originals from which various centuries launched whole schools of thought. Here is a torso with the pure calm flow the Greeks took as ideal. The photograph is not Greek; it does not need to be. The reality it reveals existed before the Parthenon; it is continuous with man."[2] True to her words, when Newhall edited the *Daybooks*, she included one of the *Neils* alongside an equally abstract nude of a woman. Two bodies, child and adult: two abstract shapes.[3]

Provoked by the *Neils'* canonical status, the American artist Sherri Levine started the second phase of their critical life in 1980 by re-photographing six of them from a commercial poster and exhibiting her "appropriation" in a Manhattan gallery. Her gesture became famous among art critics and historians when the critic Douglas Crimp theorized it later the same year.

In an article titled "The Photographic Activity of Postmodernism," Crimp explained how Levine had undermined a Modernist cult of authorship by demonstrating that images are as much found as made, and not found in nature but in other images. Even photographs, Crimp argued, are not about reality, but are about ideas, an unending chain of idealizing desires. Like Newhall, he too used a comparison of the *Neils* with ancient Greek sculpture, but for a different purpose: "According to the copyright law, the images belong to Weston, or now to the Weston estate. I think, to be fair, however, we might just as well give them to Praxiteles, for if it is the *image* that can be owned, then surely these belong to classical sculpture, which would put them in the public domain. Levine has said that, when she showed her photographs to a friend, he remarked that they only made him want to see the originals. 'Of course,' she replied, 'and the originals make you want to see that little boy, but when you see the boy, the art is gone.' For the desire that is initiated by that representation does not come to closure around that little boy, is not at all satisfied by him. The desire of representation exists only insofar as the original always be deferred. It is only in the absence of the original that representation may take place. And representation takes place because it is always already there in the world *as* representation. It was, of course, Weston himself who said that 'the photograph must be visualized in full before the exposure is made.'"[4]

From the perspective of the 1990s, Modernist and Postmodernist interpretations had one crucial thing in common: they both insisted on the formal autonomy of Weston's photographs by making a categorical distinction between reality and representation. In theory, Levine and Crimp withdrew the *Neils* further into a closed world of art than they had ever been before by emphasizing the status of the photograph as pure sign, removed from what it represents – "the desire of representation exists only insofar as the original always be deferred." Levine and Crimp also shielded their position with theory by making it somewhat difficult to understand, less explained than complicated by language (which was an integral part of their position). In effect, however, by stripping the *Neils* of their authorial aura, by denying the cult value accorded to "vintage" prints made by Weston himself or under his direct

67 SALLY MANN Popsicle Drips 1985

supervision, and by raising the issue of desire, Postmodernism entered the *Neils* into the arena of social significance. Suddenly the *Neils* were not so much sacred modernist masterpieces as beautiful images of a child that anyone could appropriate for their own practical uses. Where Newhall had written of "a torso with the pure calm flow" transcending any time or place, Crimp, though he wrote of Neil as "the original always to be deferred," also wrote about "desire ... to see that little boy."

Only five years after Levine's and Crimp's cerebral interpretations, in 1985, the American photographer Sally Mann saw passion in the *Neils*. Like Levine, Mann cited the *Neils* with a photograph of her own. Unlike Levine's conceptual alteration of the *Neils'* meanings, Mann layered one of Weston's *Neil* compositions with visceral markings. As if the Weston were seen through a flame, Mann's image twists where Weston's sways, with a sooty luminosity, blacker and brighter, smoky at the edges, and in the place of sharpest focus, clearest light, the mark. What is that fluid on the boy's body, smeared sideways across his chest like dirt, splashed below his navel, trickling down his thighs, framing his penis? Is it blood? Is the child hurt? The mark demands to be scrutinized. Examining the photograph, it becomes clear that the child's body

bears no wounds, and the fluid could be any liquid, as likely to be the "popsicle" drips of the picture's title as anything else. Mann's image certainly provokes fear in the 1990s, but it is a fear of what we already have in our mind's eye. We the viewers are the ones who assume the worst, and while Mann's image allows the worst to be assumed, it also can dispel fears, humorously even, but only if we suspend our assumptions long enough to look carefully. Whether one was willing to mingle humor with fear or not, however, Mann had attracted a gaze to the *Neils* very much more personally engaged than the detached formalism Weston had consciously courted.

The dangerous possibilities of the *Neils* had only begun to be revealed. Already in 1987, the American photography critic Abigail Solomon-Godeau pointed out that Levine's appropriation of Weston's photographs would mean nothing to anyone outside the small art world circle who knew and cared about Weston's authorship.[5] In 1990, Douglas Crimp decided to move out of that small circle and into a full-scale engagement with sexual politics. He recanted his position on Weston's and Levine's *Neils*, writing of "blindness" and "a failure of theory generally." He had decided that the content of the *Neils* did matter. "The men in my bedroom were perfectly able to read – in Weston's posing, framing and lighting the young Neil so as to render his body as a classical sculpture – the long-established codes of homo-eroticism." Crimp proceded to argue against homophobia and for the political right to protection of homoerotic images.[6]

In 1993, American novelist Kathryn Harrison chose one of the *Neils* for an issue of *American Photo* magazine devoted to erotic photographs.[7] Having picked a version that shows the torso only from just below the navel to the neck, Harrison was able to write: "It's a beautiful, graceful image. This is a child's body, and his face and genitalia are not shown. Almost everything about him is ultimately withheld. There's no consummation between the viewer and the viewed, which I think is powerful and compelling." Nonetheless, her choice had put a *Neil* in the same layout with a photograph of a nude woman on all fours chained by her neck to a bedpost.

Though it hasn't yet been done, Weston's *Neil* series could just as easily be used to indict the erotic potential of family photography as it has been to see sexuality in esthetic formalism. After all, in one sense the *Neils* are family pictures, photographs by a father of his beloved son. In fact, just as pictures intended for the art world have recently come under a newly suspicious public – sometimes even legal – scrutiny, so have photographs of children taken at home by their parents. The

68 EDWARD WESTON Brett Weston,
Nude, Reaching Up with
Flowers,Trellis Behind c.1913

69 EDWARD WESTON Neil Weston,
page from personal photograph
album, c.1925

cases that have suffered the most notoriety are those which, like the *Neils*, hover on the cusp between family snapshots and art photography, cases like those of Patti Ambrogi, Toni Marie Angeli, Eljat Feuer, Jackie Livingston, Alice Sims, Robyn Stoutenberg, and Marilyn Zimmerman, all of which involve parents who undeniably made photographs of their children for consciously artistic purposes, some of them for art classes, some of them within ongoing professional projects. There was a time when all those cases would have been doubly protected from public investigation, both by the privileged status of art, and by what was considered an inviolable right to parent-child privacy. No longer. However, without pretending to reverse the interpretive clock, let me return once more to the comfortably distant and canonical past of the *Neils* to find what might make private photographs of children feel safe.

It would be at least as plausible, historically, to compare the *Neils* with Weston's own earlier professional studio portraits of children as it is to see them in light of Mann's *Popsicle Drips*. Long before he distilled his vision into abstract modernism, Weston was an accomplished professional portrait photographer, with a special gift for portraits of children. Early in his career, in 1912, Weston went so far as to publish an article on "Photographing Children in the Studio," which he called: "the most interesting, fascinating, and one of the best paying branches of the business (excuse me, profession!)"[8] Throughout the article he expresses an unusually genial fondness for all children, and a keen appreciation of their visual appeal to parents. "Another way," he mentioned in passing, "to sell more than one position is to suggest a nude study, if the child is well formed."[9]

Even in our current suspicious climate, it is hard to see anything odd about a portrait like one that Weston happened to take of another of his sons. Brett's portrait, with its naturist analogies between child and flowers, casts a sweet light on his brother Neil's portrait, and on their father's motives. It might be even more reassuring to read further into Weston's diary accounts of taking the *Neil* negatives. "Besides Neil's companionship ... he afforded me a visual beauty which I recorded in a series of Graflex negatives of considerable value. He was anxious to pose for me, but it was never a 'pose,' he was absolutely natural and unconscious in front of the camera. When I return he may be spoiled, if not bodily changed, in mental attitude. Last spring in San Francisco at eight years, he was in the flower of unawakened days before adolescence: tall for his years, delicately moulded, with reed-like flow of unbroken line: rare grey eyes, ingenuous, dreaming, and a crown of silken blond hair. He is a lovely child."[10]

Most reassuring of all would probably be to see the *Neils* next to the many family photography albums Weston devoted to all four sons, each of whom he repeatedly photographed in the nude, casually mixing clothed and unclothed shots in the same album and sometimes on the same page. On one page he happened to put pictures of Neil that do look like close snapshot relatives of his formal *Neils*.

Some visual comparisons, verbal explanations, and contexts still do signal safety. The more traditionally private, the safer the signal. Awareness of any exposure to a public, rather than familial, gaze has become a warning sign. Take the contemporary case of Joanne Leonard's lyrically lovely 1975 photograph of her baby daughter. I have heard the photograph described in completely contradictory ways, all of them determined by the issue of protection versus danger. The picture shows a naked baby in her bassinet, limbs still foetally folded, bare back glowing with light. The photograph's point of view makes the baby seem tiny and alone in a deep, quiet, luminous space, bounded above by braided wicker edges swooping toward the viewer. For the baby's mother, who took the photograph, the image represents Julia just home from birth in a hospital, receiving maternal care; Julia was born with jaundice, so she needed exposure to sunlight. For a student in one of my seminars, who knew the photograph had been made into a commercially distributed greeting card, the baby seemed

70  JOANNE LEONARD
Julia's Morning 1975

71  JOANNE LEONARD
page from personal
Julia album, 1975

terribly vulnerable, exposed to mercenary public eyes. For some Wellesley College alumnae guided through a museum exhibition at their alma mater, the image brought back happy memories of their children growing in their wombs. When I showed this photograph to a good friend, he recoiled from it, saying the picture was ugly because the infant looked dead; he had once found his own little baby dead in a crib.[11] What we perceive as a photograph's reassurances or dangers are not usually inherent in the photograph, but produced through a complex process of gauging contextual factors that is both sophisticated and subjective.

Estimation of danger swings both ways. No context better retains its ability to soothe than the family album. Ostensibly, the subject of Joanne Leonard's photograph *Julia's Morning* is exactly the same as the subject of snapshots by Leonard's friends and family, pasted later into an album by Leonard, showing the same tiny body in the same crib, seen from a similar high vantage point. In the album, however, the proximity of other snapshots showing Leonard holding her baby, as well as those showing both mother and grandparent looking into the crib, along with the pencilled caption "arriving home from the hospital/Oma's pictures," and especially the overall look we instantly recognize of the family album page, together settle any doubts about what the baby's body means. Conversely, a photograph which once nestled in

72 Nicole Brown and O.J. Simpson Christmas card 1995

a securely private world can acquire dangerous connotations out in public. When a photograph of Sydney and Justin Simpson appeared on the cover of the immensely popular magazine *People* in October 1995, following the sensational trial of their father for the murder of their mother, it provoked some angry reactions, including one printed by *People* the next month: "I was as repulsed by your cover as I was at the outcome of the Simpson trial. Showing Justin and Sydney, seemingly nude, in a kind of incestuous mood, was in extremely poor taste."[12] Is that how the picture seemed when it was received at home by friends of O.J. and Nicole Simpson as a Christmas card, the function for which the photograph was first made? I doubt it, if only because, shortly afterwards, I happened to receive a very similar photograph on a Christmas card that charmed everyone in my household. Exposure becomes frightening when it is to strangers' eyes.

Fundamentally, the issue of a photograph's danger hangs on the problem of control. The family album context is a highly controlled context, one which we think we know, densely woven with familiar signals of affection and idealization, and created for a tiny audience presumed to have a child's best interests at heart. Whereas once a

photograph enters the public sphere, who knows how it might be seen or used? Even a family snapshot could be put to all sorts of nefarious purposes if it happened to fall into the wrong hands. This anxiety is of course infinitely magnified by our awareness of computer imaging technology. Pictures can be and are posted for a potential audience of random millions on the Internet without their makers' knowledge or consent, and once on the Internet, they can be captioned, classified, marketed, and sold indiscriminately. The private domain of pictures has become prey to public use, and the more eroded we fear the protective cordon between private and public has become, the more warranted seems public vigilance over the private, which, paradoxically, can only further erode that always fragile boundary.

Anxieties notwithstanding, the public picture domain is rife with complexly ambiguous images of children which to most people seem innocuous if not charming. In practice, our culture does more than tolerate constant spectacles of children's bodies, it craves and promotes them. Our attitude to mainstream pictures of children is anything but simple.

Even the most mercenary uses of a photograph can appear positively endearing. If the image includes someone we have reason to believe is the child's parent, if the child is very young, or if the purpose of the photograph's context is explicitly stated, then the child's body can attract us comfortably. Take for example a 1993 Johnson & Johnson advertisement for diaper rash cream. (Permission to reproduce refused by Johnson & Johnson.) The ad pictures an adoring adult kissing a naked child's bottom. No alarms ring, however, because the woman is identified by the picture's caption as the child's mother, a mother whose wedding ring shines conspicuously near the center of the image, and whose proud care for her baby is proclaimed by the ad's text. Moreover, the ad's viewers are addressed as fond parents by the concluding text: "Because your baby is all that matters." Anna Quindlen and Nick Kelsh could title their 1996 book *Naked Babies* with impunity, despite rampant child pornography concerns, because Kelsh's photographs zoomed in only on infant body parts, while Quindlen's text sang maternal love for her three children.[13]

Context overrides content. Contrary to what child pornography laws assert, clothing or behavior "inappropriate" for a child's age can look pretty cute, given the right conditions. Take a *Living Books* ad for CD-Rom interactive stories which appeared in the *New Yorker* in 1994. (Permission to reproduce withheld by Random House.) Two little girls in leotards, tights, and ballet slippers chat on an exercise room bench,

next to their mineral water bottle and towel. The caption has one girl say to the other: "It's about this little fuzzy critter who goes to the beach, and it's so neat. Like when you click on a starfish, it dances! I can even play it in Japanese, which could stand me in good stead one day given the proliferation of Pacific Rim trade." Of course it is a joke geared to adults, a flattering joke about the girls' innocent replication of *New Yorker*-reading, fitness-conscious, business-oriented adult women's roles.

What matters is not whether adult behavior is pictured, but whether our society promotes that behavior. When children mimic socially sanctioned adult appearances, "age inappropriate" behavior looks entirely appropriate. This is more, not less, true when children rehearse the adult gender roles we call masculinity or femininity. Who could possibly object to Gail Goodwin's darling 1993 greeting card photograph titled *Dressed to Kill?* Despite the adult women's jewelry, high-heeled shoes, and makeup, despite so many references to seduction, these two little girls look traditionally innocent. Goodwin has cleverly updated Romantic signs of childish innocence: the association of children and flowers, the domestic setting, the over-scaled accessories that miniaturize their wearers, the big tall objects all around the edges of the picture that ensconce bodies in a little space. Photographs of proto-heterosexual tiny couples holding hands, hugging, or kissing provoke nothing but praise.

Our society encourages a broad range of lucrative child performances. American cinema, for instance, has a tradition of child stars going as far back as the ringletted and tap-dancing Shirley Temple, who made over $300,000 in 1938, and who played a "lady" of easy virtue in the film *Polly-Tix in Washington*.[14] Temple's successor in the 1990s is Macauley Caulkin, wry eleven-year-old cult hero of the 1990 film *Home Alone*, who stunned the media with his ability to command $5 million, plus 5% of gross profits, for his role in *Home Alone's* sequel.[15] Especially in the United States, every industry based on the display of adult bodies spawns a juvenile counterpart. Cinema, theatre and advertisements all rely on professional child models or actors, children whose work days are spent hustling from one makeup job to another audition, constantly evaluated, appraised, and exposed.[16] For every child who does manage to be exhibited for public consumption – and to earn about $5,000 per television episode,[17] more than $300 a day for commercials, and $2,500 minimum for a film[18] – there are dozens if not hundreds who tried and failed. It takes an average of twenty-five auditions to get one job.[19] As a Hollywood children's agent puts it: "I hate to

73 GAIL GOODWIN Dressed to Kill 1993

say it, but kids are pieces of meat."[20] The brutal murder of six-year-old JonBenet Ramsey in December of 1996 yanked America's attention to the child beauty pageant circuit, of which JonBenet was already a winning veteran. Magazine covers referred to her as "pageant princess," and "tiny beauty queen."[21] Thousands of very young girls, like Jon-Benet, compete for prizes awarded by judges on the terms of grown women: hair tinted and curled, faces made up, attired in evening gowns and bathing suits, posed flirtatiously for the camera's lens and a multi-million-dollar business – a world soberly pictured by Mary Ellen Mark.

74  MARY ELLEN MARK Beauty Pageant: Hairspray 1997

On the beauty pageant circuit, twelve-year-olds can lose points for not wearing enough lipstick.[22]

In the realm of sports, "women's" gymnastics banks on the televised sight of pre-pubescent girls gyrating in skin-tight leotards. Performance pressures are driving down the average age of competitors in many televised and commercially sponsored sports, notably swimming and tennis. When fourteen-year-old, seventy-five-pound Tara Lipinski won the "women's" world figure skating title in March 1997, the *New York Times* ran her picture on its front page over the caption "the best and the youngest." Inside that day's sports section, everyone interviewed about Lipinski's performance spoke more or less defensively about her age, but refused in the end to see any conflict between her childhood and her career, which had already taken her out of normal school and separated both her and her mother geographically from her father. Figure skating is a sport whose popularity depends on soft sex appeal. Female figure skaters of all ages routinely perform in micro-skirts to romantic music and lyrics. As Michael Rosenberg, a sports agent who has handled Olympic skating champions, was quoted: "If we become a

sport of little girls doing little jumps, instead of glamorous young women, we lose a significant portion of our appeal."[23]

Only disasters like JonBenet Ramsey's murder ruffle consumer pleasure in all these child spectacles, and then the disasters themselves become media sensations. Following the murder, *Newsweek* reproduced on its cover, as well as inside full-page, photographs which the cover's caption called "strange," and whose ethics the accompanying article called into question. When seven-year-old Jessica Dubroff died in a 1996 plane crash while trying to become the world's youngest cross-country pilot, *Time* magazine asked on its cover next to her photograph: "Who killed Jessica? Her shocking death raises questions about how far we push our kids."[24]

Who is "we"? Questions are often raised about the motives of the parents involved in spectacles of children, but not often enough about the motives of industries and audiences. Every discussion of child performers recycles the ethical issues of stage parents who – consciously or unconsciously – confuse their children's needs with their own ambitions, who mistake a child's desire to please their parents for a desire to perform professionally. Macaulay Caulkin's father Kit, to take a famous example, was widely criticized in articles with titles like "My Art Belongs to Daddy," or "It Seems the Father of the Child Star is the Enfant Terrible."[25] On guard against abuse, the United States Screen Actors Guild regulates the amount of time a child can work per day and mandates the constant presence of a parent or guardian on the set. In California, the "Coogan Law" requires parents to put 50% of their child's earnings in trust. The law was named for child star Jackie Coogan, who sued his mother in 1938 for the four million dollars he had earned and she had spent.[26] Yet parents are not the only ones who profit directly from a child's performances. Suzanne O'Malley, whose son Zack, age seven, starred in the film *Lorenzo's Oil*, reported that of her son's earnings, 15% went to his manager, 10% to his agent, and 28% to taxes; to be with her son on location, she had to forgo half her year's income. Both child stars and their parents obey external forces. There could be no child stars without industries to showcase them, and no industries without consumers. The line between adulation and exploitation is very difficult to draw. In the final analysis, the "we" who are accountable for the success and the tragedies of all child media stars is everyone who wants to watch children perform, who wants to see an ideal realized through the bodies of children.

Most media spectacles of children do not offend anyone, because the people who enjoy them are actually quite sophisticated viewers. In

practice, the average consumer of television, magazines, and films easily navigates theoretically difficult boundaries between reality and representation. A willing and quite savvy suspension of disbelief allows viewers to enjoy the fantasies of artifice. The artifice, however, has to be clear. Knowing a child is professional helps. Hypothetically, exchange of money for children's performances might cause qualms. In practice, however, the overriding reaction to most professional child models, athletes and actors is an awareness that a role is being played, a role that does not affect the "real" child. Manifestly, a child marketed as a public spectacle is intended to provoke some kind of desire, perhaps ultimately for a product or service, a cosmetic or an athletic ideal, but inevitably for himself or herself along the way. Yet, in the past, the makers and consumers of mass media accepted the circulation of desires around child bodies because they understand those desires to be fantasies.

Desire for the image of the child, however, passed a critical threshold in the 1990s. Change accelerated in the 1960s and gained momentum during the next thirty years, until in the 1990s it became flagrant.[27] It is too simple to say either that childhood became an exploited commodity, or that the child became a sex object. Rather, the image of the child became more emotionally resonant than it had been, not losing its meanings of innocence but also acquiring others, exchanging and mingling commercial, sexual, and political forms of power in an increasingly tight knot of private and public forces.

Consider the world-famous example of the Kennedy administration's (1960-63) identification with the image of childhood. President John Kennedy and his wife Jacqueline did not so much present themselves parentally as associate their political personae with the physical charm of their children, Caroline and John Jr. Rationally, a famous 1962 photograph like the one of John Jr. grasping his laughing mother's triple strand of pearls had nothing to do with government policy and the credibility of the United States during the Cold War. Emotionally, however, such photographs of the "private" presidency, astutely produced for and released to an eager press, endowed the Kennedy administration with a public aura of idealism, youth, and beauty, of a vigor all the more potent for its innocence. When the President was assassinated, televised images of Caroline's and John Jr.'s personal mourning gestures – Caroline kissing the flag on her father's casket, John Jr. saluting the casket – became among the most effective symbols by which a national tragedy was understood.

The same photograph of Jacqueline and John Kennedy Jr., recycled,

75 Jacqueline Bouvier Kennedy and John F. Kennedy Jr. upstairs in the White House 1962

brings us to the image of the child in the 1990s. When Jacqueline Kennedy died in 1994, the aura of the Kennedy administration was revisited by American media in a nostalgic mode. Once again, photographs of Caroline and John Jr. did their political work, symbolizing national youth, promise, and innocence. This time the symbolism, set to the note of Jacqueline's death, sounded mournful, tinged with regret for what seemed past, for a nation's lost childhood. At the same time, those Kennedy children images had acquired a commercial potency unimaginable in the early 1960s. In its elegantly sumptuous 1996 catalogue for the auction of Jacqueline Kennedy's estate, Sotheby's placed well-known photographs of the Kennedys next to photographs of items for sale. Juxtaposed with item 454, a "Simulated Pearl Necklace," was the photograph of John Jr. playing with his mother.[28] Many Kennedy item-Kennedy photograph pairs were splashed all over the media, and all the items in the sale fetched prices astronomically higher than Sotheby's estimates. But the sale's spectacular money-media results peaked in the photo value-added effect of John Jr.'s photograph. Not only did the necklace, estimated at $500–$700, fetch $211,500, but virtually all media accounts of the sale reproduced the photograph or at least referred to the pearls. The author of a follow-up book titled *Jackie's Treasures* wrote: "The photo of John Jr. tugging at his mother's pearls has become one of the most lasting images of the auction. ... This is the

image ensconced in the hearts and minds of America."[29] And not only America. In March of 1997, British *Vogue* ran a four-page ad spread for the French jewelry firm Gerard Darel, whose key photograph faithfully imitated the Jackie–John Jr. pearl picture. The ad's slogan: "Une histoire de charme."

Of all the newly loaded freight weighing on the image of childhood, the most alarming is the erotic. Along with its political and commercial burdens, the child's image does carry a greater and more evident erotic charge today than ever before. No case better demonstrates this than the story of Brooke Shields, both because it was so famous and influential, and because, like the Jackie's pearls picture, it provides a historical framework within which to situate a broad cultural phenomenon.

Born in 1965, managed by her mother, Brooke Shields launched her modelling and acting career at the age of eleven months with an *Ivory Soap* ad photographed by glamour impressario Francesco Scavullo. At age ten she posed nude, skin oiled, standing in a tub, for a book published by Playboy Press titled *Sugar and Spice*, a reference to a nursery rhyme about what nice little girls are made of. At eleven she played a child prostitute (shades of Shirley Temple) in Louis Malle's *Pretty Baby*, including a scene in which her virginity was auctioned off to the highest bidder. She went on to star in the mildly erotic film *Blue Lagoon*, as well as in the self-explanatory *Endless Love*, for which she was paid $500,000. She was famous around the world for what was invariably described as a ravishingly beautiful woman's face on a perfect child's body, and famous within her profession for her self-discipline and skill. By 1981, her standard daily modelling fee was $10,000; she earned between $500,000 and $800,000 for a Calvin Klein jeans ad campaign shot by Richard Avedon in 1980 with cool, polished style, which made her, at the time, one of the most expensive models in the world, child or adult.[30] (Permission to reproduce refused by Richard Avedon Inc. and Brooke Shields.) CBS, ABC, and NBC television stations censored one of the Calvin Klein ads, in which Shields questioned: "You know what comes between me and my Calvins?" and answered: "Nothing."[31] Sales of the $40 jeans rose by 300% in 90 days.[32] At the peak of her career, Shields received at least a thousand fan letters a week. The world's most highly valued child in the early 1980s was the world's most erotic child.

Controversy stormed around Shields's career, but in the late 1970s and early 1980s controversy was still being resolved by asserting a difference between fact and fiction. For the highly theorized New York art world, discrepancies between fact and fantasy provided the material of cultural critique. Just as avant-garde artist Sherri Levine had appropri-

ated Edward Weston's *Neils* to deepen the flaws in modern tenets of authorship and orginality, so Levine's peer Richard Prince appropriated the *Sugar and Spice* Brooke Shields photograph in 1983 to strain untenable illusions of innocence, idealism, and childhood, renaming the image *Spiritual America*. (Permission to reproduce refused by Richard Prince.) The mass media, too, questioned Shields's career. *New York* magazine published a blistering cover story captioned: "Meet Teri and Brooke Shields. Brooke is twelve. She poses nude. Teri is her mother. She thinks it's swell."[33] Teri Shields did try to play both sides of the game. On the one hand, after 1975 she always stipulated a body double for her daughter's nude scenes, a provision she ceaselessly reminded the press of. On the other hand, when she noticed a small mark on the rear end of the *Endless Love* body double, she insisted the mark be erased from every frame: "Everyone is going to think that's Brooke's rear end so there shouldn't be a mark on it."[34] In 1981, Teri Shields sued Gary Gross, who had taken the nude *Sugar and Spice* photographs of Brooke in 1975, trying to ban any further sale of the pictures, on the grounds that they damaged her daughter's reputation. Brooke Shields's image was already sexual, Gross's lawyer retorted, and only the image, he argued, was at stake: "She [Brooke] is portrayed as a young vamp and a harlot, a seasoned sexual veteran, a provocative child-woman, an erotic and sensual sex symbol, the Lolita of her generation."[35] A New York judge concurred and ruled against Shields.[36] A state appeals court overturned the initial decision,[37] which was reversed again in 1983,[38] once more appealed, this time to a federal court, and finally decided by a U.S. District judge in Gross's favor. The U.S. judge, Pierre Leval, ruled that the *Sugar and Spice* photographs were not fundamentally different than the roles Brooke Shields had subsequently, and profitably, chosen to play.[39]

Brooke Shields herself made the same distinction between art and life. Over the years, she consistently told reporters that, regardless of her roles, she personally was not exploited, enjoyed meeting professional demands, and was protected by the contracts her mother negotiated.[40] Above all, she maintained: "It's just acting."[41] Asked by *Rolling Stone* in 1978: "Are you ever scared that you're being used as a sex symbol?" Shields replied: "No, not really. I know people might think that I am, but just a few opinions aren't really going to hurt me that much. People can think what they want to think, but I know what's true."[42] Later, majoring in French literature at Princeton College, she wrote a thesis titled "From Innocence to Experience: The Pre-Adolescent/Adolescent Journey in Louis Malle's *Pretty Baby* and *Lacombe Lucien*."[43]

It is hardly a coincidence that the next key marker in the recent history of child erotics involves the same company responsible for Shields's notorious jeans ads. By the mid 1990s, sexuality was seen where it would never have been before. Perhaps it would be more accurate to say that by the mid 1990s, sexual meanings in images of children seemed so clear that they had to be acknowledged, and fought. No context, however previously immune, was exempt from scrutiny. The manifestly artificial, professionally regulated, explicit (and profitable) contexts of advertisement were the last bastions of unchallenged Romantic childhood. Then, in the late summer of 1995, the Calvin Klein company was accused of child pornography. If one event definitively marks the end of confidence in Romantic childhood, it is the Calvin Klein ad scandal.

The ads were for jeans, targeted to an audience of pre-teens, and photographed by Steven Meisel. Unlike the 1980 Calvin Klein jeans ad, whose model Brooke Shields was world-famous for being underage, the 1995 ads showed anonymous models who appeared to be anywhere between twelve and twenty-five years old. (Permission to reproduce refused by Calvin Klein and by Steven Meisel.) The models were seated in front of imitation wood panelling and on violet pile carpet, in poses that allowed peeks at childish underwear. Unlike the voice-over of the censored 1980 ad, whose none-too-subtle innuendo was carried by its words, a voice-over for one of the 1995 televised ads depended partly for its effect on tone of voice, described by Maureen Dowd in a *New York Times* opinion-editorial piece as "leering Winstons-and-Wild-Turkey."[44] But times had changed. The sexual ambiguity tolerated in the 1980s seemed dangerously blatant in the 1990s. Well-organized conservative advocacy groups, led by Donald Wildmon's American Family Association, denounced the ads and put pressure on department-store chain executives to cancel their orders of merchadise from Calvin Klein. The company withdrew the ads on 28 August, to the tune of a fatuous full-page "statement" printed in the *New York Times*.[45] The story was given prominent coverage by every major American newspaper, television, and radio station, giving Calvin Klein more free publicity than he could ever have hoped for. It was negative publicity, but Oscar Wilde once observed that the only thing worse than being talked about is not being talked about. Public fascination with the sexuality of the child's image had reached a pitch which scandal, far from halting, only amplified.

Contrary to what many commentators wishfully announced, the meanings of the 1995 Calvin Klein ads were not inherently clear. What

makes any particular kind of underwear childish? Only the associations we bring to it. The FBI investigated Calvin Klein in case the models were actually underage, but apparently they weren't.[46] The erotically unleashed critic Camille Paglia reviled "the authoritarian tone of the companion TV commercials, where an offscreen male voice intrusively questions the wary, visibly uncomfortable teens ... who are shown caught and caged by manipulative, jaded adults."[47] Many adult critics associated the ads' settings and poses with porn movies and magazines, with the worst of the 1970s, with suburban "rec" rooms, or with some combination of all three. The younger audience Calvin Klein claimed to be addressing, however, and on which he had done his customary thorough market research, might not agree. Even an adult columnist with a sense of humor, Barbara Lippert, conceded that the settings might be "a 70s retro thing, so aesthetically cool and modern that to the untrained eye they seem merely ugly and tacky."[48] None of my students knew the tawdry associations their elders were so familiar with. Teenagers interviewed by *Newsweek* magazine found the people pictured in the ads "cute," like "all my friends," and "beautiful." One who had decorated her room with the controversial ads said: "Everybody likes what he sells. How can anything be wrong with that?" Another said, in praise: "What he was trying to do was use the innocence of children, because a child's innocence is beautiful."[49]

What the Calvin Klein ads did make incontrovertibly clear was that a very large 1990s public consciously recognizes eroticism in mainstream images of children. Whether any one audience likes it or not, whether the behavior pictured is socially approved or disapproved, sexuality is now part of what we see in images of children. The sexualization of childhood is not a fringe phenomenon inflicted by perverts on a protesting society, but a fundamental change furthered by legitimate industries and millions of satisfied consumers (also in its minor way by the art world). By the 1990s, the image of the child had become perhaps the most powerfully contradictory image in western consumer culture. Promising the future but also turned nostalgically to the past, trading on innocence but implying sexuality, simultaneously denying and arousing desire, intimate on a mass scale, media spectacles of children are bound to be ambiguous.

An incident like the Calvin Klein jeans ad scandal has to be understood against the background of countless less dramatic but similar images, each of them contributing to a climate of unease. Despite ongoing concerns for the safety of boys from predatory homosexual pedophiles, the most visible anxiety swirls around the mainstream

appeal of ever younger girls to ordinary heterosexual men. This is quite sensible, since studies of sexually abused children show that "most sexual abuse of children is perpetrated by young heterosexual men who are considered quite normal by others. ... Of all adults, homosexual men are the least likely to commit a sexual offense against a child."[50]

One label expresses the phenomenon succintly. Ever since Vladimir Nabokov published his literary masterpiece *Lolita* in 1958, the word "Lolita" has stood for a sexy girl, the "nymphet" Nabokov's middle-aged anti-hero lusts after obsessively. Nabokov's narrative may have been primarily about compulsive obsession, but by the time Stanley Kubrick made his famous film from the book in 1962, only the aura of pedophiliac deviancy remained common knowledge. The film's opening image of actress Sue Lyon wearing heart-shaped glasses became an icon of child sexuality. Controversy over a new film version of *Lolita* in 1996 and 1997 sparked a batch of articles assessing the Lolita phenomenon – and of course spreading it.[51] On the cover of the British edition of *Esquire*, "the sharper read for men," as it announces itself, appeared, once again, the heart-glasses shot. Inside were reproduced publicity stills from Adrian Lyne's new version of *Lolita*, matched by a slew of other Lolita-type film shots, advertisements, magazine covers, and fashion editorial pages.[52] In the guise of satire, the American *Spy* magazine bluntly proclaimed on its cover: "Jailbait 1997. The Sudden Thor-like Rise to Power of Sexy Little Girls," accompanied by romping articles on "the new lolitocracy," including the stars of Olympic women's gymnastics.[53]

Girls and women look more and more alike in many media images. Children's television programs, movies, and other entertainment industries offer adult appearances and behaviors for children to identify with, and children eagerly respond. In American folk tales, Pocahontas used to be a twelve-year-old girl cartwheeling in the woods; in Disney's 1990s film for children, *Pocahontas*, drawn by animator Glen Keane, was inspired by adult sex appeal, especially the allure of fashion supermodels like Kate Moss and Naomi Campbell.[54] Meanwhile the supermodels get younger and younger, starting their careers as early as fourteen. In 1994, *Vogue* pictured its model of the moment, Bridget Hall, lying in her underwear surrounded by stuffed animals above the caption "Lolita Lives!" and went on to describe their "Dream of Contemporary Beauty Incarnate" as "a sixteen-year-old girl with an eighth-grade education."[55] At "image clubs" in Japan, male clients pay prostitutes to masquerade in schoolgirl uniforms.[56] *Rolling Stone* began a 1995 article: "Alicia Silverstone is a kittenish 18-year-old movie star whom lots

of men want to sleep with." Touted as "a dreamy-eyed Rapunzel with the brand-new look of a still-wet painting – touch her and she'll smudge," Silverstone explains how she was legally "emancipated" from her parents at age fifteen to avoid child-labor laws.[57] To illustrate its 1996 article on "The Scent of a Woman," *Allure* chose a 1962 Diane Arbus photograph of a little girl in a flower garden, wearing a ruffled party frock, patent-leather strap shoes, and white ankle socks.[58]

Images like Madonna in the guise of a sexy toddler on the cover of *Vanity Fair* send quite disturbing messages. (Permission to reproduce refused by Madonna.) The cover heralded publication of Madonna's picture book titled *Sex*, whose photographs by Steven Meisel catalogued sexual fantasies, not including child-sex. For the 1992 article in *Vanity Fair*, however, Madonna and Meisel produced an additional portfolio casting Madonna as a blatantly erotic baby-woman. On the cover of the magazine, she floats in a pink plastic swim-ring, breasts almost entirely visible, pastel baubled blond pig-tails juxtaposed with sultry makeup. Underneath the photo reads the caption "Hot Madonna! The Material Girl's Sexual (R)evolution," while inside the magazine, the use of child-images to promote a book that includes explicit adult sex scenes could not have been clearer. Of course no one thought Madonna was a child in 1992. But equally obviously, no less a connoisseur of sex appeal than Madonna had acted on the understanding that child-sex sells.

Far more subtle and less entirely sexual images may well be the most significant of all, because they show how tightly the pleasures of looking at children's bodies are being bound into our current cultural ideals. These pictures represent cultural norms, not cultural exceptions.[59]

Take, for example, a 1992 Ivory Soap advertisement, still being published in 1995. (Permission to reproduce refused by Proctor & Gamble.) The advertisement's text explicitly aims it at adult women, yet the image is of a prettily grinning girl, pictured from quite close up, propped on her elbows. Soap products, after all, do have a long history of identification with the purity of Romantic childhood. Nor is it so hard to understand why an adult would want her skin to look like the beautiful skin of a child, which it is the photograph's function to show. Nonetheless, the advertisement's text implies a tenser and more complicated relationship of adult feminine ideals to childhood: "Jennifer Anne Murphy, 14, and never been kissed." Ostensibly, the text reinforces the child's innocence; we are being euphemistically told that the child presented for our admiration has not yet encountered sexuality. Then why refer to age and kissing at all? Why bother to situate the girl on the

76  DEWEY NICKS Two Girls 1996

cusp of sexuality, where experience is supposed to be imminent? As in the case of Brooke Shields, an ideal child can apparently be one tantalizingly close to sexuality, not just for heterosexual men, but also for adult women, not just in an explicitly sexual framework, but in the most routine cosmetic context: "You're never too old to baby your skin."

Why the flash of stomach in a 1995 Tommy Hilfiger ad? (Permission to reproduce refused by Tommy Hilfiger U.S.A. Inc.) A little boy swings by his hands from a tree branch, layered shirts pulled out from khakis. The skin can't be missed, right there in the center of the photograph, rising over the horizon, t-shirt pulled exactly up to the middle of his navel, low ride of the underpants doubly underlined by the pants waistband and still lower belt. The image conveys unselfconscious innocence, so fresh and fun, the boy absorbed in his play, tongue rolled out in concentration. Hilfiger identifies childhood with untrammeled nature: "Please support the fresh air fund," a small caption requests. Still, the child hangs there for us to look at, all body. The photograph has been cropped top and bottom so we cannot see what his relationship is to his space, so that he has no relationship except to our gaze. In a moment, the glimpse of stomach will be gone, but for that one moment it is ours.

Both advertisements make promises to adults. The beauty and the natural freedom they hold out in the guise of a child are pleasures or forms of power coveted by adults. One Geoffrey Beene company advertisement for a men's perfume called Grey Flannel makes this appeal to ordinary adult aspirations abundantly and I think quite amusingly clear. (Permission to reproduce refused by FFI Fragrance International.) A smiling man in a grey flannel suit strides toward the viewer, an apple in each hand. In addition to the round fruit placed on either side of his flannel fly, we see big bunches of bananas hanging nearby. Back in the 1970s, the influential art historian Linda Nochlin pointed out the countless visual analogies between women's breasts and fruit in traditional painting, and the absence of any such analogies between penises and fruit; to clinch her point with a joke, she printed a photograph of a comely young male nude holding a tray of bananas at the level of his genitals. Our ads do what paintings did not do. Better than a penis, Geoffrey Beene's man in grey flannel displays a naked child, irrationally but cunningly included in the photograph directly below the bananas, glowing in a gorgeous golden light. Why bother showing off the means when you can produce the results instead?

Sensuously attractive children can enhance the image of just about

anything. In its comeback September 1996 issue, the magazine *House & Garden* included a full page color photograph by Dewey Nicks of two beautiful girls on a sofa hugging each other closely, forehead to forehead, interlaced legs ending in high-heeled white sandals. The picture illustrated an article on the interiors of desert homes, and the photograph's caption read: "The house is blessed with several living areas, all outdoors except for this one, opposite, and all relaxed enough for children. The Burgesses's granddaughter Emily, right, and her friend, Bijou Phillips, fit right in. The glass table is by Noguchi."[60] Picking up quickly on the article's implications, Julie V. Iovine soon described in the *New York Times* "a new trend: an artificial world where home life can be as disquieting as contemporary art and fashion," and she explicitly compared the Nicks photograph with work by Sally Mann. "Welcome Home," she wrote.[61]

It has become possible to treat the relationship between the changing image of childhood and the power of mass media with intelligent wit, as David LaChapelle does in a photograph for a 1995 *New York Times Sunday Magazine* children's fashion feature, precisely because that relationship has become so familiar. (Permission to reproduce refused by the mother of the model.) "McKenzie Robertson, 6" wears the proverbial little black dress, once a hallmark of the sophisticated woman. Bright pastel plastic mirrors flank the girl: mirrors, we learn from the picture's credits, called "Naturally Pretty Beauty Set" and "Dream Vanity." On these toys appropriate for a child-woman appear cut-out covers of decidely adult women's fashion magazines, featuring the adult super-model Linda Evangelista. The six-year-old holds another such magazine on her lap, showing us the glamour pose she imitates. The whole picture is faintly surreal and quite humorous, but it comments on a cultural trend many people find frightening and deadly serious. The public dangers of photography have come home.

Photographs Against the Law

Photography's threats to children's safety provoke retaliation. The strongest reaction has been child pornography law. Most developed in the United States, both at the highest federal level, and at the subsidiary state level, child pornography law defends the ideal of childhood innocence against pictures. Lurking unresolved in these laws is the most fundamental problem of visual representation: the relationship between reality and images, a problem posed in its most acute form by the medium of photography. As a crisis in "ideal childhood" has appeared to spread everywhere in the media, the scope of child pornography law has become correspondingly wide, affecting pictures of all sorts, yet at its emotional core, child pornography law strikes back not at pictures but at sexual child abuse.

Few if any crimes are now so odious to western societies as the sexual abuse of children. During the fall of 1996, the inept prosecution of Marc Dutroux, child murderer, rapist and pornographer, outraged the Belgian nation; King Albert called for a national "moral revival" and some 300,000 citizens in a population of 10 million marched to demand government reform.[1] More than a thousand delegates attended a conference held in Stockholm in August 1996 to condemn the worldwide sexual exploitation of children; at the conference, France's state secretary of humanitarian action announced: "I consider our fight a crusade," against a "diabolical phenomenon."[2] Meanwhile, in the United States, the California state legislature drafted laws to punish child molestation with "chemical castration."[3] In prison, hardened violent criminals ostrasize child abusers.

Since the early 1980s, photography has been increasingly implicated in the crime of sexual child abuse. This trend originated in the United States, and then spread to Europe. By the middle of the 1990s, photography, in the form of child pornography, has become as crucial to the negative values associated with childhood as it is to the positive. As with all crimes, the social significance of child pornography is expressed most forcefully by prohibition, both by laws that forbid it and by scandals that crystallize and articulate social anger against it.

Responding to cultural pressure, often in the acute form of scandals, child pornography laws have become broader and stricter. Originally intended to punish actions against children, these laws have extended their reach to include representations of children both real and imaginary. The goals of child pornography laws are both unequivocal and highly laudable. Their means, however, are not always nearly as clear or as safe as their ends. Intertwined with absolutely unimpeachable provisions are some quite problematic assumptions about the relationship between actions and images, about realism, and about the interpretation of meaning. It is frightening to question any provisions of child pornography law because they are so closely bound to the emotionally explosive issue of actual child abuse. And yet they do have to be questioned. As long as we are in the domains of the ideal and the normal, photographic confusions between fantasy and reality can be entertaining, consolatory, or even productive. When it comes to the law, however, with its actual victims, crimes, and punishments, we have to be much more rigorous. The most obvious issue at stake is freedom of expression. Less obviously and more pragmatically, child pornography laws could be improved if they were more care-fully reasoned. And, most importantly, current child pornography laws allow us to turn away from many real abuses of children in our society.

Child pornography law in the U.S. has a surprisingly recent beginning. In 1982, judges of the law case *New York v. Ferber* ruled that child pornography could have no artistic significance, and hence could not be defended on those grounds. But it was not until 1984 that child pornography was legally distinguished from other pornography and defined according to a stricter standard. Along with irrefutable provisions against the actions of pornographers, this 1984 U.S. federal law banned the "lascivious exhibition of genitals" in pictures. The "factors" which could make a picture of a child's body illegal in the United States included: "whether focal point of visual depiction was on minor's genitalia or pubic area, whether setting of visual depiction was sexually suggestive, whether minor was depicted in unnatural pose or in inappropriate attire considering his age, whether child was fully or partially clothed or nude, whether visual depiction suggested sexual coyness or willingness to engage in sexual activity, and whether visual depiction was intended or designed to elicit sexual response in viewer," and, finally, the defendant's use of the picture regardless of the photographer's intent. In contrast with adult pornography: "constitutional requirements for child pornography are much simpler and more susceptible to credible assertion... [a] conclusion based on observation, not one based on evaluation."[4]

Despite its confident tone, the 1984 law used some rather vague language. What does "sexually suggestive" mean, applied to places, poses, or attire? Did Congress have at its disposal a geiger counter for "sexual coyness"? "Sexual response" is deemed remarkably singular, as if all sexual responses were the same. Legislators asserted their ability to see right through pictures to someone's unambiguous thoughts, but who is that someone, and how many someones need be involved – will one suffice, and which one? Most disturbingly, the frame of legal interpretation slips and slides in every direction; "design," "intent," and "use" are treated interchangeably, but somehow "observation" remains putatively reliable, precise, and consistent.

In 1984, it did not matter too much whether the legal language defining child pornography was vague and overly broad, because at that point the law only considered pornography as evidence of actions perpetrated against real children. Prompted by a rising concern about all pornography, President Ronald Reagan launched an investigation under Attorney General Edwin Meese in 1986. The investigation culminated in a report titled *Attorney General's Commission on Pornography Final Report*. Sponsored by a conservative Republican administration, the Meese report, as it is often called, was bound to be conservative in its assumptions, logic, and conclusions.[5] Yet in the very first paragraph devoted to child pornography, the Meese Commission declared: "The distinguishing characteristic of child pornography, as generally understood, is that actual children are photographed while engaged in some form of sexual activity, either with adults or with other children."[6] Later the Commission emphasized: "'child pornography' is only appropriate as a description of material depicting *real* children" (their emphasis).[7] In a footnote, a very important footnote, the Commission elaborated: "The Court also required that the 'category of "sexual conduct" proscribed must also be suitable [sic] limited and described'[458 U.S. 474, 746 (1982)] and must not include mere 'nudity.'"[8]

By 1989, however, the judgment of *Massachusetts v. Oakes* included children's nudity within the definition of pornography, provided the image showed "lascivious intent." "Mere nudity" is a key concept, much more crucial than it might seem. If nudity can be construed as an extension of "sexual activity," it can also be construed otherwise. Bodies represented nude or naked or undressed are not necessarily sexual, although of course they could be. Pictures of the bodies of children are not necessarily or exclusively bait for pedophiles. What else pictures of children's bodies might mean is the subject of the entire next chapter. For now, the point I want to make is that nudity is not an

action. Nudity might imply or suggest an action involving the person pictured and the person taking the photograph, but it is not in and of itself an action, let alone a criminal action. To introduce the issue of "mere nudity" therefore introduces the possibility that the criminal category of child pornography could include images whose "sexual activity" was not a matter of action but of interpretation at best, fantasy at worst. Of course nudity might be a sign that some criminal activity was taking place outside the image, and the law could have stigmatized that activity outside the image. Instead, the law was beginning to stigmatize the image itself, on the basis of a "lascivious intent" so vaguely defined that it could depend entirely on subjective interpretation.

At the same time, U.S. law was beginning to define child pornography as being generally visual and specifically photographic. The 1984 federal law already uses the word "exhibition" to signal a visuality the law assumes and condemns but never confronts. A close reading of federal and state statutes reveals that, by the mid 1990s, law equated child pornography with what was most often called "visual depictions" and that visual depictions were equated with photography (photography including prints on paper, film, video, and computer images). Rather than cite every state law, which would be tedious, let me just cite the Meese report, itself citing the important 1982 *New York v. Ferber* decision: "the category of 'child pornography' is limited to works that *visually* depict sexual conduct by children below a specified age."[9] The emphasis is the commission's.

Why photography? Because photographs can and do document actions. Also, though, because photographs look realistic to us, it is therefore commonly believed that photographs occupy a threshold between reality and representation. Despite the idealization that makes commercial and amateur photography of children so popular, the idea persists that photographs – especially photographs of children – are always and entirely real. Commercial and amateur photographic myths of childhood have convinced us all too well, as have popular myths about photography in general. Kathryn Harrison's 1993 novel *Exposure*, for instance, based its plot on the assumption that photographs reveal the psychic truths of both makers and subjects. An abusive father's entire relationship with his daughter can be apprehended through his photographs, and indeed it is to his picture-taking that her neuroses and near-suicide are directly attributed. The book became a best-seller and its many reviews extended the messages of its narrative, explicitly linking *Exposure's* fiction to actual photographers, most

often to Sally Mann.[10] I would respond by adapting Abraham Lincoln's famous adage: some photographs can document reality all of the time, all photographs can document reality some of the time, but all photographs can't document reality all of the time.

It is perfectly understandable that the first reaction against sexual child abuse should be to exterminate its every manifestation, and to extend the definition of child abuse as far as necessary to achieve that objective. Ever since child abuse was recognized as a social problem, in about the middle of the twentieth century, western nations have been using the tools of law, social policy, and protective agencies to eradicate it.[11] As time goes on, however, it should become possible to refine and sharpen the policy instruments at our disposal, rather than relying on blunt, inefficient, and inaccurate tools. The easiest, and most negative, way to think about the problem of child pornography is as a direct win-lose confrontation between children's rights to safety and adults' rights to freedom of expression, in which the gains of one value necessarily entail the losses of the other. A more constructive approach would ask how both kinds of rights can be protected at once. No one gains when fundamental liberties are needlessly sacrificed. If freedom of speech were always and everywhere the opponent of children's safety, then we would face an irreconcilable conflict. But if we could find a crucial distinction between the rights of real children to be protected against real abuse, and the rights of imaginary pictures to legal protection as free speech, then we would face not a conflict, but two categories of rights, which might well be mutually compatible. The way to maximize both freedom of expression and children's protection is to locate a workable boundary between the real and the imaginary in photographs. Such a boundary will have to be flexible, but it must be found to avoid collision between two socially imperative values.

Let me repeat that I am not questioning child pornography laws as they were first issued in the early 1980s and approved by the 1986 Meese report, nor am I questioning the majority of the subsequent provisions that have been introduced at the federal or state level. Like most people, I would be horrified if the law did not protect real children from real sexual abuse. But what, I feel compelled to ask, is real? The issues of photography's links to reality are slippery and will never be definitively resolved. Nonetheless, because the issue of realism has been introduced into both child pornography laws and public attitudes toward all photographs of children, questions need to be asked. We must not be deluded by the argument that the protection of children precludes rational discussion of difficult issues. Proclamations such as

this one by Andrew Vachss, a lawyer who works on child abuse cases, are intended to stifle vital debate: "In truth, when it comes to child pornography, any discussion of censorship is a sham, typical of the sleight-of-hand used by organised paedophiles as part of their ongoing attempt to raise their sexual predations to the level of civil rights."[12] No one wants to be branded a child abuser (even by association). Not surprisingly, therefore, no one trained in visual issues or visual history has participated in drafting, deciding, or debating child pornography law. But what about the proverb: "Don't throw the baby out with the bathwater"?

We first need to consider the distinction between photography and other visual media. Is it always so clear that photographs are about reality while other forms of expression do not involve real people or situations? Take a comparison between Dorothea Lange's *Torso, San Francisco* (1923) and Ronna Harris's *Pygmalion* (c.1995).

Lange's photograph certainly originated in the act of clicking a camera at a real person. Apart from that fact, however, the photograph conveys very little evidence of anything except the appearances of a body. A girl has been pictured at a poignantly fleeting moment, just as she passes from childhood into adulthood, a moment rendered as a universal subject rather than a personal or social one. In the Romantic tradition of the elegiac sculptural fragment, the image represents only an anonymous torso, a torso bathed in a gentle light that blurs contours

77  DOROTHEA LANGE Torso, San Francisco 1923

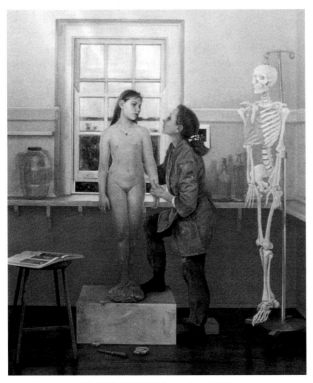

78 RONNA HARRIS Pygmalion c.1995

and minimizes surface variations. Lange conveys burgeoning adult-
hood as the luminous emergence of form. Brightness eddies around an
otherwise almost imperceptibly swelling breast, while at the image's
center bottom edge, a slanting thigh shadows delicate pubic tracery.
The torso in Lange's photograph could almost be a detail of Harris's
painting. Indeed, the smoothly illusionistic style of the painting not
only cues a photographic kind of looking, but also signals the reliance
of the painting on live models, in this case two good friends of the
artist, a real mother-daughter pair.[13] Both the painting's title and its
content retell an old story about realism and desire. According to an
ancient Greek myth, the adult male sculptor Pygmalion fell in love with
a beautiful sculpture of an adult woman he had carved. Lo and behold,
the statue came alive; you can guess the rest. In Harris's version, the
adult woman artist desires a live child, which, given both metaphoric
equations and gendered oppositions between masculine artistic creation
and feminine biological procreation, puts a decidely modern and femi-
nine spin on the Pygmalion tale. (When Harris made this painting, she

was trying to adopt a daughter.[14]) The photograph's anonymous formalism could – hypothetically – seem less real than the painting's personalized illusionism. The photograph's laconic abstraction of sexuality could also seem more aloof than an explicit reference to a story of desire, no matter how maternal the desire might be. It is much more likely, however, that the body in the photograph will seem more real than the body in the painting, simply because of their difference of medium. We perceive Harris's image through the expectations of imaginative distance associated with oil painting, while we perceive Lange's image through expectations of immediacy.

Strong signs of sexuality can become invisible in a painting, while ambiguity can seem sexually explicit in a photograph. I don't think anyone has yet suggested censoring Caravaggio's canonical *Cupid*, a raunchy baroque painting of a boy in the iconographically explicit guise of Eros, complete with centrally located penis and arrow of love. As a friend and baroque art specialist, Elizabeth Honig, pointed out to me, Robert Mapplethorpe's 1976 photograph *Jessie McBride* looks

79 CARAVAGGIO Cupid 1598–99

rather like Caravaggio's painting, only much cooler and more domestic – no reaching, no smile, and no arrows. Unlike the Caravaggio painting, however, Mapplethorpe's photograph has been the subject of intense controversy.

In the late spring of 1989, a retrospective exhibition of Mapplethorpe's work became a national scandal. After having showed at three respectable art institutions, its fourth venue at the Corcoran Gallery of Art in Washington D.C. was abruptly cancelled by the Corcoran director. Heated debate over the cancellation, Mapplethorpe's recent death from AIDS, and a $10,000 NEA (National Endowment for the Arts) grant to the organizers of the retrospective, all contributed to the Helms Amendment (H.R. 2788), passed in July of the following summer, which forbade NEA money to "promote, disseminate, or produce" among other things, "the exploitation of children or individuals engaged in sex acts." When the Mapplethorpe show proceded to the Cincinnati Contemporary Art Center, the Center's director, Dennis Barrie, was charged under Ohio state law with both "pandering obscenity" and two counts of child pornography. (Barrie was acquitted in September of 1990.[15])

Two subjects were at stake: explicit sado-masochistic homosexual acts and exposed children's genitals. You know child nudity has become controversial when an image of a naked boy doing nothing but perching on a chair in a kitchen, a photograph taken with the full knowledge and consent of both the boy and his mother, gets the same reaction as an image of one rubber-clad man urinating into another man's mouth. The other picture of a child in the retrospective, *Rosie*, admittedly challenged viewers more than *Jessie McBride* did; the girl's

80  ROBERT MAPPLETHORPE Jessie McBride 1976

81 ROBERT MAPPLETHORPE Rosie 1976

placement squarely in front of us, pushed forward spatially by the stone bench she sits on, incites us to peek up her raised skirt. The girl's childish pose and her apparent lack of concern with her exposure contrast ambiguously with the formality of the bench's rich carving, as well as with her traditional, even nostalgic, smocked plaid dress.[16] Nonetheless, the only explicit aspect of *Rosie* is the sight of her genitals, especially in comparison with Mapplethorpe's X-folio images that not only represent sexual acts, but also costumes explicitly designed, marketed, and worn for sex acts.

Very few people hold sexual images of adults and sexual images of children to the same standards, if only because of the issue of consent. Mapplethorpe himself felt very strongly that photographers should have the consent of their subjects, a feeling he twice expressed as a story told about himself as a child. "I found myself in a situation with a dirty old man wanting to do nudes and being pushy, pulling my clothes off, it was horrible. I would never do that to somebody."[17] As philosopher and critic Arthur Danto, writing admiringly on Mapplethorpe, points out, though, our modern western culture does not believe that children can give consent to adults because children are inherently powerless in relation to adults.[18] We hold this to be particularly true in the case of consent to sexual acts because we believe children, by definition, cannot know the adult sexuality to which they might seem to consent. The issue of consent is particularly vexed in the case of photographs taken by a child's parents. It used to be thought that relation-

ships within families were both trustworthy and private, but this is no longer universally accepted. Some would argue that the only person to whom a child can give consent is a parent, while others would retort that a parent is the last person from whom a child would be able to withhold consent.

Consent will remain a key issue in the interpretation of photographs. Any investigation into the circumstances of a photograph has to include questions about coercion, power imbalances, and authority. Consent, however, is not an infallible or conclusive test. Arguably, no person less powerful in any way than their photographer can give genuine consent: no person poorer, less mentally stable, racially discriminated against, socially marginal, etc.; yet many legitimate photographers, including many great documentary photographers, have made it their professional mission to represent exactly such people, while many historians and critics as well as photographers have argued that the disadvantaged benefit from becoming culturally visible. Moreover, if we were to maintain that consent is essential to photography, yet also that no child can give consent to any adult, then all family snapshots of children become unethical, which is patently absurd.

Mapplethorpe's case also raises the issue called "art." The verdict in Cincinnati Art Center Director Barrie's trial was reached, in the end, on the basis of whether or not Mapplethorpe's photographs were art, and Mapplethorpe himself had deemed the category crucial: "having a formalist approach to it all, which I hadn't seen in photography or pornography."[19] When *New York v. Ferber* ruled in 1982 that child pornography could not be defended on grounds of artistic significance, photographs of "mere nudity" were not at stake. Once the *New York v. Ferber* ruling could be combined with rulings or laws like the 1989 *Massachusetts v. Oakes*, which included "mere nudity" within the definition of child pornography, then any photograph of a nude child, including those long considered "artistic," could potentially be criminally indicted, since "lascivious intent" is hopelessly vague. Besides being the product of stricter standards for the protection of children, the legal trend of child pornography law is also the product of shifting attitudes toward art.

Few people outside the professional art world categorically shield "art" from political and social censure. For one thing, modern art purports to intervene in politics and society, and thereby courts political and social counter-attack. The postal inspector asked to comment on the Alice Sims case (about which more later) was not entirely unfair when he proclaimed: "Art is anything you can get away with."[20] Calling

a photograph art should not automatically grant any kind of immunity, nor calling oneself an artist, or exhibiting in something called an art gallery, or publishing in something called an art press, or participating in a class on something called art. Art can be a misleading, if not deceitful, label, of course. So why not interrogate images with more basic questions, including but not limited to formal issues? Does the image, whatever its label or origins, treat its medium ·with skill, imagination, or critical thought? Does the image interpret its subject? For what purposes and in what circumstances was the image made, exhibited, or circulated? The list of questions could go on and on. It should go on and on, because if suspicion about a label like "art" can foreclose careful looking and serious thought about the beauty, meaning and function of images, then a huge portion of our modern culture will have been exempted from intelligent discussion.

As child pornography laws, goaded by issues like consent and artistic immunity, have extended their reach to any photograph of a nude child, a whole new territory has been opened to suspicion. While most child pornography law convictions attack criminals who willfully inflict physical harm on real children, enforcement of these new laws has also wreaked havoc on the lives of a very different sort of person. Since the mid 1980s, the American legal system has dealt with an increasing number of photographs which could not have been defined as child pornography earlier. Dozens of photographers, many of them the parents of their subjects, who never imagined anyone would see pornography in their work, have incurred penalties ranging from attacks in print to time in jail. Some have been separated from their children, others have had their studios ransacked, property impounded, or their friends, family, dealers, and models harassed. Many, even if they were never indicted, let alone convicted, have had to pay legal fees for their defense that leave them deeply in debt. The psychological traumas incurred were no less deep, all the more so for having been unanticipated. These cases have been widely reported in the popular press, and thoughtfully presented in several art periodicals to what one could call their professional constituencies.[21] What I want to emphasize here about these "pseudo-pornography" cases, as they are sometimes called, is that they all depend on a new starting point; rather than being initiated by actions against real children, they begin with interpretations of photographs.

"Pseudo-child pornography" cases revolve around photography. Take the story of Alice Sims. Sims's tangle with the law was not provoked by her finished "Water Babies" series – drawings made from

superimposed slides of naked babies and waterlilies – but by the pho-
tographs she used to prepare her final work. Sims had shot scenes of her
gamboling naked children and their friends, which, as usual, she had
dropped off for development at a Dart Drug store. Some frames showed
children with their hands near or touching their genitals. In July 1988,
one of those rolls of film was sent for processing by Dart across state
lines from Virginia to Maryland. On 14 July, police and postal inspec-
tors arrived at Sims's house, searched it, and seized "evidence." She was
being investigated for interstate child pornography, a federal crime that
made her liable for a ten-year prison sentence. Someone at the photo
lab had judged Sims's photographs "sexually explicit" and reported her
to the police. Meanwhile, Sims's two children, aged one and six, were
taken by Department of Social Services social workers into "protective
custody" (their parents never found out where). Doctors examined the
two children for signs of sexual abuse. None was found, and the Sims
children were returned to their parents within twenty-four hours. The
police never pressed charges, but neither did they definitively close the
case.[22]

Accusations of child pornography only partially or tangentially
involving photography, and that do not involve the display of genitals,
can still be reasonably negotiated. In May of 1994, residents of Brook-
line, Massachusetts were startled to find two additional traffic signals at
one of their busy street corners. Instead of the usual walk/don't walk
signs, the signals flashed two quasi-photographic images of a naked
mother and child. In both images the mother was restraining the child,
holding its arm or wrapping her arms around it. I say "it" because both
figures were posed so that no genitals were visible. At first some view-
ers could not tell whether even the adult was male or female. The sig-
nals were a public project by local artist Denise Marika, funded with
$1,500 in state arts lottery money allotted by the Brookline Council on
the Arts and Humanities. Brookline viewers described the work various-
ly as "out of place," "isn't the least bit suggestive or erotic," "offensive,"
"close, but I don't think it crosses the line," "not something I get a good
feeling about," "disgusting." One member of the arts grant committee
joked: "The results are mixed. Half the people are holding onto their
kids. But so far, nobody's taken off their clothes."[23] Newspapers and
television heralded the controversy. The town's transportation director
had never gotten so many calls. Some residents demanded the work's
removal. A town meeting was called to discuss the installation. Marika
explained her intentions and goals. She managed to soften even her
fiercest opponent, the president of a local Parent Teacher Organization.

82　DENISE MARIKA Crossing 1994

The twelve-inch square images, transferred onto acetate, had origi-
nally been photographs Marika took of herself and her son. She wanted
her figures undressed to convey the universal meaning of her message
about maternal protection from danger, a message she felt belonged in
the public domain. Marika, when preparing an installation like *Cross-
ing*, takes roll after roll of film in order to obtain an impersonal image
of rote repetition, the opposite of personal documentation. The fact that
the image was once a photograph of herself and her child is "irrele-
vant," in her opinion, to the final work.[24]

Robyn Stoutenberg was not able to sway her accusers with a similar
argument about expressive intention because the image in question was
a photograph that did show a child's genitals. Like Marika's traffic sig-
nals, Stoutenberg's boxed photograph originated in a broad philosophi-
cal question. The image contrasts two kinds of flesh – one precious, the
other disposable; one tenderly alive, the other starkly dead. Moreover,
again like Marika's work, Stoutenberg's photograph forms the center

83  ROBYN MCDANIELS Oscar With Birds c.1993

but not the entirety of her image. The photograph of the boy and the bird was enclosed within a box with yet another body, a stuffed (real) bird. Both Marika's and Stoutenberg's works pose questions about their photographic medium. Is a flashing photograph a more effective sign than a red light? What kinds of protection can signs of danger trigger? Can photography, like taxidermy, preserve a life that has died? Do we consume photographs like dead meat? What bodies do we treasure, and for what purposes? The background facts of the boy in *Oscar with Birds* being Stoutenberg's own son – the flesh of her flesh – and of the stuffed bird (a cut-throat finch dead from being egg-bound) having been given to her by the boy's father, might further complicate her image.[25] All these interpretive possibilities were cancelled by the documentation of a child penis.

Stoutenberg's photograph certainly did document a penis. It did also put that penis on public display. The people who complained to the police were employees of a middle school next to the gallery exhibiting

Stoutenberg's work, fearful their students would see her photograph through the gallery's window-front, a picture which they said showed a child having sex with a chicken.[26] Look at the image carefully, however. It documents nothing but the sight of a penis. Not only, in documentary terms, is the penis several inches away from the chicken, but, for sex-act purposes, the chicken is upside-down. Moreover, an uninformed viewer can have no idea who the child is because his head is not included in the photograph. The documentation and display of a child's genitals now suffice to override everything else about a photograph, and even, in the Stoutenberg case for example, suffice to distort visual evidence. Inextricably connected though the documentary and expressive aspects of a photograph might be, mainstream moral and legal opinion feels able to dismiss representation and judge photographs entirely as

84 PATTI AMBROGI X's and O's; The Sun and the Earth 1992

reality. If photography is the gate between representation and reality, then law has decided that it swings open in one direction only.

Patti Ambrogi directly denies photography's realism in her 1992 work *X's and O's; The Sun and the Earth*. Ambrogi's nine-image piece reacts against allegations of child abuse and pornography aimed at her work in 1989. *X's and O's* layers photographs of her twin daughters playing outside, writings by Mary Calderone and Kate Millet, and a pattern of x's and o's that, in the words of an art critic, refer to "the game Tic-Tac-Toe, and in turn the randomness and the limiting strategies of censorship."[27] According to Ambrogi, photography and writing are both modes of analysis, and both subject to win-or-lose censorship tactics. According to American law, only photography is. Whatever Calderone or Millet might write, they are not subject to prosecution for child pornography, nor does the law "read" photographs as a medium.

The arguments for censoring sexually ambiguous photographs of children carry enormous emotional force. The issue is not arguments about photographs that record explicit sexual acts with real children, or any photographs that are used instrumentally as evidence of such acts. The issue is the arguments for criminalizing photographs on the basis of nudity alone, a nudity whose sexual meanings have to be interpreted, or, even more subjectively, images of clothed children someone deems sexually suggestive. There are basically four of these arguments, and they are all both highly charged and problematic. The first is the correlation between sexual child abuse and possession of pornography. The second is the use of pornography to entice children into abusive situations. The third is a market for pornography that motivates the exploitation of children. And the fourth is the trauma suffered by the children who are photographed, both at the time the photographs are taken, and then at any future time when they see or remember the photographs.

Many child molesters possess pornography. This is a very frightening fact. Whether the picture collection appears hard-core, ambiguously suggestive, or mixed, is immaterial. Some expert witnesses have testified to researchers and government investigatory commissions that a majority of the sexual child abusers they convict collect child pornography. The official and very thorough "report to the General Assembly" on the sexual exploitation of children by the Illinois Legislative Investigating Committee, published before any draconian child pornography laws were passed, stated: "Without an exception, all of the child pornographers with whom we came in contact were also child molesters."[28] Plenty of particular law cases record the sordid association of

abuse and pornography. In a sad New York case decided in May of 1992, a father, referred to as Mr. G., was convicted of abusing his tiny son and daughter sexually in several ways, one of which was photographing them. The pictures he had taken were used as key pieces of evidence against him. The children's mother was fully aware of their abuse, but was too battered by her husband to protect them.[29] Another case, the story of Robert Black, gripped the entire United Kingdom. First convicted for molesting and kidnapping a girl in 1990, Black was later tried for the murder of three other girls, and sentenced in 1994 to ten life sentences. The pornography Black had collected in his home, including scrapbooks, 110 magazines and 50 videos or films, was shown to the jury during his trial. Part of his collection had been bought in London, the rest in the Netherlands and Denmark.[30] Even more wrenching are spectacular public acts of violence against children, like the Dunblane massacre, committed by child pornography collectors. In April 1996, Thomas Hamilton burst into the kindergarten class of his local school and gunned down sixteen children, together with their teacher. Hamilton had a large collection of child pornography at home.

The association between child molesting and pornography is so strong that child molesters are assumed to make or collect pornography. During the still controversial 1984 Fells Acres case in Massachusetts, the assumption was strong enough to survive contradictory evidence. Violet, Cheryl, and Gerald Amirault were accused of abusing the children enrolled in their family-run day-care center, Fells Acres. Soon the headline "Day-Care Kiddie Porn Probe" blazed across the front page of the *Boston Herald* newspaper. Gerald Amirault said: "the media kept portraying my family as kid pornographers." The toddlers on whose (induced) testimony the prosecution relied had spoken of photographs. Yet neither intensive searches nor cross-examinations ever discovered any evidence whatsoever of any pornographic activity on the part of any of the Amiraults. Nonetheless, a state postal inspector was called to testify at the Amiraults' trial that child pornography existed in the state of Massachusetts. The Amiraults were convicted. A juror, Carol Beck, recalled in 1995: "I don't think it was so much a sex-abuse case as it was a child-porno case. The kids didn't show a lot of abuse signs because what was going on was mostly for pictures. In my mind, that's what I honestly felt."[31]

Needless to say, the action of taking photographs can by itself be a form of child abuse. In 1992, for example, L. Lane Bateman, at the time of his arrest a drama teacher at the prestigious Phillips Exeter Academy, was convicted of having abused a former student by taking explicit

photographs of him, collecting them, and sending copies to him. Bateman collected child pornography over a period of twenty years, amassing books, prints, and more than three hundred pornographic videotapes.[32] It is very tempting indeed to put possession of child pornography and actual child abuse into a cause and effect relationship – too tempting. Many professional studies have been carried out on the relationship between images of violence or sex and acts of violence, but none has proved that images directly cause actions. There simply is no consistent or reliable evidence that looking at an image all by itself can make a person commit an action, even the action represented in the image. These studies are discussed in detail in several excellent books and articles, accompanied by extensive bibliographies.[33] The easiest way to consider the problem is this: all convicted child molesters might collect child pornography, but not all people who look at child pornography molest children. The high incidence of child abusers who possess pornography could indicate that both abusive acts against real children and the possession of pornography share a common cause, but if so, eradicating child pornography would do little if anything to attack the abuse of real children at its root.

Consider the logical analogy of gun control. A much better cause and effect argument could be made about guns and violent crime than about pornography and molestation. The children murdered in the Dunblane massacre, for instance, were actually killed by guns, not by pornography. Yet even those who advocate gun control, for instance in reaction to the Dunblane massacre, do not argue that no one under any circumstances should be allowed to own a gun, but rather that some kinds of guns should be outlawed, and that some surveillance of all gun sales should be exercised. The principle of gun control rests on careful differentiation among kinds of guns and among kinds of people. Most murders might be committed with guns, but not all people who own guns commit murders. Organizations which oppose gun control, like the American National Rifle Association, completely reject gun-cause, crime-effect arguments.

Most importantly, the overwhelming share of child abuse is not primarily correlated to pornography, let alone perpetrated by profit-driven commercial pornographers. According to the National Committee to Prevent Child Abuse (whose statistics tend to the high end of widely varying estimates), in the United States alone 11% of 3,111,000 reported child abuse cases in 1995 were cases of sexual abuse. Depending on the studies, between 6% and 63% of adult women report they have been sexually abused as children.[34] According to the *Encyclopedia of Child*

*Abuse*, "about 70% of sexual abusers are known to children before the abuse takes place. The most frequent offenders are fathers and stepfathers." The better the child knows the offender, the more prolonged and repeated the abuse is likely to be.[35] In many cases the abuses of dedicated pornographers might not be possible without child abuse in the home. The exemplary 1980 Illinois government report on the sexual exploitation of children discovered that "a large percentage of children involved in pornography and prostitution have been runaways or have been abused by their parents."[36] Many child molesters, like Robert Black and Thomas Hamilton, themselves came from deeply troubled homes. The enemy is not outside but inside.

A second argument for attacking child abuse from the direction of photographs is the use of pornography to lure children into sexually abusive situations. Show children susceptible to peer pressure pictures of other children engaged in sex acts or naked, the argument goes, and they can be induced to do what they would not do otherwise. There are certainly cases in which pictures have been used with exactly those intentions. In 1995, for example, David Cobb, teacher of English for twenty-seven years at another elite school, Phillips Andover Academy, was arrested on charges of child kidnapping and sexual abuse. The fourteen-year-old boy who turned Cobb in testified that he had not only been paid to rub lotion on Cobb, but had also been shown photographs of naked children and adults. Police reported finding 512 such polaroid photographs in Cobb's possession.[37] Precisely because the harm is done by the action of using images, the burden of criminality should be placed on actions, not on photographs themselves. David Cobb's 512 polaroids, for instance, did no harm to his young victim until he used them as bait. If a photograph does not depict any sex acts, but only the body of a child, the appearance of a photograph does not itself prove how it was used. If a photograph, no matter how sexually ambiguous, can be proved to have been used to lure a child into abuse, then the action of using the photograph is unambiguously criminal.

Tolerance, the third argument proposes, lends legitimacy to pedophilia in general, irrespective of violent acts, which in turn stokes the profit-motive of a child-pornography industry. Here two different problems are at issue: first, whether sexual fantasies harm real children, and second, whether a child pornography industry is harming real children.

Consider the constitutional implications of outlawing private fantasies about all sorts of crimes, fantasies that never express themselves in any action other than looking at pictures. How many television

shows or films would survive censorship? The entire genre of the suspense thriller would have to be eliminated, as well as most romances. The Constitution of the United States is grounded in a respect for freedom of thought. Extremely sophisticated arguments have been mounted by some legal theorists, notably Catherine McKinnon, to establish cause and effect relationships between private fantasy and violent action,[38] but those arguments have been widely discredited by the legal and feminist communities they address.

In any case, the market for child pornography in the United States was never large, and contracted dramatically under the pressure of the laws passed against it in the early 1980s. Child pornography does exist. All expert research, government reports, or police investigations that rely on systematic study, however, concur that there is virtually no commercial child pornography in the United States, and that what little pornography survived the laws of the early 1980s is home-made and clandestinely circulated among a small group of people.[39] We do not live in a society that fosters any significant presence of incontrovertible child pornography in the public domain. The myth of a huge child pornography industry fuels many arguments in favor of strict censorship, but has been consistently disproved ever since its inception. Already by 1980 the Illinois report dismissed recycled rumors of 300,000 children involved in multi-million dollar child porn rings run by the Mafia. The report did discover child pornography, most of it made for private use or circulation by "individual child molesters."[40] According to the report, in 1980 the FBI completed a two-and-a-half-year porn sting operation. "None of the 60 raids resulted in any seizures of child pornography, even though the raids were comprehensive and nationwide."[41] The longest lasting, biggest-selling underground child porn magazine of the 1970s, the *Broad Street Magazine* (of which one out of twelve pages in a typical issue included images), never sold to more than 800 individuals nor grossed more than $30,000 a year.[42] Then came the crackdown of the 1980s. According to the conservative Meese report, 66 persons were indicted for child pornography between 1 January 1978 and 21 May 1984, and 183 persons between 21 May 1984 and 27 February 1986.[43] Even a spokesman for the National Law Center for Children and Families, a conservative children's advocacy group, said to the *New York Times* in February 1994: "There's really no commercial child pornography in the United States."[44] Anxiety has shifted to a black market exchange in images, particularly in computer images. Yet when, in September of 1995, the FBI announced the results of an investigation into the viewing habits of 3.5 million America

Online subscribers, they had only been able to locate 125 potential child sex offenders, which included persons soliciting sex acts with children as well as persons trafficing in pornography.[45] A sting appeal for images of children engaged in sex acts reportedly received eight replies.[46] Kevin Di Gregory, Deputy Assistant Attorney General of the Criminal Division of the Justice Department, testified to a Senate Hearing in June of 1996 that all recent Justice Department operations, including the vast programs "Innocent Images" and "Operation Long Arm," resulted in "over 40" convictions. These are numbers that signal a marginal fringe phenomenon, not an epidemic or a cultural crisis.

The fourth argument, about the trauma of the photographic record, is not only problematic; it may also be counter-productive. Remember we are talking about photographs that only display the child's body, not photographs that record any sex acts. Of course any photograph of child nudity might be taken in circumstances that are highly unethical, if not illegal; if so, then the photographer may well be liable for prosecution for his or her actions. An inherently innocuous photograph of a child could be marketed as sexually explicit pornography through packaging, promotional material, captions or whatever, and these attached meanings could make the photograph seem retroactively traumatic to its subject. In either case, the best protection against the photograph itself becoming traumatic is to stop casting moral doubt on the photograph, and instead shift blame to where it belongs, on the abusive makers and users of photography. Recent child pornography law casts shame on the child's body. When every photograph of a child's body becomes criminally suspect, how are we going to avoid children feeling guilt about any image of their bodies? This fourth argument against child pornography will become a self-fulfilling prophecy. Children will be traumatized by photographs of themselves if they are taught that those photographs are criminal. And the reverse. Rosie Bowden, the subject of Mapplethorpe's 1976 *Rosie*, raised in the 1970s, says the photograph is: "very, very sweet ... The only unnatural thing about that photo was that I was wearing a dress." She intends to hang a copy of it on the wall of the restaurant she owns.[47] Were your parents or grandparents traumatized by the existence and even public display of photographs of themselves as naked babies? No, of course not, because such photographs were a completely standard fixture of family photography, and because the explanation given for the photographs was that their bodies were so cute – and innocent.

Actions and images are not the same. All four arguments in favor of including any photograph of a child's body within the purview of child

pornography law depend on a confusion between two aspects of photography. The actions of making and using photographs are real. Photographs themselves may seem convincingly real, but they are not real. In between these two absolutely true facts stretches a difficult grey zone: the zone in which a photograph documents some real action. That grey zone will always require close looking, common sense, and adjudication. No one principle can ever deal in advance with everything in the grey zone of documentation. Whatever the difficulties, however, photographs should always be looked at instrumentally for evidence of actions. If child pornography law confuses two categorically different things – the actions of making or using photographs with the photographic image itself – then its logic will be fundamentally flawed.

Here is a typical example of highly dubious child pornography logic, all the more dangerous because it is expounded with the genuine desire to protect real children: "We further assert that child pornography is the documentation of child abuse and, therefore, cannot be considered protected speech and/or a Constitutional right." The speaker is Sara O'Meara, the co-founder, Chairman, and CEO of Childhelp USA, an organization devoted to "abused and neglected children."[48] Because this argument is not only compressed, but relies on compression, I want to restate it more slowly, step by step. Children are inherently powerless and therefore cannot give consent to sexual acts. Sexual acts with children are therefore criminalized sexual abuses. The conditions under which children are photographed to produce sexual images are a form of child abuse. Therefore the making of sexual images of children is a criminal act. Sexual photographs of children document their own making, therefore they are documents of a crime. Therefore the photographs themselves become criminal actions. Speech is protected by the First Amendment, but actions are not. Therefore sexual images of children, being actions, are not protected by the First Amendment and can be prosecuted as crimes.

This logic should be difficult to follow, because in its fully articulated form it includes some difficult steps. Are the documents of an action equivalent to that action? If the action is a crime, are documents of it a crime? Are all visual representations of an action documents? The assumption that allows these questions to go unanswered is the assumption that all photographs are documents, as opposed to representations, or forms of expression.[49] O'Meara's statement reveals the constitutional stakes of child pornography debates. In the United States, freedom of "speech" is protected by the First Amendment of the nation's Constitution, first because it was so primary in the minds of the

nation's founders. Actions are not protected by the First Amendment. If the mere fact of the photographic medium renders every photograph of a child an action, rather than a visual form of "speech," then no photograph is safe, and the freedom guaranteed by the First Amendment has been significantly curtailed, especially in the highly visual, if not photographic, culture of the late twentieth century.

At this critical juncture came *Knox v. the United States. Knox*, as I will call it for the sake of brevity, was a crucially transitional case, at once a series of judicial decisions and a national scandal. It was a case that reached the right conclusions for the wrong reasons. Because the judges and the grass-roots movements involved were eager to convict child pornography by whatever means available, *Knox* established a dangerous precedent. *Knox* denied distinctions between form and content as well as between action and image, and therefore left a legacy of rulings and attitudes which made child pornography law potentially affect every photograph of a child, nude or clothed.

Stephen Knox was a history graduate student at Penn State with a previous conviction for possession of child pornography when, in 1991, his apartment was searched, and the images in question, videotapes produced by a company called Nather, were seized along with supporting evidence. On 11 October 1991, Knox was convicted of possessing child pornography, a crime punishable by up to ten years in prison under federal law.

*Knox* set a legal precedent. The genitals of the children pictured in the Nather tapes were covered, the children were wearing what the court called "normal" clothing, and the children were not engaged in explicitly or implicitly sexual conduct, though often judges and reporters referred vaguely to "sexually suggestive poses." The children pictured had not been posed, had not been brought anywhere to be pictured, and were not even aware they were being taped. The Nather tapes were condemned as pornography because a zoom lens had been used to create extended close-ups of the children's clothed genital areas. Framing had made content illegal.

*Knox* had crossed a dangerous line. Judgments on the circumstances in which a photograph was made, based on the documentary evidence supplied by photographs, are sound. Judgments on an image's meaning based on its content might be acceptable. Judgments on an image's meaning based on the framing of its content, or based on any other stylistic or technical aspect of an image, are intrinsically suspect. However marginally, the Nather tapes were not being used as documentary evidence. They were being judged as representations.

While the courts did not agree with this distinction between evidence and representations, *Knox* gave them enough trouble to produce some curious reasoning. The U.S. District Court of Pennsylvania, where Stephen Knox was first tried, ruled against him on the grounds that the upper thighs of the children, which were sometimes exposed, were a part of the pubic area. Stephen Knox received a five-year sentence. His appeal to the Third Circuit U.S. Court of Appeals was denied on 15 October 1992. The upper thigh was not a part of the pubic area, the appeals court ruled, but exhibition of the genitals did not require that the genitals be visible.

*Knox* was appealed to the Supreme Court. As is customary in controversial or legally difficult cases, the Solicitor General wrote a brief to the Supreme Court advising it of his opinion. Unlike the Attorney General, under whom he nominally serves, the Solicitor General is not a political appointment and acts almost as an additional Supreme Court Justice. In his brief dated 17 September 1993, Drew Days III, for the first and last time in *Knox's* history, addressed the central issue of the case. Days argued that "lascivious exhibition" did require visibility because some aspect of the documentary content of the images, as opposed to their technique or effect, was required to constitute pornography. (Days's argument has frequently been caricatured as saying that all nude photographs of children are pornographic.) Days consequently argued that *Knox* had been judged on incorrect grounds. *Knox* was accordingly remanded, with new instructions, to the Third Circuit Court of Appeals on 1 November 1993.

*Knox* exploded. Days had anticipated trouble, but not this much trouble.[50] Religious groups, child-advocacy groups, and almost the entire U.S. Congress claimed to represent children's interests by attacking Days's position. Tapping into their grass-roots organization, right-wing religious groups jammed congressional phone circuits with calls. Phone circuits at the Justice Department were so overloaded they almost broke down.[51] Within three days of Knox's remand, on 4 November 1993, the Senate passed a non-binding resolution censuring the Justice Department position, by a vote of 100 to 0. According to a constitutional law scholar, such censure is "almost unprecedented."[52] Eight days after the Senate censure, on 12 November, President Clinton publicized a letter to Attorney General Janet Reno ordering tougher child pornography laws to obviate the Days brief. On 8 April 1994, a Federal Judge allowed a "friend of the court" (*amicus curiae*) brief criticizing the Days brief to be filed at the Third District Court of Appeals by 173 Republican and 61 Democratic members of Congress, joined by several

organizations describing themselves as children's advocates, including the national organization Law Center for Children and Families. Twelve days later, on 20 April, the U.S. House of Representatives echoed the Senate's censure of the Justice Department, voting 425 to 3. The Third District Court reaffirmed its ruling on 9 June 1994. The court rejected the argument of the Days brief, citing the intent of Congress, an intent clarified by Congress in its censures and in its friend of the court brief.[53] Immediately following the 1994 mid-term congressional elections, on 10 November 1994, the Justice Department reversed its position on *Knox* in a brief signed by Attorney General Janet Reno. Because it is legally unprecedented for such a brief to be signed only by the Attorney General, and not by anyone else in the Solicitor General's office, it can be assumed that Reno's position was not supported by her own department, but instead by the White House. The lawyer for the Law Center for Children and Families, John D. McMickle, reacted to this last *Knox* brief by saying to the *New York Times*: "This case is the first indication of how the Justice Department and the Clinton Administration will react in a conservative world."[54]

*Knox* treated all photographs of children as actions. The case itself did not end in a wrong decision, but it left dangerous possibilities in its wake. It did not matter any longer whether real children had actually been harmed. And, meanwhile, the definition of child pornography had been broadened well beyond any explicit sexual content. So logically, it might not matter much longer whether the image was photographic, because documentary evidence of a crime was no longer the point. If someone, anyone, could see sexuality of any sort in any image of a child, that image might be judged pornographic and its maker, distributor, or possessor could face $100,000 in fines and ten years in jail.

By September of 1995, all these possibilities had been proposed as law. Senator Orrin Hatch (R-UT), speaking also for Senators Spencer Abraham (R-MI) and Charles Grassley (R-IA), introduced to the U.S. Senate "The Child Pornography Prevention Act." Hatch's proposal included several quite sensible provisions, notably stricter rules against the marketing of child pornography. At the same time, however, he also suggested outright that no real children had to have been involved at all in the making of an image for the image to be a form of child abuse. Hatch was particularly concerned about computer-generated or computer-altered images, which are notoriously not "real," though photographically realistic. Moreover, Hatch proposed that rules against the "lascivious display" of the genitals be extended to prohibit the depiction of "the buttocks of any minor, or the breast of any female minor."[55]

In June of 1996 a Senate Judiciary Committee convened to hear arguments in favor of Hatch's proposal. Present were Senators Hatch, Grassley, Joseph Biden (D-DE), Dianne Feinstein (D-CA), Paul Simon (D-IL), and Strom Thurmond (R-SC). Once again, several useful and effective measures were discussed. And once again, those reasonable ideas were intertwined with dangerously vague and sweeping suggestions. It seemed to be a foregone conclusion that images of children which did not involve any real children at all should nonetheless be considered actions against children, and prosecuted as such. Images were being granted an autonomous power greater than ever before. Bruce A. Taylor, President and Chief Counsel of the National Law Center for Children and Families, reassuringly argued that paintings and classical art would not be affected by proposed changes in the law because they "don't look like real children being abused." I wonder, then, why computer-generated images look "real" if everyone knows how likely they are to have been artificially created. Will a generation raised with computers believe any photographic image looks "real"? Senator Hatch conceded that not all pictures of children's buttocks and chests were pornographic. He had "faith in the intelligence and common sense of the justice system" to know what was lascivious and what wasn't.[56] In other words, all pictures of children's buttocks and chests are presumed guilty until the legal system proves them innocent.

The Child Pornography Prevention Act of 1996 was passed in October 1996, tucked into an omnibus spending bill. Punishable by penalties ranging from five to thirty years, child pornography had come to mean any image of any child's body. Bruce Taylor summed up the difference between old and new laws: "Congress has moved from seeing child pornography as a crime scene of yesterday's child abuse. It is also a tool for tomorrow's molestation. In other words, pedophiles look at child pornography and become incited to molest children, and pedophiles show those pictures to children to seduce them into imitating the pictures."[57]

The specter of an evil power hangs over all images of children's bodies. *Knox* was about popular attitudes as well as about law. Both the law and attitudes have continued to drift in the direction *Knox* pointed to, and not just in the United States. The rock group Megadeath's *Youthanasia* album was released in October 1994 with a computer generated digital image of an older woman hanging naked babies on a clothesline. Dave Mustaine, a member of Megadeath, said the image was inspired by the song-line: "We've been hung out to dry." "That line," Mustaine said in a television interview, "is probably the strongest

representation of how we feel about the young people who listen to our music and what their future holds for them." Some retailers in Canada and Germany refused to stock the album because of its cover, while the album was completely banned in Malaysia and Singapore because the cover image was deemed "defamatory."[58] In December of 1995, Germany censored the on-line service CompuServe, banning child pornography, illegal adult pornography, and legal pornography judged too explicit for children to see. For technical reasons, Germany's ban required a worldwide black-out affecting four million CompuServe members around the world.[59] In September of 1996, England's Hayward Gallery withdrew Mapplethorpe's 1976 photograph *Rosie* in advance from a major Mapplethorpe exhibition, after warnings from child charity groups and advice from the police.[60] Times had changed, the police warned, since 1976.[61]

The case of Toni Marie Angeli shows just how much times have changed. Compound expanding suspicions with increasing revulsion and you get an accident waiting to happen. In the fall of 1995, Toni Marie Angeli was taking a photography course at the Harvard University extension school with a highly respected professor, Jack Leuders-Booth. She decided to do her final class project on "Innocence in Nudity," using her four-year-old son as a model. At her professor's suggestion, Angeli took her negatives to a lab she had not worked with before, Zona Photographic Laboratories. There a lab technician, Ashling Bar, decided the images looked pornographic. Bar shared her concerns with Zona co-proprietor Mary Osgood, who called the police. The entire contact sheet of these images has never been publicly reproduced, yet it is essential to see the entire sheet to understand how flimsy the allegations against it were. (I was fortunate to be shown the sheet by Angeli's lawyer.) It is quite true that many frames showed the boy's genitals, and several pictured him peeing toward a chain-link fence. In two frames the boy's face was in tears. A majority of frames, however, showed the child smiling and laughing, playing with his fully-dressed father in a home setting. More shots were centered on the child's face than were centered on his body. In one frame, Angeli had apparently given someone else (her child perhaps) a chance to use the camera, which has been turned on Angeli and her husband hugging and smiling. Absolutely nothing anywhere on the contact sheet was explicitly sexual in any adult sense, and the contact sheet as a whole, which is what Zona was looking at, provided an affectionate family context for each individual image. Indeed, no pornography charges were ever pressed against Angeli. At least, not directly.

When Angeli, together with her husband and child, came to pick up her photographs at Zona on 2 November, she was stalled. Two plain-clothed police officers arrived and said they were investigating a crime, the crime of child pornography. At this point, the police officers and Angeli tell different stories. The two police officers claim Angeli immediately became violent and verbally abusive. Angeli claims she started fighting and swearing after the officers told her they could take her child away from her. Under the aegis of assistant Middlesex county DA Marilee Denelle, Angeli was charged with damaging Zona's property – damages valued at less than $250 – and convicted by a jury. Ostensibly, the trial had nothing to do with pornography, but in practice it had everything to do with pornography. Zona's owners would not have passed their highly subjective judgment on Angeli's photographs if they had not been motivated by the fear of pornography. Neither the police officers nor Angeli would have lost their tempers if child pornography were not so serious an accusation. Though the jurors heard all about the accusation, they were never allowed to see the photographs. The mere accusation of pornography, though it could not be substantiated, was in and of itself enough to ruin Angeli's credibility. About that, everyone agreed. Since the accusation was so damning in Angeli's own eyes, she refused to accept any sentence which, in her estimation, would in any way concede she or her photographs had been at fault. She therefore refused Judge Roanne Sagrow's initial, lighter, sentence. Sagrow, following the example of everyone else in the case, lost all rational restraint, sentenced Angeli to thirty days in a medium-security prison, and refused appeal. No one in jail could believe that Angeli was really serving thirty days for the crime of which she was convicted, so they all assumed she must be a child pornographer, and treated her accordingly.

Of course everyone wants to catch child molesters, and to err on the side of caution. Weighed against each other, the safety of one child feels more imperative than the comfort of a few dozen photographers, no matter how innocent they might be. The adults will probably recover, especially if they are innocent, while the child might be irrevocably damaged. If the price of a strong child pornography law were logical flaws in the law, if the law had to be vague in order to be effective, then of course the price would be trivial. Adults would have to give up some freedom of expression in order to prevent child abuse. These arguments are extremely effective emotionally, and they are voiced in all debates over child pornography law. Dee Jepsen, for instance, President of "Enough is Enough!" – a non-profit, non-partisan women's organization opposing child pornography and illegal obscenity – testified to a

Senate Judiciary Committee in 1995: "Does it really matter what the *exact* percentage is of material that is available by computer, to children as well as adults – material that degrades and tortures women, sexually uses children and debases human beings (and, in the view of animal lovers, even animals). Any is too much. One child's life misdirected into unhealthy sexual behavior is too much."[62]

Perhaps, however, some other questions should also be asked. What is the most effective way to protect one more child from real sexual child abuse? How can we adjust the wording of child pornography laws to protect both children and a constitutional right to free expression ? How does our modern society want to picture the child's body? These are questions whose answers go beyond facile oppositions between the needs of children and the rights of adults. The goal, I believe, is not to oppose one value against the other, but rather to see how the two values can be constructively reconciled. To achieve this goal, it is necessary to think critically about the degree of power we attribute to photography, and to consider the problem of child pornography as one part of a broader cultural situation. It is not necessary to put real children at risk or to curtail freedom of expression.

The most effective protection of children is law that targets actions. Needless to say, real children are effectively protected by all prosecutions of actual child molestation. Any action that materially harms a child is a crime, including actions that involve photography. Images themselves are not actions, let alone criminal actions, but the ways images are made, distributed, and marketed can be crimes. Expanding child pornography law so that it potentially affects every image of any child only diverts precious resources from the efficient to the inefficient, from certainty to possibility, and from fact to fiction. If we want to be sure to save more children, we should pay attention to the enormous number of children whose sexual abuse has nothing to do with pornography. The disparity between the numbers of child pornographers being convicted and the numbers of real children being abused is staggering. The U.S. Justice Department convicted some sixty child pornographers in the years 1995-6. Of the 3 million children whose abuse or neglect was reported in 1993, of whom about 1,300 died,[63] some 300,000 were sexually abused. Clearly, child pornography is a small area of sexual child abuse, a tiny corner of all child abuse. According to child-welfare agencies, the main factors associated with almost all child abuse are not pornography, but single parenthood, poverty, and substance abuse.[64] Society is turning away from the whole situation of abuse to fixate on one tiny corner. The United States

devotes more and more resources to pornography, and less and less to real children.

The history of the 1980s and 1990s suggests that surveillance of images substitutes for the care of real children. The years during which child pornography law escalated were the same years during which funding was slashed for social services that protect children. Americans seem willing for their government to spend money controlling pictures of children, but not for government to spend money on children themselves. We live in a society that is willing to pay for the monitoring of 3.5 million computer users in order to catch some 40 pornographers, but which will not pay for day-care, foster parent programs, adoption services, or school lunches. We live in a society that is willing to pay for FBI agents and DA offices to launch massive legal investigations based on photographs of naked children that might or might not be interpreted by some person as possibly showing lascivious intent, but not willing to pay for social workers who deal every day with already documented abuse, rape and murder of children. There were resources for the New Jersey DA office to investigate Eljat Feuer for months in 1995 on the suspicion that photographs of his naked daughter (photographs taken for a photography class, in the presence of the child's mother and nanny) might betray some hint of a weird attitude of which there had never before been any other signs. But apparently there were no resources that year for New York City child welfare workers to pursue repeated complaints of actual sexual abuse and prevent Elisa Izquierdo from being violated by her mother with a toothbrush and a hairbrush, being forced to eat her own feces, and finally having her brains smashed against a cement wall.[65] "Please encourage your workers to follow this simple mathematical equation," the Child Welfare Administration had written to its case-workers. "For every opening you should have two closings/transfers."[66]

Why have a bad law when a good law would do the job just as well? Returning legal prohibition from images back to actions would not affect the prosecution of actual child molesters in any significant way, and at the same time it would uphold freedom of expression. The point is not to eliminate pictures of children from among the forms of evidence against child abusers, but rather, simply, to emphasize that pictures have to be used instrumentally as evidence of an actual crime against real children. I doubt that any final judgments against child molesters would be changed by this shift in the language of the law. For one thing, the Anglo-Saxon judicial system is already based on the careful consideration of circumstances surrounding alleged crimes and

the evidence of those crimes. In practice, for instance, *Knox* was not judged on the basis of the images of the Nather video tapes themselves, but – both by the courts and the press – on the basis of the ways in which the images were titled and marketed, with explicit promises of adult masculine sexual arousal, and names like "Young and Sassy," or lines like "just as good as nudity, some say better." Yet this reliance on context was never acknowledged, and all judgments therefore purported to rely on the content alone of images. The mistake both judges and the press made was not about whether Knox was guilty or whether the Nather tapes were pornographic. Their mistake was a confusion between the logic they used and the logic they turned into law. If *Knox* had been decided overtly instead of covertly on the basis of how the Nather tapes were actually used, the verdict would have been the same, and freedom of speech could have remained completely unthreatened.

No sensible judge will be fooled by specious distinctions between the content of an image and its use. In the late spring of 1996, for example, Judge Guido Calabresi of Connecticut faced an appeal from Robert David Sirois, who had been convicted of sexually exploiting boys and transporting across state lines the pornographic images he had made of sex acts between the boys and another adult man. Sirois trotted out several arguments on his behalf, including the idea that his films and photographs should not be evidence against him because their content did not document exactly the "use" of which he was accused. Calabresi replied: "There is undoubtedly an active component to the notion of 'use.' But that component is fully satisfied for the purposes of the child pornography statute if a child is photographed in order to create pornography." Sirois argued that he had not crossed state lines only to create pornography. Calabresi retorted: "A person who transports children across state lines both to engage in sexual intercourse with them and to photograph that activity is no less a child pornographer simply because he is also a pedophile."[67]

Shifting child pornography law back to actions, where it began, would not protect the guilty, but it might protect the innocent. An emphasis on the uses rather than the interpretations of photographs could change the way cases are investigated and argued. Lawyers and judges could avoid the pitfalls of personal taste and return to solid laws of evidence. Returning the aim of the law to actions would certainly change some of the ways child pornography cases are initiated. One uninformed person's completely subjective interpretation of the sexual meanings of an image of a child's body should not be a legal basis for the investigation of people's private lives. Unfortunately, most Ameri-

can states have passed laws which mandate such dubious citizen judgments, by requiring photo processors to report images they believe might be lascivious. Photo processors work in a void that can only be filled by their own tastes and, now, with the assumption that all photographs of children's bodies are guilty until they are proved innocent. True, they can consider single frames in the context of contact sheets or a roll of film, but otherwise, they have no knowledge of the circumstances in which a photograph was taken. Yet they have been put in the position of state censors, able and even urged to set ruthless legal machines into motion. Those machines cost time and money.

The investigation of Jock Sturges, a San Francisco photographer of adolescent girls, reputedly cost taxpayers over a million dollars. The investigation led nowhere. On top of the FBI bill, the lab whose technician had reported Sturges lost almost $200,000 to protest pickets or boycotts and went out of business the next year.[68] In a climate of fear, any image of a child's body can seem dangerous to a lab. Following the Angeli case, the *Globe* newspaper surveyed photo processors throughout the Boston area. They all responded that they too would have turned in photographs of child nudity they deemed suspicious. What did they think was suspicious? Each had its own criteria. Janice Dee, a customer service official of Qualex, a Marlborough lab that processes more than 7 million photos a year, including for the Caldor's, Walgreens, Kmart, and BJ's Wholesale Club chains, said: "We'll print pictures of a baby in a bathtub. Anything else, even a three-year-old, is not an acceptable picture. That's not a normal thing to do." Sharon Howard, owner of Double Exposure in Gloucester, Massachusetts, would not print any photographs of nude children, not even bathtub or bearskin shots of infants and toddlers. Kathy Salerni, a technician at Perfecta Camera in Chelmsford, Massachusetts, said: "If I saw a nude child, I would call the police immediately."[69]

Child pornography law avoids the most basic cultural issues it inadvertently raises. The new scope of child pornography law has been triggered by ubiquitous media sexualization of children, yet the law persists in digging a gulf between the demonic and the sacred. We are thus allowed to ignore our own complicity in the changing image of childhood. We may not want to think about it, but perhaps children are just as sexualized by ordinary consumer culture as they are by pornography. It should give us pause that a child molester can be excited by the trappings of "normal" childhood as well as by child pornography. When the van belonging to Robert Black, serial child murderer, was searched, a camera was found, and so was a girl's dress and several

girls' bathing suits; when his apartment was searched, pornographic videos, books, and magazines were found, and so were more children's clothing.[70] Institutionalized child molesters told researchers studying them that "one of the most erotic stimuli they had encountered" was Coppertone's venerable suntan lotion ad illustrated with a picture of a dog pulling off a tanned girl's bathing suit from her pale bottom.[71]

Child pornography law deals with change by catering to fear of change. At the very least, United States law treats childhood extremely inconsistently. On the one hand, child pornography law is based on an assumption, and a defense, of absolute childhood innocence. On the other hand, most states are moving to abolish distinctions between adult and child by prosecuting and punishing child offenders according to the same laws as adult criminals. The ideal of childhood innocence is in its death throes. The ideal is not dead yet, but it cannot survive the media transformations of the 1980s and 1990s. Child pornography panic fixates us on images like Calvin Klein jeans ads or Coppertone ads that feed off what remains of Romantic childhood, marshalling the signs of traditional innocence one last time in order to fuel their modern spectacles of desirable children. The late twentieth century is a troublingly transitional time in the history of childhood, a time in which the old signs of childhood are no longer viable but new ones have yet to become credible. In the absence of known and acceptable alternatives, only the destruction of the old order appears evident.

Yet we are witnessing not only the end of one era of childhood, but also the beginning of another. Some people, I know, perceive any departure from the Romantic ideal of childhood as an intrinsically negative trend, to be fought against with every means, including legal. Many more people, I believe, will resist changes in the image of childhood only until they feel confident a new concept of childhood can protect children effectively. As long as changes in the image of childhood seem entirely exploitive, then of course they will be unacceptable. But it is not impossible for childhood to be constructively redefined. Not only could the image of childhood be reinvented. It is being reinvented.

Knowing Childhood

Anything that was invented once can be invented again. The image of childhood created in the eighteenth century has run its course, and is now being replaced by another way of picturing childhood. Many people have noticed how radically the image of childhood is changing, but this change is virtually always understood as a distortion or even perversion of a true, natural childhood. Such a negative interpretation depends, however, on a conviction that the childhood we already know is eternally and universally valid, a conviction disproved by the evidence of history. The eighteenth century did not suddenly discover real childhood; it invented a childhood consonant with new values. What happened in the eighteenth century is happening again, on the same order of magnitude. Just as the eighteenth-century invention of Romantic childhood caused anxiety, resistance, and also brilliant innovation in its time, so is the reinvention of childhood doing now.

Some of the most disconcerting visual objections to stereotypes of childhood innocence have come from the youth-oriented, high-tech world of rock music, in the form of pictures like Van Halen's *Balance* album cover with which I opened the second part of this book. As one might expect, the "alternative" rock movement has been especially vociferous. The single most influential alternative rock album, the group Nirvana's 1991 cult album *Nevermind*, which by 1997 had sold 6.5 million copies in the United States alone, placed on its cover the photograph of a noticeably naked baby boy swimming underwater after a dollar bill (ill. 1). Never too soon to chase money? Thrown overboard to entertain? Unfolded, the cassette version of *Nevermind*'s cover puts a photograph of group leader Kurt Cobain giving us the finger right next to the baby. Male groups use pictures of boys, while female groups – sometimes called riot grrl groups – show pictures of girls. Playing savagely on women's identification with dolls and with images of themselves as cute little girls, groups like Hole, Bikini Kill, and Babes in Toyland have all identified their music with juxtapositions between photographs of abused dolls, photographs of themselves as children, and very tough photographs of themselves as adults. For their 1992

*Fontanelle* album cover, for instance, Babes in Toyland chose a photograph of a naked doll tumbled crotch toward us, looking more like a waxen corpse than a toy, an image whose resonance is amplified by the album title: fontanelle – the vulnerably open spot in a newborn's skull. (Permission to reproduce refused by Warner Bros. Records Inc.) Riot grrl song lyrics follow suit. These are not lamentations, but denunciations.

The image of childhood innocence is now in jeopardy not just because it is being violated, but because it was seriously flawed all along. Always latent, occasionally surfacing, now the problems of Romantic childhood must be confronted. Innocence, as Nirvana reminds us, turns out to be highly susceptible to commercialization. The ideal of the child as object of adoration has turned all too easily into the concept of the child as object, and then into the marketing of the child as commodity. This problem, in turns, draws attention to the gender difficulty of Romantic innocence, one which riot grrls aggressively object to. In a society that insists on the dependence and passivity of adult women (and to some extent on their relative sexual innocence), it is very tempting to liken women to the children who have also been declared innocently and passively dependent, and who furthermore have been idealized. Once adult women are infantilized, it becomes plausible to flip the equation and consider infants to be like adult women. Women, though infantilized, remain sexually attractive to adult men. The female child, consequently, always runs a high risk of being sexualized in a system that combines the ideal of childhood innocence with an extreme imbalance of power between genders.

Rock music imagery, lastly, draws our attention to the problem of considering childhood as one undifferentiated age group. Teenagers, to whom rock music appeals strongly, do not like to be treated as children, but they are incapable of behaving like adults. Absolute distinctions between child and adult leave them stranded on a very uncomfortable boundary. How can children possibly become adults from one instant to the next? The English and American cultures which above all others have glorified the ideal of childhood innocence deal badly with adolescence. Critics and commentators wail when they see images like Larry Clark's 1994 movie *Kids*, horrified at scenes of teenage sex, stupefaction, and brutality. What they want to see is either innocent children or mature adults. Instead, they are faced with the worst of both worlds.

At this critical juncture in the history of childhood, the photography of Sally Mann was bound to catalyze debate. Like many of the pictures that have created a climate of extreme anxiety about the current state of childhood, a photograph by Mann such as her 1987 *Jessie at 5* sends

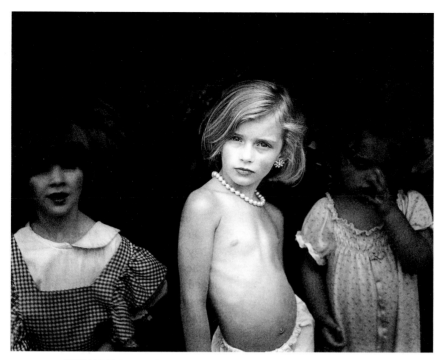

85  SALLY MANN Jessie at Five 1987

signs that used to convey two conflicting messages: childhood inno-
cence and adult sexuality. The central girl in Mann's photograph snakes
outward, flat torso naked, gaze unabashed, face made up with rouge
and lipstick, hair slinking, adorned with earrings and a pearl necklace.
*Jessie at 5* insists on the vivid presence of its central child by contrast-
ing her with girls on either side, both of them dressed in the traditional
clothing of childhood innocence, both receding into the background,
out of focus and oddly stiff, relics of an impossibly lost past like the
dolls in riot grrl imagery. Over and over, Sally Mann photographed
three children – two girls named in titles Jessie and Virginia, one boy
named Emmett – often naked, always intensely physical. Many of the
photographs contain allusions to, or evocations of, what might be inter-
preted as violence or suffering, as well as eroticism. Precisely because
everyone agrees that Mann is a superb technician and formalist, her
photographs have been perceived as estheticizations and eroticizations
of violence against children. But Mann's work wouldn't go away.
Unlike media flotsam and jetsam, Mann's work claimed to be art, to be
serious, to be permanent. Her work was sustained and consistent: hun-

dreds of impeccably crafted photographs of the three children produced over a dozen years, from about 1984 to 1996. Mann had a distinguished professional background, she had explored subjects other than children, she had the backing of a prestigious dealer, and collectors were willing to pay high prices for all her prints. She was reputed to earn as much as a half a million dollars out of every exhibition of her work, and, regardless of their opinions, the art critics couldn't stop talking about her.

What really shocked people was that Mann was the mother of the three children she photographed. Had she betrayed the most sacred of all trusts? Clearly Mann's children colluded in the making of her work. Intricately composed, perfectly lit, and shot with cumbersome equipment, the photographs were hardly family snapshots. I have seen some of Mann's snapshots of her children, and though they are not entirely unlike her professional work, and though her children include a few of her professional images in the albums they assemble for themselves (including *Jessie at 5*) with the snapshots she takes, the snapshots look categorically different, as if they belonged to the ordinary flux of things, while the professional moments escape into a stiller, more resonant world, one which is very much less personal. Moreover, as photography critic Shannah Ehrhart has shown, Mann repeatedly cites famous photographs, not only by Weston, but by others, notably Julia Margaret Cameron and Dorothea Lange.[1] The children had to have been willing, on some level. But on what level? The more they loved their mother, the more their mother loved them, the harder it could have been for the children not to want to be a part of their mother's work. Had she, consciously or unconsciously, exploited their family intimacy to create sensational images that would further her own career? Had she sold her children's bodies to cater to an abusive public, just as surely as any advertiser or sports agent, or even as any pornographer? Had the family been utterly vanquished by the market?

Those are the questions raised by Mann's work during the final agonies of Romantic childhood innocence. As long as the ideal of Romantic childhood lingers, as long as it seems viable, work like Mann's will violate that ideal. And her relationship to her children will also seem to be the violation of an ideal. If the ideal mother is a selfless guardian of the domestic sanctuary, then clearly Mann is no model mother. If.

New models of parenting are cropping up everywhere in the media, and they provide another context within which Mann's photographs can be understood. In these images, issues of childhood and of parenting are mingled, just as debates over Mann's photographs of her children have involved her maternity. Alternative father-figures can easily

be found, but it is the images of maternity which are the more strikingly new because it is the Madonna with which we have for so long associated childhood. The child has been pictured as it was seen by the ideal mother, in images designed for feminine audiences of maternal picture consumers.

Quite the opposite of the infantilized woman, the new mother asserts a decidedly adult experience. Mothers know more than they used to. They know about something more than maternity. Even advertisements, which deal cautiously with change, and then only in terms of idealizing images, are beginning to show mothers playing new roles. A 1993 ad for Tylenol children's pain medication, for instance, takes the hallowed image of the Madonna and Child, and layers a professional identity onto it. (Permission to reproduce refused by Johnson & Johnson Ltd.) A woman tenderly holds and caresses a near-naked baby, just like a traditional Madonna, but this Madonna wears a white lab coat, and a stethoscope hangs prominently around her neck. The ad directs our eye to a boxed center, free of text, which cordons off the faces and hands of mother and infant. Yet even in this lyrically maternal center we see a part of the doctor's scientific instrument. The ad's text begins: "When their own kids are sick, most pediatricians practice what they preach," while the smaller type text ratifies the doctor/mother's dual authority by citing both her parental instincts – "I look at his face. Hold him. He's mine." – and her medical experience, signed with her credentials: "Peggy L. DeFelice, M.D." Two previously incompatible roles are being conflated. At once loving mother and skilled professional, this woman cares for her child on new terms.

Innovative mother-images furthermore assert that maternity is compatible with an adult female sexual experience. Again, the fact that advertisements reiterate this message shows how acceptable it has become. A 1995 ad for Anne Klein II, a clothing brand, presents a complete ideal lifestyle in an eight-page fold-out spread. (Permission to reproduce refused by one of the models.) On the outside, the ad asks: "who says this woman isn't working?", in front of pictures showing women doing two things at once: jogging at the helm of a high-tech stroller, snacking with an open power book computer, etc. Inside the fold-out, over the caption – "Think about what feels good. About what's touched you lately." – run little photographs, two showing a woman hugging and kissing a toddler, and right next to those, two pictures of a woman ecstatically embracing a bare-chested man. According to this ad, a woman's adult sexual pleasure now belongs side by side with her maternal pleasure in her children's bodies, and both forms of pleasure

are integral components of a working life. The point is hardly to shock anyone, or if so, only pleasantly, because the point of the ad, being an ad, is to tap into positive feelings and elicit identification. Nor is this Anne Klein II ad at all unique, though it is unusually deft. On its 26 May 1997 cover, *People* magazine announced "The Sexy New Moms! Finally, Hollywood discovers a woman can be a mother *and* a hot number!"

Unlike the old Madonnas who adored their children with chaste reverence, new mother and father figures are intimately and vigorously involved in their children's physical existence. Just as they display their other adult experiences, so they revel in the experience of parenting. Perhaps the most refreshingly outrageous example has been the public persona of star Courtney Love. Lead singer of the riot grrl group Hole, wife, then widow, of Nirvana lead singer Kurt Cobain, more recently fashion and film personality, Courtney Love has cultivated an image whose shock value rests on contradictions of femininity. First she dressed like a hybrid between a toddler and a vampire. She wore plastic bow clips on the black roots of her bleached hair; "in some pictures," she said, "I come across as a fourteen-year-old battered rape victim."[2] Then she became pregnant and let rumors fly of heroin use, posing for *Vanity Fair* in 1992 in transparent grunge neglige over round abdomen. When her daughter Frances Bean Cobain was born later that year, she posed for *Rolling Stone's* Guzman feeding her baby a bottle in her arms, like a good mother, but clad only in a tiny black bikini bottom. She declared her love for her child and her belief in a kind of childhood innocence, but with surprising force. Asked by a *Rolling Stone* reporter to assess the year 1993, she replied: "And I'm a mother, and it's great. I don't care if that's a cliché. It really is great. [Interviewer: How has that changed you?] That's such a personal question. There's some kind of mother blood that just makes you want to buy firearms when you have a child. She's like this perfection, this utter purity that's uncorrupted by anything. And if somebody were to fuck with my child, I would not hesitate to kill them. I'll answer anything, but on every level that question operates, it's just too personal. It's too deep."[3]

Ever since, Love has refused to ratchet down her sexuality, her violence, her publicity, or her maternity. She insists not only on their coexistence, but on their union. For a 1995 *Vanity Fair* cover story, she posed in several guises, once as Venus (Love goddess) with attendant cupids. Was it Love or was it a *Vanity Fair* editor who also decided to include as a part of the article on Love a full-page photograph of her daughter? (Permission to reproduce withheld by Courtney Love and Herb Ritts.) Taken by Herb Ritts, the photograph is a lyrical late twenti-

eth-century revision of nineteenth-century innocence. This is the "utter purity," the "perfection" her mother sees in her: the figure still, central, and contained, a limpid play of light and dark, two bright lights shining in enormous eyes. Yet this innocence is also carnal, superficially because the child is naked, more fundamentally because the child confronts us with her being, and with her gaze. We see nothing but the figure, close and frontal, with the head spatially dominating the body. She is not a cute object. She is a beautiful and knowing person.

Both Sally Mann and Courtney Love turn their maternity into the vehicle of their desire. Their representations of maternity are suffused with desire, not desire in any single sexual sense, but in a much broader sense, including the need to flaunt the physical beauty of the children who are the flesh of their flesh, and the ambition to cast themselves simultaneously as mothers, as disturbingly creative artists, and as successful professionals. They do more than add a professionally independent dimension to traditional feminine identities; they completely undermine the entire opposition between professional and personal identities. They take the role that was supposed to be ineffable and make it material; they transform sentiment into passion; above all they replace self-denial with self-assertion. No wonder they are scary. It is frightening in one way when a woman claims that the feminine sexuality which society always thought was the subject of masculine desire should be hers to control. It is frightening in quite another way when a woman claims that what society deeply believes to be antithetical to desire could be the very subject of her desire. A woman who unleashes an artistic impulse on the subject of her maternity, who lets it go beyond the narrow limits of ideal Romantic innocence, is bound to offend.

Image theorists are sensing a change in the creative possibilities of maternity. The psychoanalytic theories, dominated by Sigmund Freud and Jacques Lacan, that have most persuasively articulated the role of gender in the constitution of identity, as well as the most basic impulses to representation, have described maternity as the antithesis of the symbolic (or enforced that antithesis, depending on your point of view). If, as these Freudian and Lacanian theories posit, the symbolic order requires a characteristically masculine, and desiring, critical distance from a characteristically feminine object of desire, then the almost symbiotic bonding between mother and child is inimical to the symbolic. Two of the most brilliant essays along these lines were written by French theorist Julia Kristeva. One of them, titled "Stabat Mater," contrasted a poetic first-person account of her own maternity, of her "incommensu-

rable, unlocateable" maternal body, with a rigorous analysis of the theme of maternity in Christian theology.[4] In another, "Motherhood According to Giovanni Bellini," Kristeva specifically designates the visual subject of the Madonna and Child as the point at which representation reaches its limits.[5] Visuality compounds the inexpressibility of maternity. Barthes's *Camera Lucida* takes much the same position, if only implicitly, by associating the maternal, represented by his own mother, with the least rational, least representational, "punctum" aspects of photography.

Another generation of critics, however, are working within Freudian and Lacanian psychoanalytic theory to find a creative position for the maternal. Diana Fuss takes the concept of identification, so essential to the problem of parenting, and rethinks it. Not that Fuss herself addresses the parent-child relationship, but what she has to say is pertinent to it. There is, arguably, no identification at once more intense and more vexed than the identification a parent feels with her or his child, perhaps especially so in the case of the mother, whose child begins biologically as a part of herself, and whom she often feeds as an infant with her own body. If, moreover, as Fuss suggests, identification reacts defensively against loss, then again, identification would be a crucial issue for parents, who must inevitably begin losing their children as soon as they are born. For Fuss, identification can be rethought as a potent mode of "self-recognition," but also self-alteration, at once self-absorbed and engaged with the outside world: "Identification is the detour through the other that defines a self. This detour through the other follows no predetermined path, nor does it travel outside history and culture. Identification names the entry of history and culture into the subject, a subject that must bear the traces of each and every encounter with the external world."[6]

Thinking more specifically about work by younger contemporary women visual artists, Ewa Lajer-Burcharth looks at the problem of their self-representation. Reworking concepts of both identification and narcissism, she suggests that these young artists are turning femininity in on itself, producing symbolic distance within the very subjects previously consigned to the inchoate pre-symbolic. For Lajer-Burcharth, the representation of one's own psychic or physical self is not necessarily simply a gratuitous act of narcissism, but may, on the contrary, pry open spaces for inquiry into the complexities of identity, and turn oneself into, as she puts it, a subject of desire. The closest look at oneself can be the most critical. The loss that motivates representation, Lajer-Burcharth argues, can be internal, not necessarily provoked by the loss

of something other or someone else, but experienced as a loss of what one is oneself, or was.[7] In a related but more utopian move, Bracha Lichtenberg Ettinger has gone so far as to argue that maternity provides the most useful model for an alternative to Freudian and Lacanian models of representation, a model that privileges identification and narcissism to break down oppositions between self and other, between symbolic and non-symbolic. Introducing the concept of the "matrixial gaze," she proposes the mother's relationship to the unborn child who is both herself and another as her creative paradigm.[8] Critic Jane Gallop analyzes photographs of herself as a mother taken by her partner Dick Blau, wittily and personally challenging Barthes's equation of the mother with the passive object of photography.[9]

Abstract as these approaches may seem, they speak to a widespread anxiety about parents who photograph their children intently. Have they compromised both their artistic and their parental responsibilities by merging two different roles? Do photographer-parents collapse what must be kept separate? Is there something oddly inward about an artis-tic project that takes one's own children as its subject, year after year? At its most acute, this fear is of incest, metaphoric or literal. Writing of the photographer Lee Miller and the father who photographed her nude in the 1920s as a young adult, one of her biographers writes: "But she may also have had a troubled relationship with him – while he was a direct source of strength and a powerful mentor, he became for a time a somewhat obsessed photographer of her, and she a compliant model. The closeness between them, especially when Lee was in her early twen-ties, may have bordered on an unhealthy intimacy."[10] Cultural critic Annette Michelson has argued that denials of child sexuality, accompa-nied by escalating suspicions of child abuse, now mount "a last-ditch defense of crumbling incest taboos."[11]

No one would lightly dismiss the threat of incest. Nevertheless, on the levels of both practice and theory, evidence suggests that incestuous implosion is not inevitable when parents photograph their children. Let me return to Sally Mann's work, which has been, implicitly or explicity, accused of narcissism or worse. The children in her photographs are erotically beautiful. But what does that mean? Anyone who already sees children incestuously or viciously will certainly see incest or vice in Mann's erotics. Nothing Mann can intend or do or say will prevent that. Not everyone, however, sees Mann's work alike.

Mann herself says her photographs are not about her children's sex-uality, but about "the grand themes: anger, love, death, sensuality, and beauty."[12] Of all the photographs of children I have worked with,

taught, or talked about, none have elicited a wider range of interpreta-tions than Mann's. In part this is because of the demands Mann's work makes on the eye; you have to look closely at her pictures to know what they represent; a quick glance or a grainy reproduction induces factual errors which in turn trigger wild projections. The fingers of the man in her *Last Light* (1990), for instance, are laid lightly on the side of a child's throat, but how many times have I been confidently told the child is being strangled? I have also been told the image is about trust and confidence, or about the fragility of life, about being sick, or show-ing off tattoos. As an art historian, I think it is a modern remake of the Madonna and Child image, with the mother now the artist, and the father the parent who cradles his child against their shared knowledge of what life has in store. As a parent, it seems to me the child is aching-ly beautiful, too precious not to dread losing – so quickly, the watch on the father's wrist and the child's pulse remind me.

Mann could be said to implode the world, compressing her dramas

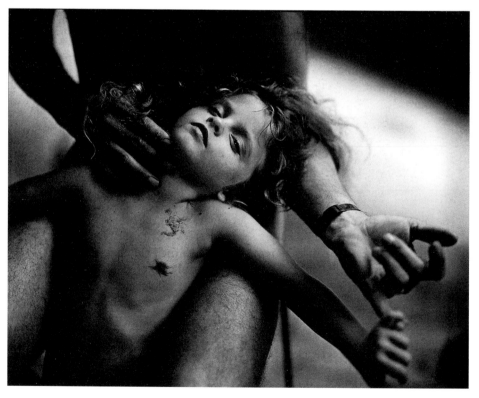

86  SALLY MANN Last Light 1990

into what she calls "Immediate Family." But the reactions to her work I have encountered, in private and in public, in the classroom and on the lecture circuit, go so far beyond the boundaries of Romantic childhood that it seems to me I am hardly witnessing implosion, but rather explosion. I have felt a large lecture hall in Philadelphia tremble with rage; I have heard the catharsis of parents; I have listened to the most detached formalist appreciation; I have been sought out by a well-meaning young woman desperate to convince me the photographs represented stages of satanic rituals; I have been whispered fear for the safety of beloved children; I have seen fierce joy and serene empathy. Small pictures don't get such big responses.

Mann's work is not easy to look at. Whether in confrontational or visionary modes, her images upset cherished conventions of idyllic childhood. A photograph like her *The New Mothers* (1989) drives cuteness into bankruptcy. Some right elements are there: the ruffled print dresses, the jolly dolls, the two sisters out together playing mommy. But

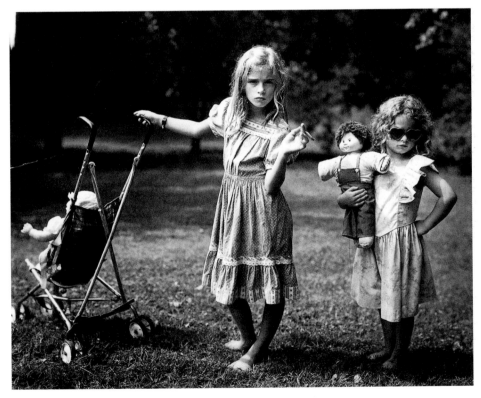

87  SALLY MANN The New Mothers 1989

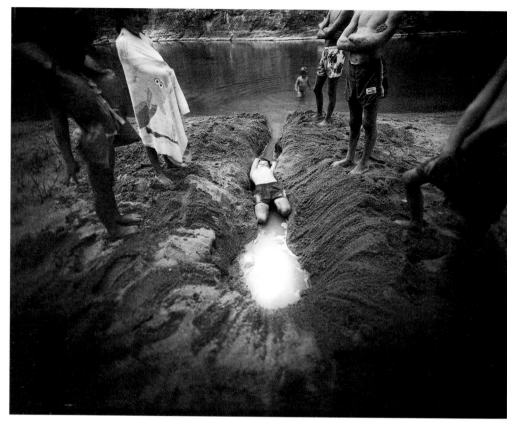

88 SALLY MANN The Ditch 1987

some wrong elements are there too: the cigarette, the Lolita heart-glasses, and above all the tough stances, turned to us in harsh sunlight. The pieces we hoped were seamless don't fit together. A maternal future does not emanate from these children's bodies. According to Mann, maternity is a role, complete with costume and props, and these girls aren't predestined by biology to play it sweetly. When Mann stops ripping at old fantasies of a naturally ideal innocence, she presents startlingly novel archetypes. In some primal sense, for instance, *The Ditch* (1987) is a birth image, not exactly a common theme in a western art tradition dominated by men. A boy, Mann's son, presses head first along a narrow channel in the sand, furrowing through the matter extending out from the photographer's, the mother's, position. At the end of the passage, the child will reach open water. Already he belongs to crisp light and defined forms, not to the mother's inchoate blur.

Anonymous figures loom on either side, silently waiting for the child who leaves the mother's place. The scene, however, is neither grandiose nor epic; it lodges the universal at the level of the ordinary incident.

Who said parenting or childhood was easy? I wouldn't want to implicate anyone else in the perversity that has been attributed to Mann's work, so I'll just speak for myself. Parenting has yanked me every which way. It has brought me joy, and also guilt. It has thrilled me, plagued me, divided me, angered me, shoved me grimly through exhaustion. It has also stirred me viscerally. My maternal experience has been a passion for my son's body. How many times have I stared at him adoringly, caressed him, kissed him, hugged him, inhaled his infant breath like the smell of life? I long for him when we are apart, I want to hold him, to walk always with his dimpled hand in mine. During the first years of his life I spent most of my time with him, caring for his body: feeding him, cleaning him, carrying him, rocking him to sleep – with love. Our relationship is driven from its origins by a primal erotic energy. I conceived, carried, and gave birth to my son with my body. Only a passion sprung from primal origins could drag me through the sleepless nights, the tantrums, the resentments, and the boredom. Like all passions, mine has its nastier sides: its aggression, narcissism, fears, madly exorcised nightmares of damage, and a perpetual mourning for the child who is always growing up, growing away from me.

As to my own childhood, my parents did their best to shelter me. They sent me to a Catholic nun's school, they didn't have a television in the house, and they subscribed me to English book clubs to supply me with a steady stream of charmingly antiquated reading. Yet I seem to remember death, sex, violence, political injustice, discipline, and religious fervor as being high on the list of my childish preoccupations. So much of it seems to be there in Mann's work: the exhibitionism, the turbulent fantasies, the disgust at adult platitudes and cowardice, the communion with mud, wind, sun and water – all of it inextricably mingled with the most mundane moments of family life. But what I see is not so much my own childhood, as memories being replayed before my eyes as my baby becomes a child, transfigured by the effulgently foolish conviction of his being the most beautiful and precious person on earth.

If personal experience seems too subjective, there are always statistics to fall back on. Who has not heard or read them? Even without the gruesome numbers of abused children, the facts of ordinary home life explode myths of domestic nuclear family security. About half of all mothers work outside the home. According to a *New York Times Magazine* "Portrait of the American Child, 1995," some 30% of households

with children were headed by a single parent, 26% by mothers, 4% by fathers; one in every six children was a stepchild; the number of children living in foster homes, group homes, or residential treatment centers had increased 77% since 1982; children spent an average of three hours a day with their parents, down 40% from 1960;[13] 40% of children aged 6 to 11 claimed to often prepare their own meals;[14] 1,200,000 children went from school to unsupervised homes in which there were guns.[15] Rounding out the statistics are more individualized revelations of family trouble, ranging from searing works of fiction like Dorothy Allison's 1992 novel *Bastard Out of Carolina*, which unsparingly recreates the rawest childhood experiences and most brutal abuses within family life, to the first-person accounts sociologically assembled by Arlie Russell Hochschild, telling ordinary stories we can all identify with of stresses and tensions within the family difficult enough to make the workplace seem more attractive than home.[16] Family life just isn't what it used to be – or what we thought it was – so how could childhood be?

Nor are Sally Mann's photographs the only ones to confound the limits of Romantic childhood and its innocent ideal. Hers have aroused the most acute controversy because they deal with exactly those aspects of the child's body that Romantic childhood denied. Mann's work flouts the sexual innocence that was at the core of the Romantic child ideal. Her photographs, however, also participate along with the work of many other excellent photographers in a widespread revision of childhood which is not at all exclusively about sexuality. Together, the work of these photographers expands the definition of childhood and parenting so irrevocably beyond the sentimental that another vision of childhood appears before our eyes. One of its principal differences from Romantic childhood is precisely that it refuses to treat the child's body only in terms of its sexuality, or lack thereof. Childhood now appears to be embodied in many ways.

In Nicholas Nixon's subtle 1990 photograph *Sam and Clementine*, for instance, the childhood he represents through his son and daughter is at least as mentally alert and self-assertive as it is sexual. A boy's leg commands the front of the picture's space, its scratched insect bites more immediately apparent than the penis we can only see if we peer. His sister provides the prone horizontal to his controlling vertical, yet she is the one whose looking dominates the picture. Her fixed stare at a small mirror contrasts with his anonymous physical presence, and also with the traditionally feminine toy music or jewelry box she ignores and which retreats into the corner shadows. Nixon insists we see sever-

89  NICHOLAS NIXON Sam and Clementine, Cleveland 1990

al unconventional aspects of childhood at once, all of them connected to and compared with each other.

What shall I call this late twentieth-century child? Not the New child, because Romantic children were already new, in the eighteenth century. Post-Romantic? Post-Modern? Too post-. How about the Knowing child, in honor of Henry James's 1887 novel *What Maisie Knew*, the story of a child who understood rather more about adults' motives and foibles than their belief in her innocence allowed them to guess. Maisie, a child of the Victorian age, was very much ahead of her time. In the late twentieth century, many children are Maisies. These Knowing children have bodies and passions of their own. They are also often aware of adult bodies and passions, whether as mimics or only witnesses.

Where do these new photographs of the Knowing child come from? In a sociological sense, they come from a change in ideas about both who makes art and who takes care of children. Until the last few decades, by and large, the women who took care of children had very few opportunities to make art. They faced barriers both psychological and institutional, not the least of them being the responsibility they felt for their children. Now many more women are entering artistic careers, and many more men are helping with the children. The mothers who once had few creative outlets can now express their experience, while

the fathers who deemed parenting a pretty dull subject are finding it more challenging than they had imagined. Many, if not most, of the more innovative and ambitious pictures of Knowing children are made by the adults who know them intimately, usually their parents. This is not only true among photographers who aim for an art audience, but also those who work commercially. Betsy Cameron photographs her own children; Gail Goodwin has used her child – "my daughter and pride and joy" – to model hundreds of her photographs, including the bare-headed child in *Dressed to Kill*.[17] The late designer Gianni Versace put the niece and nephew who became his heirs in some of his advertisements, on the labels of his children's perfume, and in the picture books promoting his vision of style.

New experience puts pressure on old habits. Regardless of how much time or what kind of time any one parent may spend with children, today's cultural climate asserts the importance of parenting and childhood. The "Coalition for America's Children" runs an ad nationally with a picture of president Bill Clinton, his wife, and their child captioned: "The toughest job in the world isn't being President. It's being a parent." Politicians both left and right claim childhood as their cause, campaigning for social programs or family values, all addressing their constituents more as parents than as anything else. Virtually no other political or social cause can rally such consensus. In a 1996 *New Yorker* column on the significance of the upcoming Washington D.C. march *Stand for Children*, activist Betty Friedan described the demise of an "old paradigm of 'identity politics'" and the arrival of a "new paradigm" whose "strongest unifying theme is a concern for children."[18]

In a historical sense, today's photographers have precedents. By 1971, a book as mainstream in its intentions as Time-Life's *Photographing Children* (one in a series designed to introduce a very general audience to popular photography subjects) diagnosed sclerosis in traditional childhood types, and heralded "A Newer – and More Honest – View."[19] The book, impersonally produced by a team of editors, only purported to provide useful ideas for fresh work, but in retrospect it looks prophetic. Though espousing no particular concept of childhood or photography, the editors came back repeatedly to the work of professionals who were also parents, and to unusually unconventional photographers. The book showcased, notably, Mary Ellen Mark, already doing outstanding documentary work, as well as Emmett Gowin, Arthur Tress, and Ralph Eugene Meatyard, whose photographs of their homes and families have deeply influenced, among others, Sally Mann and Wendy Ewald.[20] Meanwhile, Star Ockenga, not included by Time-

Life in its book, was also doing important work, particularly attentive to the image of mothers and daughters.[21]

Thematically, new work about children, which is always implicitly about children's relationships to the adults who photograph them, belongs within a much broader current photographic revision of family. As they call into question the norm of the dream nuclear family and the fictions of the family album, explorations of familial relationships bring to light what had been unseen. The work of Deborah Bright, Charlee Brodsky, Judy Gelles, Vince Leo, Philip-Lorca diCorcia, Andrea Modica, Bea Nettles, Virginia Nimarkoh, and Laurie Novak – to name only a few – suggests more flexible, inclusive, and incisive notions of family. An increasing number of photographers, among them Joanne Leonard, Larry Sultan and Hannah Wilke, have confronted the issues of ageing parents, while family portraits by photographers such as Carrie Mae Weems, Clarissa T. Sligh, and Albert Chong have drawn attention to how exclusively white the norms of family photography have been. All of these images occur at a crossroads between the family album photograph and professional photography. Of course there has been, and continues to be, extremely important work done on the subject of children in other media. Käthe Köllwitz's early twentieth-century graphic work set a standard for all work on the suffering of children in poverty and war, as did Mary Kelly's 1973-79 mixed media *Post-Partum Project* on the separation of mother from child. The cultural legacy of a distinctly photographic tradition, however, fed both by the family album snapshot and by commercial work, overwhelms all other media with its sheer magnitude.

Despite photography's realism, or the temptation to think that whatever is newer is more real, images of Knowing children are no intrinsically better or more honest (*pace* Time-Life) or more real than any other definition of childhood. They may correspond to genuinely felt perceptions, just as Romantic childhood did. But to the extent that they succeed as photographs, they remove themselves from the reality a camera recorded to become independent expressions of an idea. The Knowing idea belongs to our particular historical moment. Photography's fidelity is to the values of that particular moment, not to some "real" truth about children. The childhood in new photographs is not real, and I am not pretending it is ideal either. The vision we are being presented with is difficult in many ways, and confronts adults with many more challenges as well as many more pleasures than any idea of childhood has done before.

I have tried to indicate the scope and quality of a historical move-

90 NICHOLAS NIXON Clementine, Cambridge 1992

ment with only about two dozen photographs, some of which I discussed in previous sections, some of which follow. At the same time, I hoped to represent individual photographers' styles and strengths fairly. Needless to say, I dreamed of including many more examples, but the length and type of this book set their limits. So every choice was difficult. I do want to say at the outset that all of the photographers whose work I discuss have made photographs that celebrate their children's pure beauty, pictures every bit as Romantic as any made in the nineteenth century. My point, however, is that these photographers do what photographers did during Romantic childhood, and much more.

Photographers respond to Knowing children by looking at them very closely. Sometimes that closeness can be literally spatial and optical, a style perfected by Nicholas Nixon. In a photograph like his 1992 *Clementine*, the expressive possibilities of a high quality lens, a large negative, and impeccable printing are maximally exploited to produce an image which is at once tenderly intimate and objectively detached. Tendrils of hair glisten sinuously close, every fold of her thumb, every eyelash looms large, yet she pays no attention to us, finger distractedly touching her gently smiling lip. No matter how closely we look, the child remains in her own world. The more attentive the camera becomes, the more elusive the child. Unlike Romantic children who are

arranged and presented as a delightful spectacle to be enjoyed, Knowing children are neither available or controllable. They themselves are looking at an inner world of the imaginary, or at the adult world. Nancy Honey captures the duality of the child's and adult's gaze with the title

91  NANCY HONEY The Apple of My Eye, No. 12 1991

92  LORRAINE O'GRADY Worldly Princesses No.10 from *Miscegenated Family Album*

and the forms of *The Apple of My Eye* (1991). Like Nixon, Honey uses technique to express the look of the parent at a beloved child, the child so dearly seen, so closely identified with, that she is the "apple" of her mother's own "eye." But here the child turns away, her look drawn to a mirror – another mirror, apart from her parent's photograph – by the sight of herself in something added to her body but about her body, about the transformation of her body from child to adult: a brassiere. The parent's view, but not the child's, includes the brassiere's price tag. The parent's view is so close; the daughter's is more distant, and less defined. The child looks out and away, while the parent fixates on the immediate material present.

The world children look out toward is more divided and more diverse than the sheltered world of Romantic childhood. The issues Lorraine O'Grady presents us with in her 1980/94 *Miscegenated Family Album* used to be non-issues. *Worldly Princesses*, one diptych of the *Album*, visualizes the previously invisible. Not only is this child not white, but her racial identity involves both history and contemporary politics. A girl's photograph is paired with a photograph of the sculpted bust of an ancient Egyptian princess. Are they alike? Is the child's photograph idealized by its comparison with a great work of sculpture, or does the comparison help us see the sculpture more realistically? Is the child a cultural descendant of one of the world's most sophisticated ancient cultures? What does it mean to be "black"? Is the modern child, like the

Egyptian princess, the product of a racial hybridity so alien to the white tradition of the family photo album that it has to be called "miscegenated"? Acrid debates over Afrocentric history charge the questions with controversy. O'Grady lets the viewer make up her or his own mind, but does insist that the questions be considered.

Children and adults may not enjoy the world they share. What children know about adults is not always pleasant. Dick Blau confronts us with the bleaker possibilities. In his grim *Family Scene* (1978), the adults seem to have given up, hands over their eyes, slumped and weary. Two children plod on, both moving blindly in the same direction, their rhymed movements pushing against the adults' static bulk. The seam of the dock, right in the middle of the foreground, acts as a psychological barrier between the opposed forces of adult and child. This is the kind of scene no one would want in their family album, including Blau. His partner Jane Gallop puts her snapshots in the family albums instead. Blau has told me he and his family find it hard to look at some of his work, this photograph in particular.[22] Yet it expresses, in part by the ordinariness of its moment, in part by the extraordinariness of its insight, a side of family life that shapes

93  DICK BLAU Family Scene 1978

94 JUDITH BLACK Dylan and Erik 1979

family identities as surely as happy, smiling Kodak moments.

   If the adult world can be a less than ideal place for children, a world with children can seem less than ideal to adults. Judy Black admits parental ambivalence in *Dylan and Erik* (1979). The two boys (her two sons) are needy, and their needs fill the image oppressively. One boy shivers beneath his towel, the other looks imploringly up at his parent, hands clutched and mouth not so cutely open. They want every bit of their mother's attention, pulling it all down toward them, leaving no room for anything else in her field of vision. Though the children are seen from above, they loom large. Like Black, Sheila Metzner deals with a child's body in a less than ideal moment in *Stella on Fire* (1982; ill.46). The child, Metzner's daughter, is suffering from a fever. She looks sick, her small body stilled by pain rather than sprawled in sleep. Yet her mother can see the beauty in her suffering: the subtle color combination of black, pale green, red and yellow checks, the elegant simplicity of the curving composition. Metzner uses the trade-secret Fresson printing technique to soften her forms and suffuse her colors with a smoky haze, which conveys the trance of fever and also removes her subject from the here and now, a strategy opposite to Black's, which uses sharp focus to express the urgency of her children's demands. *Stella on Fire* transposes the Mexican folk tradition of the post-mortem portrait into a thoroughly urban and contemporary idiom. Like the post-mortem portrait, Metzner's photo-

graph represents an esthetic transcendence of painful physical reality.

The child who cannot exist perpetually in a perfect state of ideal innocence is vulnerable. Over and over, parental photographers return to their visions of danger, summoning terrors in order to expose them. Ever since his son Carl was born, Vance Gellert has been dealing photographically with the issues of vulnerability at the heart of a masculine American ideology of invulnerability. Gellert uses brightly colored large photographs of elaborately staged sets to express the artificial hyper-realism of an aggressive, macho imagery that bonds him to his son and also puts his son at risk. In one of his *CarlVision* series, this one made in 1990, polished torpedo forms aim toward an altar-like cube, on which are placed an animal skull and a nude male figurine holding an

95  VANCE GELLERT Untitled from the *CarlVision* series 1991

96 NICHOLAS NIXON Bebe and Clementine, Cambridge 1986

American flag. Behind the cube stands a headless nude male torso (Gellert himself) holding in front of him, as if an x-ray of a vital organ, a photograph of Carl's face, pinned by the cross-hairs of a rifle's sights. Is the male body like a torpedo or nakedly defenseless? Is the camera a rifle? Is the father offering his son as war fodder? Is the anonymous father all fathers?

To acknowledge childhood's fragility is to concede one's own weakness, if not mortality. Romantic childhood offered a vision of timeless edenic bliss as an escape from the vicissitudes of adult life. Today's photographs may contrast the pristine bodies of children with the worn bodies of adults, but the contrast is also a comparison. Nicholas Nixon zooms in on the arm and hand of his wife holding their infant daughter, revealing wrinkles, pores, and creases. The photograph captures the instant a long filament of drool falls from a drop on the baby's chin to the mother's arm. The drool stream is quintessentially innocent and, in its own way, immaculate: a thread of pure light. But drool is also mess, and it leads our eye straight down to a crooked line of spiky sutures. Children's beauty reminds adults of their wounds.

However sublimely perfect their bodies may look to adults, Knowing children like to alter their appearances. Far from pretending that children always belong to a state of original nature, new photographs recognize children's artifice. Of course some costumes, makeup, and

posing have been standard features of the Romantic child repertoire: the ones that look "cute" to adults. Now, in addition, we see erotic, scarier, and more defensive disguises. The fantasies that lurk in children's minds may not all be so benign. Nan Goldin accepts children's displays of themselves, perhaps with the most grit in *Io in Camouflage, New York* (1994; ill. 47). Out on the commercial street, Io isn't taking any chances. He is on the look-out in full camouflage, complete with face painting. Goldin grants him his purpose, finding a moment at which his colors do match his setting, yet also brings him forward, pulling him spatially away from his setting, contrasting his tense isolation with the confident contraposto and occupied bulk of the adult behind him. Io's child version of adult camouflage reminds me of Gertrude Stein's comment on national differences among World War I camouflage styles. "The idea was the same but as after all it was different nationalities who did it the difference was inevitable. The colour schemes were different, the designs were different, the way of placing them was different, it made plain the whole theory of art and its inevitability."[23] Io is doubly camouflaged. He lives his daily life in drag, adopting the protective surfaces of masculinity.

Photographer and subject together create the image of *Io in Camouflage*. Pictures like this suggest that Knowing children's views of themselves may not be so different from the views attentive and unconventional photographers have of them. Wendy Ewald's remarkable twenty-year photographic career lends credence to the possibility. Of course children, especially small children, can never truly represent themselves because they cannot manage advanced techniques of picture-making on their own. They have to work with limited motor-skills in situations and with tools controlled by adults. Nonetheless, Wendy Ewald realized that simple cameras could allow children an unrivalled degree of self-expression. So for the last twenty years she has organized a series of projects, lasting one or two years each, in which she goes into a community (usually underprivileged), teaches children how to use photographic equipment, encourages them to picture what matters most to them about themselves, exhibits the work in the children's communities, and then later, selecting among the products of all the projects, shows groups of pictures in art galleries and museums, some of the photographs signed by the children, some taken and signed by herself. There is nothing more brutal, carnal, tragic, or strange about any of the most controversial new photographs of children taken by adults than there is about the photographs children make of themselves under Ewald's aegis.

Ewald began one program in Durham, North Carolina in 1989, hoping to help children deal with issues of racial segregation in their public schools. In 1994, she and fellow teachers asked African-American and white students to pose as their racial "self," draw on the large-format photographic negatives to reinforce their image, and then switch racial identities. Black marker lines printed white. As Ewald put it: "negative and positive and black and white took on a meaning that was both conceptual and physical."[24] Gregory Blake takes Io's camouflage strategy to extremes in his self-image titled *White Self* (1994). In Blake's case, the result was ferocious, and very much altered by his own hand. Dense force fields of line collide over almost the entire surface of his *White Self*, masking everything but his hands, mouth, and eyes. He stands like a fighter on the alert, one fist clenched, ready to strike, or to redirect the energy around him.

Many of the children Ewald works with manipulate their medium in highly sophisticated ways. Freddy Childers inscribes a photograph within his photograph. In *Self-Portrait with my Biggest Brother, Everett* (1976), Childers creates a classic image of loss and mourning. His background silhouettes him starkly, and against his black form he holds a light photograph of his dead brother, a photograph whose stereotyped smiling expression renders Freddy's sorrowful face, directly above, almost unbearable. The image as a whole taps photography's uncanny power to make absence present.

97 FREDDY CHILDERS Self-Portrait with my Biggest Brother, Everett 1976

98  GREGORY BLAKE White Self 1994

99 DENISE DIXON Phillip and Jamie are Creatures from Outer Space in their Spaceship 1979

According to Ewald's results, children's fantasies are released by photography's potential, not fettered by its realism. One of my personal favorites is Denise Dixon's *Phillip and Jamie Are Creatures from Outer Space in their Spaceship* (1979). I find the image at once hallucinatory and hilarious, a hommage to identical twins' eerie replication, as well as a cunning domestication of the grotesque. When Ewald worked in Mexico and in India, children rendered folk tales and religious beliefs with their photographs. Show me your dreams, Ewald said to them.

No camera automatically allows a child access to identity or self-affirmation. The children Ewald teaches have to learn to use mechanical equipment, but also to use their imaginations. Seeing through the camera lens requires a heightened vision in every sense of that vision, a theme Ewald returns to again and again in her photographs of her students. In *Two Girls Learning to Use a Camera* (1988), only one child actually has a camera; the other covers an eye with a hand. Blindness brings insight.

Even supposing, though, that new photographs of Knowing children are powerful, or beautiful, or true to a major contemporary experience, even to children's own experience, the problem of children's right to

privacy still remains. The photographer might be a great photographer, and her or his ambitions could still conflict with a parent's responsibility to protect their children from intrusion, exploitation, painful memories, or just plain embarassment. Any photographer with any sense of decency could be expected to guarantee all child models similar rights, including protection from their own self-revelations. The issue cannot be underestimated. None of the photographers of children with whom I have spoken or corresponded do. All of them let children make some kinds of decisions about which photographs they will exhibit, publish, or sell. More often than not, the power they allow children is not one of consultation, but of absolute veto. Nicholas Nixon, for instance, warned me in advance when I first contacted him about the possibility of an exhibition that he would lend nothing without the consent of his children. None of the photographers I have been in contact with take photographs of children after the children have indicated they no longer

100 WENDY EWALD Two Girls Learning to Use a Camera 1988

wish to be photographed. Some of them have not photographed an older child for years. Sally Mann stopped photographing her son long before her daughters.

Growing up, and out from under, a famous childhood persona may never be easy, especially if that persona was created by an exceptionally gifted and successful parent. The more extensive the parent's project, the more focused and inventive the attention, the graver the problem. Long-term evidence suggests, however, that it is no harder than usual to escape a parent's work when that work is photographic, even when the photographs reveal the child's body. The most disastrous examples of children tormented by the legacies of their parents' creations are the ones you would least expect. Christopher Robin, the charming hero of the Winnie-the-Pooh stories, became completely estranged from his father A.A. Milne. The son for whom Kenneth Grahame wrote the whimsical *Wind in the Willows* committed suicide, as did two of the boys for whom their surrogate father J. M. Barrie wrote the classic *Peter Pan*.[25] Whereas Alice Liddell, whose photographs by Lewis Carroll are now viewed with such suspicion, apparently grew up without problems, posed again for a great photographer – this time Julia Margaret Cameron – married, raised children, and to the end of her long life contributed genially to the cult of *Alice in Wonderland*. Neil Weston, the subject of his father Edward's great 1925 nudes, didn't even mention the nudes in his recollections of his father's work for a posthumous documentary movie, though he said he disliked sitting for portraits, and missed his father terribly when he was not at home.[26] A portfolio of the *Neil* nudes was printed at the end of Edward Weston's life by Neil's brothers Brett and Cole. Neil built his father a house. All four Weston brothers remained close to their father his whole life. Asked when he was eighteen about the extremely controversial photograph Mapplethorpe had taken of him as a four- or five-year-old nude, Jesse McBride replied: "Now when I look at the photograph I think it's a really beautiful picture. I think back to when I was so young and innocent. I look particularly angelic."[27]

Everything seems to depend on a family's circumstances. One of Dorothea Lange's sons was angered by a photograph she took of his arm and hand holding a bouquet of daisies. The child had approached her with the gift; his mother's first reaction was to take a photograph;[28] behind this incident were years of Lange's frustration with undervalued and heavy domestic responsibilities. A bunch of flowers can cause more pain than a naked body. A delightful sprite from Neverland can be more oppressive than an unflattering scene of conflict. Responsibility to a

child whom one photographs, or represents in any way, requires above all a sensitive response to the child's individual personality and needs, as well as to an entire family's dynamics. A climate of hostility to a type of image, nudes for instance, would of course have to be considered, but every family has a right to teach its children to deal with public opinion according to its own values. The issue of a photographer's responsibility to her or his child model is tremendously important, but the issue is responsibility to the individual child and his or her circumstances, not to interpretations of photographs.

The problem has so far been posed in terms of public and private domains. These categories, however, may do more to exacerbate the problem than to explain it. Protecting a child's rights by calling them rights to privacy assumes that a child is best protected by being sheltered within a realm called private, which in modern western culture has meant the family. What is called the public – meaning primarily the state, other collective institutions, and the capitalist market – is then cast as an inherently treacherous zone in which the child's identity always risks abuse. As we have seen, this allocation of childhood to the private family is a distinctly modern phenomenon driven by the same social and cultural forces that produced the concepts and images of Romantic childhood. I would propose that the end of Romantic childhood entails the end to the utility of thinking about childhood in terms of rigidly opposed private and public values.

Generally, the argument in favor of placing childhood within a private family domain is protection. In the best of all possible Romantic worlds, the family cordons off childhood from the rigors and abuses of public adult life. Mother and father act as guardians. Transposed into the more particular subject of this book, which is pictures, this argument presents the image of Romantic childhood innocence as a protective device, a system of images that defends children categorically. The logic of the system protects children against sexuality on the grounds that they are asexual, against violence because they are weak, against deceit because they are guileless, against knowledge because they are innocent.

Has this logic really worked so perfectly? Have children really been so well protected by the privacy of the domestic family? Apparently not. The family seems to be a site of psychological conflicts as dangerous as any other. Moreover, the very large majority of sexual child abuse takes place within the family. And according to Nancy Hutchings, in a book intended to guide social workers: "The available official statistics do indicate that the family is perhaps society's most violent insti-

tution. Americans are more likely to be murdered in their homes by members of their families than anywhere else. It is also estimated that 2,000 to 5,000 children are killed each year by their parents, although these figures probably underestimate the true incidence of child mortality rates, as many cases are labelled 'accidents' rather than homicides."[29]

Steering back again to the ways in which the general issue plays itself out in pictures, the history of the imagery of childhood teaches in its own vivid mode how high the price has been for the protection of domestic privacy. The price has been high for women. Maternity has been idealized at the expense of its power. Women artists were allowed and even encouraged to devote themselves to the subject of maternity and childhood, but only on the condition that the subject become narrowly defined at best, sentimental at worst. And the price has been high for children. Consigned to forms of art treated as minor, relegated to artists refused access to prestigious careers, childhood was made to look charmingly innocent – and also trivial, passive, and exploitable.

The opposite of protection is of course unacceptable. The obvious alternative to protection is no protection. New images of childhood, however, argue for a less simple alternative. Photographs of the sort this chapter has been showing, photographs most often taken within families, are as much about celebration, admiration, and passionate attachment as they are about difficulty, trouble, and tension. They deny that a recognition of children's bodies and emotions is incompatible with the protection of children. They show how adults can value children for what they are instead of for what they are not. There was always a negative current in Romantic insistence on innocence, a need to define children in terms of what adults were not: not sexual, not vicious, not ugly, not conscious, not damaged. It might be a healthy change to substitute positive for negative, tolerance for denial. Only one form of innocence is needed to justify adult society's protection of children – innocence of adult society. We can be absolutely sure of one thing: children are not responsible for the society into which they are born. Just because children whine and grump and throw themselves on the ground does not mean that adults are justified in doing the same. Just because children might be sexual doesn't mean they can deal with the ways in which adults conduct themselves sexually. Just because children may be violent does not mean they do not deserve to be defended against adult violence.

The photographs now inventing childhood again, despite coming out of close personal relationships and intimate experiences, are emotional-

ly ambitious, free-ranging in their moods, intelligent, beautifully composed, and finely crafted. Photograph by photograph, some are major creative works. As a movement, they represent one of the decisive cultural changes of our time. If only for those reasons, they mount a solid argument in favor of childhood as a great human subject. Like all great subjects, it is bound to have its dark and turbulent side. Why, then, should we be surprised that childhood has the power to threaten as well as to delight, to repel as well as to rivet? Pictures of childhood plead eloquently through their intrinsic quality for the devotion of our personal energies and our social resources to what they represent. Art asks us on its own terms to take our children seriously.

# Notes and Sources

**Part 1: Introduction**

*Notes to pages 15-21*

1. David Ryckaert III, *The Five Senses*, c.1650. Oil on wood, 59 x 82 cm (23.2 x 32.3 in.) Inv. 1888-6. Musée d'Art et d'Histoire de Genève.

2. Edward Snow, *Inside Breughel: The Play of Images in Children's Games*, New York, Farrar, Strauss and Giroux, 1997.

3. Pietro Aretino, *Lettere sull'arte*, ed. 1957, I, p. 217.

4. See Luba Freedman, *Titian's Portraits through Aretino's Lens*, University Park, PA, Pennsylvania State Press, 1995, p. 27; Rona Goffen, "Sex, Space and Social History in Titian's Venus of Urbino," in *Titian's Venus of Urbino*, Rona Goffen, ed., Cambridge, Cambridge University Press, 1997, pp. 63-90.

**Part 1: Chapter One**

*Notes to pages 22-30*

1. For an excellent, thorough and well-illustrated study of the entire movement, see James Christen Steward, *The New Child. British Art and the Origins of Modern Childhood, 1730-1830*, University Art Museum and Pacific Film Archive, University of California, Berkeley, 1995.

2. Cited in Martin Postle, *Sir Joshua Reynolds: The Subject Pictures*, Cambridge, Cambridge University Press, 1995, p. 3.

3. Cited in Frederic G. Stephens, *English Children as Painted by Sir Joshua Reynolds*, London, Remington, 1884, p. 71.

4. Patricia Crown, "Portraits and Fancy Pictures by Gainsborough and Reynolds: Contrasting Images of Childhood," *British Journal for Eighteenth-Century Studies*, vol. 7, no. 2 (Autumn 1984), pp. 159-167.

5. Robert R. Wark. "Gainsborough's 'The Blue Boy,'" *Ten British Pictures, 1740-1840*, San Marino, CA, The Huntington Library, 1971.

6. For an excellent summary of historians' positions and of eighteenth-century attitudes to children, see Steward, "The Age of Innocence," in *The New Child*, pp. 81-84.

7. Jean-Jacques Rousseau, *Emile or On Education* [1762], tr. Allan Bloom, New York, Basic Books, 1979, p. 33.

8. Deborah Cherry and Jennifer Harris, "Eighteenth-Century Portraiture and the Seventeenth-Century Past: Gainsborough and Van Dyck," *Art History*, vol. 5, no. 3 (Sept. 1982), pp. 287-309.

9. Nicholas Penny, ed., *Reynolds*, exhibition catalogue, New York, Abrams, 1986, p. 319.

10. Peter Thornton and Helen Dorey, *Sir John Soane: The Architect as Collector, 1753-1837*, New York, Abrams, 1992, p. 61, catalogue entry 57.

1. Robert Rosenblum has written extremely well on the German Romantic child tradition in *The Romantic Child from Runge to Sendak*, London, Thames and Hudson, 1988.

2. Suzanne Muchnic, "San Marino. X-Ray Visions," *ARTnews* (Oct. 1995), p. 51.

3. Alexander Hesler, *Three Pets*, c.1851. Crystalotype from original daguerreotype in *Photographic and Fine Arts Journal*, April 1854. International Museum of Photography at George Eastman House, Rochester, New York.

4. Susan Casteras, "Excluding Women: The Cult of the Male Genius in Victorian Painting," in Linda M. Shires, ed., *Rewriting the Victorians: Theory, History, and the Politics of Gender*, New York, Routledge, 1992.

5. David Lubin, "Guys and Dolls: Framing Femininity in Post-Civil War America," in *Picturing a Nation: Art and Social Change in Nineteenth-Century America*, New Haven, Yale University Press, 1994, pp. 204-271.

6. Marcia Pointon, "The State of a Child," in *Hanging the Head; Portraiture and Social Formation in Eighteenth-Century England*, New Haven and London, Yale University Press, 1993, pp. 177-226.

7. James R. Kincaid, *Child-Loving: The Erotic Child and Victorian Culture*, New York and London, Routledge, 1992.

8. James R. Kincaid, "Producing Erotic Children," in Diana Fuss, ed., *Human All Too Human*, New York and London, Routledge, 1996, p. 211.

9. David Alan Brown, *Raphael in America*, Washington, DC, National Gallery of Art, 1983.

10. F.-A. Gruyer, *Les vierges de Raphael et l'iconographie de la vierge*, 3 vols, Paris, Renouard, 1866, p. 640: "Raphael est, en effet, par excellence le peintre de la Vierge, et la Vierge est pour l'art la plus sainte incaranation de la beauté."

11. Quoted in Brown, *Raphael in America*, p. 27.

12. Carol Duncan has shown extremely well how this worked in late eighteenth-century French images of maternity: "Happy Mothers and Other New Ideas in Eighteenth-Century French Art," in Norma Broude and Mary Garrard, eds, *Feminism and Art History: Questioning the Litany*, New York, Harper & Row, 1982.

13. Brown, *Raphael in America*.

14. Christina Rossetti, "A Christmas Carol," 1875, in Margaret Randolph Higonnet, ed., *British Women Poets of the 19th Century*, New York, Penguin, 1996, p. 384.

15. Lawrence Alma-Tadema (1836-1912), *An Earthly Paradise*, 1891. Oil on canvas, 86.4 x 165.1 cm. Private Collection.

16. Henry James, *The American* [1876-7], London, Penguin, 1981, pp. 33-38.

17. Brown, *Raphael in America*, p. 27.

18. Based on a pun between "Angles" and "Angels," attributed to St. Gregory the Great by the Venerable Bede's *The Ecclesiastical History of the English Nation*. Cited in Frances Diamond and Roger Taylor, eds, *Crown and Camera. The Royal Family and Photography 1842-1910*, London, Penguin Books, 1987, p. 135.

19. Brown, *Raphael in America*, p. 27.

20. Michel de Certeau, *L'invention du quotidien. 1. Arts de faire* [1980], Paris, Gallimard, 1990.

21. Rollin Van N. Hadley, ed., *The Letters of Bernard Berenson and Isabella Stewart Gardner, 1887-1924*, Boston, Northeastern University Press, 1977, p. 365.

22. Penny, *Reynolds*, p. 35.

23. Penny, *Reynolds*, p. 36n.

24. Pointon, *Hanging the Head*, p. 220.

25. Wark, *Ten British Paintings*, pp. 38-41.

26. Phyllis Bixler, *Frances Hodgson Burnett*, Boston, Twayne, 1984, pp. 50-55.

27. Emily Baker Smalle, "Willie Lee's Thanksgiving," *The Pansy*, vol. 16, no. 1 (3 Nov. 1888), p. 2.

28. Pointon, *Hanging the Head*, p. 220.

**Part 1: Chapter Three**
*Notes to pages 50-71*

1. A. L. Baldry, *Sir John Everett Millais. His Art and Influence*, London, 1898; cited in Pointon, *Hanging the Head*, p. 220.

2. *Millais*, exhibition catalogue, Liverpool and London, Walker Art Gallery and Royal Academy, 1967, p. 59. Laurel Bradley, "Millais's 'Bubbles' and the problem of Artistic Advertising," in Susan Casteras and Alicia Craig Faxon, eds, *Pre-Rapahelite Art in its European Context*, Cranbury, NJ, London and Mississauga, Ontario, Associated University Presses, 1994, pp 193-209

3. Rodney Engen, "Kate Greenaway and Mother Goose," in *Kate Greenaway's Mother Goose or Old Nursery Rhymes*, New York, Abrams, 1988, pp. 9-10.

4. Engen, "Greenaway," p. 10.

5. Susan E. Meyer, "Greenaway," in *A Treasury of the Great Children's Book Illustrators*, New York, Abradale Press, 1983, p. 111.

6. *Ibid.*

7. Engen, "Greenaway," p. 10.

8. Cited in Meyer, "Greenaway," p. 117.

9. *Ibid.*, pp. 112-113.

10. M. H. Spielmann and G.S. Layard, *The Life and Work of Kate Greenaway* [1905], London, Bracken Books, 1986, preface, np.

11. *Ibid.*, p. 2

12. Engen, "Greenaway," pp. 13, 14, 21.

13. Rowland Elzea and Iris Snyder, *The American Illustration Collections of the Delaware Museum*, Wilmington, Delaware Art Museum, 1991, p. 11.

14. Regina Armstrong, "Representative American Women Illustrators: The Child Interpreters," *The Critic*, vol. 36, no. 5 (May 1900), p. 418.

15. See Alice Barton Brown, *Alice Barber Stephens, A Pioneer Woman Illustrator*, Chadds Ford, PA, Brandywine River Museum, 1984.

16. Cited in Bertha Mahony and Elinor Whitney, *Contemporary Illustrators of Children's Books*, Boston, 1930, rep. Detroit, 1978, pp. 70-71.

17. *Ibid.*, p. 71.

18. Clara Erskine Clement, *Women in the Fine Arts*, Boston and New York, Houghton, Mifflin & Co., 1905, p. 324.

19. Janis Connor and Joel Rosenkrantz, *Rediscoveries in American Sculpture: Studio Works, 1893-1899*. Austin, TX, University

of Texas Press, 1989, pp. 161-199.

20. Arthur Hoeber, "A New Note in American Sculpture: Statuettes by Bessie Potter," *Century Magazine*, vol. 54 (1897), p. 735.

21. Cited in Connor and Rosencrantz, *Rediscoveries*, p. 165.

22. Richard J. Boyle, "Connection with a Place: The Collection of the Brandywine River Museum," *Brandywine River Museum Catalogue of the Collection, 1969-1989*, Chadds Ford, PA, Brandywine Conservancy, 1991, p. 15.

23. Harrison S. Morris, "Jessie Willcox Smith," *The Book Buyer*, vol. xxiv, no. 3 (Apr. 1902), p. 202.

24. James J. Best, *American Popular Illustration. A Reference Guide*, Westport, CT, Greenwood Press, 1984, p. 5.

25. Elzea and Snyder, *American Illustration*, pp. 8-9.

26. Boyle, "Connection," pp. 16-17, fn. 16; Elzea and Snyder, 1991, *American Illustration*, p. 165.

27. Edward James, Janet Wilson James and Paul Boyer, eds, *Notable American Women, 1607-1950*, vol. 3, Cambridge, MA, Belknap Press of Harvard University Press, 1971, p. 316.

28. 1899 Ivory Soap advertisement.

29. According to a close friend of Smith's, Edith Emerson; cited in Ann Percy, *Philadelphia: Three Centuries of Art*, exhibition catalogue, Philadelphia Museum of American Art, 1973, p. 505.

30. Ethel Tait McKenzie, "Jessie Willcox Smith, 1863-1935," in Gertrude Biddle and Sarah Lowrie, eds, *Notable Women of Pennsylvania*, Philadelphia, PA, 1942, pp. 279-80.

31. Anon, "Mother-Love in Jessie Willcox Smith's Art," *Current Literature*, vol. 45, no. 6 (Dec. 1908), p. 635.

32. Caption to "Jessie Willcox Smith," *Good Housekeeping* (Oct. 1917), p. 25.

33. Anon, "Mother-Love," pp. 24-25, 190; Mahony and Whitney, *Contemporary Illustrators*, pp. 68-69.

34. Anon, "Mother-Love," pp. 190, 193.

35. *Ibid.*, pp. 640-41. Parts of this article are lifted from Sidney Allan [Sadakichi Hartmann], "Children As They Are Pictured," *Cosmopolitan*, vol. xliii, no. 3 (July 1907), pp. 235-247.

36. Edith Emerson, "The Age of Innocence. Portraits by Jessie Willcox Smith," *The American Magazine of Art*, vol. xvi, no. 7 (July 1925), pp. 345-47.

37. Catherine Connell Stryker, *The Studios at Cogslea*, Wilmington, Delaware Art Museum, 1976, p. 4.

38. Cecilia Beaux, *Ernesta (Child with Nurse)*, 1894. Oil on canvas, 50 $\frac{1}{2}$ x 38 $\frac{1}{8}$ in (128.3 x 96.8 cm), Metropolitan Museum of Art, New York.

39. See Stryker, *Studios at Cogslea*; Patt Likos, "The Ladies of the Red Rose," *The Feminist Art Journal*, vol. 5, no. 3 (Fall 1976), pp. 11-15; Charlotte Herzog, "A Rose By Any Other Name: Violet Oakley, Jessie Wilcox [sic] Smith, and Elizabeth Shippen Green," *Woman's Art Journal* (Fall 1993/Winter 1994), pp. 11-16.

40. For instance Regina Armstrong, "Representative American Women Illustrators: The Decorative Workers," *The Critic*, vol. 36, no. 6 (June 1900), pp. 520-29; Mary Tracy Earle, "The Red Rose," *The Lamp*, vol. xxvi, no. 4 (May

1903), pp. 275-284; Jessie Trimble, "Succeeding in Art," *New Idea Women's Magazine*, vol. xiv, no. 4 (Oct. 1906), pp. 12-15.

41. See Rowland Elzea and Elizabeth H. Hawkes, eds, *A Small School of Art: The Students of Howard Pyle*, Wilmington, Delaware Art Museum, 1980.

42. James J. Best, "The Brandywine School and Magazine Illustration: *Harper's, Scribner's,* and *Century*, 1906-1910," *Journal of American Culture*, vol. 3, no. 1 (Spring 1980), pp. 128-144.

43. While Pyle was still alive, a critic wrote: "It is said, however, that although some of Mr. Pyle's best-known pupils are women, he has no very strong faith in the permanent artistic ambitions of the feminine sex, and rarely encourages women to study with him. He is merely another man who believes that the average woman with ambitions loses them when she marries." Jessie Trimble, "The Founder of an American School of Art," *The Outlook*, 85 (3 Feb. 1907), p. 455.

44. Cited in Anne E. Mayer, "Introduction," *Women Artists in the Howard Pyle Tradition*, Chadds Ford, PA, Brandywine River Museum, 1975, np.

45. Joe Hyams, *Bogart & Bacall: A Love Story*, New York, David McKay, 1975, p. 4.

46. Armstrong, "The Child Interpreters," p. 420.

47. Helen Earle, *Biographical Sketches of American Artists*, Lansing, MI, Michigan State Library, 1912.

48. Victor J.W. Christie, *Bessie Pease Gutmann: Her Life and Works*, Radnor, PA, Wallace-Homestead Book Company, 1990, pp. 70-72.

49. Elizabeth North, "Women Illustrators of Child Life," *Outlook*, vol. 78, no. 5 (1 Oct. 1904), p. 273.

50. Sidney Allan, "Children as They are Pictured," *Cosmopolitan Magazine* (July 1907), p. 235.

51. David Wootton and Julia Cornelissen, *The Illustrators: The British Art of Illustration 1800-1990*, London, Chris Beetles Ltd, 1991, Attwell entry.

52. *Ibid.*, Tarrant entry.

53. Trimble, "The Founder of an American School of Art," pp. 453, 455.

54. For a delightful compendium of advertisement babies, see Alice L. Muncaster, Ellen Sawyer and Ken Kapson, *The Baby Made Me Buy It. A Treasury of Babies Who Sold Yesterday's Products*, New York, Crown Publishers, 1991.

**Part 1: Chapter Four**
*Notes to pages 72-86*

1. Cited in Sidney Allan, "Children as They are Pictured," *Cosmopolitan Magazine* (July 1907), p. 247.

2. *Ibid.*, p. 242.

3. In Douglas Collins, *Photographed by Bachrach: 125 Years of American Portraiture*, New York, Rizzoli, 1992, p. 110.

4. Andra Miller, "The Serene, Sunlit Summer of Childhood," *Confetti*, vol. 4, no. 5, p. 42; Priscilla Dunhill, "Photographer Betsy Cameron: Her Own Garden of Eden," *Victoria*, vol. 7, no. 5 (May 1993), p. 70.

5. Dunhill, "Betsy Cameron," p. 68.

6. Dunhill, "Betsy Cameron" and Miller, "Summer of Childhood."

7. "Baby Sitters," *People* (30 Sept. 1996), p. 119.

8. Sue Swanezy, Interview with Anne Geddes, *Family Photo* (1996), pp. 28-31, 72.

9. Nora Isaacs, "Monitor: Genesis; Geddes Gardening Tips," *American Photo*, vol.7, (Sept./Oct. 1996), p. 32.

10. Especially Kids press release, 1997.

**Part 1: Chapter Five**
*Notes to pages 87-103*

1. Steven Maklansky, "Photography by Numbers: Five Years of New Acquisitions," *New Orleans Museum of Art Bulletin*, 1995, p. 14.

2. Lydia Wolfman, *1991-1992 Wolfman Report on the Photographic and Imaging Industry in the United States*, New York, Hachette, 1992, pp. 27, 34, 42.

3. *Ibid.*, p. 18.

4. Mihaly Csikszentmihalyi and Eugene Rochberg-Halton, *The Meaning of Things; Domestic Symbols and the Self*, Cambridge, Cambridge University Press, 1981, pp. 55-69.

5. 20th Century Plastics, Brea, CA, 1996.

6. Eastman Kodak Company, 1995.

7. *Ibid.*

8. Susan Sontag, *On Photography*, New York, Farrar, Strauss & Giroux, 1977.

9. Anne Cassidy, "Raising All Girls," *Working Mother* (Mar. 1995), p. 34.

10. Bernice Kanner, "Baby, It's You," *New York,* vol. 19, no. 14 (7 Apr. 1986), p. 27.

11. P. E. Guerin, Inc., 1996.

12. Jean Baudrillard, *Le système des objets*, Paris, Gallimard, 1968.

13. *Ms.*,vol. V, no. 5 (Mar./Apr. 1995), p. 59.

**Part 2: Introduction**
*Notes to pages 104-107*

1. Letter from Glen Wexler to the author, 22 Sept. 1997.

2. Letter from Glen Wexler to the author, 17 Sept. 1997; Steve Morse, "Covers That Rock the Senses," *Boston Globe* (10 Feb. 1995), pp. 59, 63.

3. Morse, "Covers That Rock the Senses," p. 63; letter from Jeri Heiden to the author, 17 Nov. 1995.

4. Letter from Glen Wexler to the author, 22 Sept. 1997.

5. "Statement by Van Halen on *Balance* Album Cover Art," issued by Warner Brothers Records Media Information.

6. Quoted in Morse, "Covers That Rock the Senses," p. 63.

7. Quoted in Steve Morse, "Van Halen Rebounds," *Boston Globe* (20 Jan. 1995), p. 38.

8. Letter from Glen Wexler to the author, 22 Sept. 1997; Morse, "Covers That Rock the Senses," p. 63.

**Part 2: Chapter Six**
*Notes to pages 108-132*

1. Helmut Gernsheim, rev. ed., *Lewis Carroll, Photographer*, New York, Dover Publications, 1969.

2. Waggonner wrote an excellent term paper

for me on Carroll's photography, which she is now building into a Yale history of art doctoral dissertation.

3. On Cameron's dual attachment to family life and career, see *For My Best Beloved Sister Mia: An Album of Photographs by Julia Margaret Cameron*, exhibition catalogue, Albuquerque, University of New Mexico Art Museum, 1994.

4. Julia Margaret Cameron to Sir John Herschel, 31 Dec. 1864, quoted in Helmut Gernsheim, *Julia Margaret Cameron: Her Life and Photographic Work*, New York, Aperture, 1975, p. 14. [First ed. 1948].

5. *The Court Circular*, London (1 Feb. 1868, quoted in Gernsheim, *Cameron*, p. 65). Gernsheim notes of this review that the author was unaware of Carroll's photographs because they were not exhibited or published until 1949.

6. Charles Baudelaire, "The Modern Public and Photography," in Alan Trachtenberg, ed., *Classic Essays on Photography*, New Haven, Leete's Island Books, 1980, p. 87.

7. Edgar Allan Poe, "The Daguerreotype," in Trachtenberg, *Classic Essays*, p. 38.

8. Roland Barthes, *Camera Lucida: Reflections on Photography*. Richard Howard, trans., New York, Farrar, Strauss and Giroux, 1981. (*La chambre claire*, Paris, Seuil, 1980)

9. Umberto Eco, "Critique of the Image," in Victor Burgin, ed., *Thinking Photography*, London, Macmillan, 1982, pp. 32-38.

10. Alan Sekula, "On the Invention of Photographic Meaning,' in Burgin, *Thinking Photography*, p. 86. Thanks to Kristin Curtis for bringing these ideas of Sekula's to my attention.

11. At least nine negatives were made in 1925. Of these, six were printed. In 1977, all six were published in a portfolio titled *Six Nudes of Neil*. Two, including the one discussed here, were printed by Brett Weston as "Project Prints," a collection of what Edward Weston considered his finest work. Amy Conger, *Edward Weston – Photographs: From the Collection of the Center for Creative Photography*, Tucson, Center for Creative Photography, University of Arizona, 1992, p. 43, figs. 170-175/1925.

12. Edward Weston, *The Daybooks of Edward Weston. I. Mexico*, ed. Nancy Newhall, New York, Aperture, 1990, p. 146.

13. *Ibid.*, p. 147.

14. Sally Stein, unpublished talk on Dorothea Lange, delivered May 1996 at Dartmouth College.

15. See George Dimock, "Children of the Mills: Re-Reading Lewis Hines' Child-Labour Photographs," *Oxford Art Journal*, vol. 16, no. 2 (1993), pp. 37-54.

16. Marianna Torgovnik, *Gone Primitive: Savage Intellects, Modern Lives*, Chicago and London, University of Chicago Press, 1990, p. 79.

17. Denis Dutton, "Mythologies of Tribal Art," *African Arts*, vol. XXVII, no. 3 (Summer 1995), pp. 41-42.

18. Goethe, *Propyläen*, Tubingen, J.G. Cotta, 1798 (intro.).

19. For example Lindsay Smith, "'Take Back Your Mink': Lewis Carroll, Child Masquerade and the Age of Consent," *Art History*, vol. 16, no. 3 (Sept. 1993), pp. 369-385.

20. Another important comparison, between Carroll's photographs and naturist photographs, is made by George Lewinski in his *The Naked and the Nude: A History of*

the Nude in Photographs 1839 to the Present, New York, Harmony Books, 1987, pp. 46-52.

21. George Bernard Shaw, *The Star* (1889), quoted in Gernsheim, *Cameron*, p. 67.

22. Carol Mavor, *Pleasures Taken: Performances of Sexuality and Loss in Victorian Photographs*, Durham, Duke University Press, 1995; Carol Armstrong, "Cupid's Pencil of Light: Julia Margaret Cameron and the Maternalization of Photography," *October* (Spring 1996), pp. 114-141.

23. Patricia Gray Berman, "F. Holland Day and His 'Classical' Models; Summer Camp," *History of Photography*, vol. 18, no.4, pp. 348-367.

24. Laurel Bradley, "From Eden to Empire: John Everett Millais's *Cherry Ripe*," *Victorian Studies*, vol. 34, no. 2 (Winter 1991), pp. 178-203.

25. Pamela Tamarkin Reis and Laurel Bradley, "Victorian Centerfold: Another Look at Millais's *Cherry Ripe*," *Victorian Studies*, vol. 35, no. 2 (Winter 1992), pp. 201-206; Robert M. Polhemus, "John Millais's Children: Faith, Erotics, and *The Woodsman's Daughter*," *Victorian Studies*, vol. 7, no. 3 (Spring 1994), pp. 433-450.

26. James Kincaid, *Child Loving: The Erotic Child and Victorian Culture*, New York, Routledge, 1992.

**Part 2: Chapter Seven**
*Notes to pages 133-158*

1. Abigail Solomon-Godeau, "Winning The Game When The Rules Have Been Changed: Art Photography and Post-Modernism," *Exposure*, vol. 23, no. 1 (Spring 1985), p. 6.

2. Nancy Newhall, "Edward Weston and the Nude," from *Modern Photography*, 16 (June 1952), in *Edward Weston Omnibus: A Critical Anthology*, eds Beaumont Newhall and Amy Conger, Salt Lake City, UT, Gibbs M. Smith, 1984, p. 103.

3. Edward Weston,*The Daybooks of Edward Weston. I. Mexico*, ed. Nancy Newhall, Aperture, 1990, pls. 20, 21.

4. Douglas Crimp, "The Photographic Activity of Postmodernism," *October*, 15 (Winter 1980), pp. 91-101. Crimp's position was expanded by Rosalind Krauss in "The Originality of the Avant-Garde: A Postmodernist Repetition," *October*, 18 (Fall 1981), pp. 47-66. It has been taken up again recently by Howard Singerman in "Seeing Sherrie Levine," *October*, 67 (Winter 1994), pp. 78-107.

5. Abigail Solomon-Godeau, "Living with Contradictions: Critical Practices in the Age of Supply-Side Aesthetics," *Screen* (Summer 1987), in *The Critical Image; Essays on Contemporary Photography*, ed. Carol Squiers, Seattle, Bay Press, 1990, pp. 59-79.

6. Douglas Crimp, "The Boys in My Bedroom," *Art in America*, vol. 78, no. 2 (Feb. 1990), pp. 47-49. The original *Art in America* article used a *Neil* showing no genitals; when "The Boys in My Bedroom" was reprinted several years later in a gay anthology, it was illustrated by two *Neil*s, one showing the boy's buttocks, and another his penis.

7. Stephanie Dogloff, "Eros Explored," *American Photo*, vol. 4, no. 6 (Nov.-Dec. 1993), pp. 15-16.

8. Edward Weston, "Photographing Children in the Studio," *American Photography*, vol. 6, no. 2 (Feb. 1912) in *Edward Weston on Photography*, ed. Peter C. Bunnell, Salt Lake City, UT, Gibbs M. Smith, 1983, p. 4.

9. *Ibid.*, p. 4.

10. Weston, *Daybooks*, pp. 118-19.

11. Joanne Leonard has herself written eloquently about the multiple meanings of *Julia's Morning*, including Julia's own reaction to the photograph as an adult. "Photography, Feminism and the Good Enough Mother," forthcoming in Marianne Hirsch, ed., *The Familial Gaze*, Hanover NH, University Press of New England, 1998.

12. Letter from Charlotte Orren, Danville, CA, *People* (6 Nov. 1995), p. 4.

13. Nick Kelsh and Anna Quindlen, *Naked Babies*, New York, Penguin Studio, 1996.

14. Sandra Choron, *The Big Book of Kids' Lists*, New York, World Almanac Publications, 1985, p. 171.

15. David Handelman, "$5 Million Man," *The New York Times Magazine* (29 Dec. 1991), pp.10-13 ff.

16. Lou Harry, "Kid, We're Gonna Make You a Star," *Philadelphia*, vol. 84, no. 7 (July 1993), pp. 89-92.

17. Douglas C. Lyons, "Show Biz Kids," *Ebony*, vol. 45, no. 7 (May 1990), p. 106.

18. John Stark, "Kids for Sale," *People*, vol. 22, no. 20 (12 Nov. 1984), p. 118.

19. *Ibid.*, p. 117.

20. Iris Burton, quoted in Stark, "Kids for Sale," p. 116.

21. *People*, vol. 47, no. 2 (20 Jan. 1997); *Star* (21 Jan. 1997); *National Enquirer* (21 Jan. 1997).

22. Karen de Witt, "Never Too Young to Be Perfect," *New York Times* (12 Jan. 1997), p. E4; Jerry Adler, "The Strange World of JonBenet," *Newsweek* (20 Jan. 1997), pp. 42-47.

23. Jere Longman, "Lipinski, 14, Is Youngest World Champion," and "The Road Ahead Has Perks and Pitfalls," *New York Times* (23 Mar. 1997): 1, section 8, pp. 1, 5.

24. *Time* (22 Apr. 1996).

25. Howard Chua-Eoan, "At Home, but Not Alone," *Time* , vol. 38, no. 23 (9 Dec 1991), pp. 82-83; Stephen J. Dubner, "My Art Belongs to Daddy," *New York*, vol. 26, no. 47 (29 Nov. 1993), pp. 52-57; James Greenberg, "A 'Stage Father' Flexes his New Muscles," *New York Times* (25 Apr. 1993): sec. 2, pp. 17, 24; Greg Kilday, "Who's the Boss at Fox?" *Entertainment Weekly*, no. 147 (4 Dec. 1992), p. 7; Bernard Weinraub, "It Seems the Father of the Child Star Is the Enfant Terrible," *New York Times* (1 Nov. 1993), pp. C13-14.

26. Zoe F. Carter and Mary Ellen Mark, "Baby, It's You," *Premiere* (Nov. 1991), pp. 96-97.

27. For an analysis of the changing role of children in advertisements, and the numbers of them, see Victoria D. Alexander, "The Image of Children in Magazine Advertisements from 1905 to 1990," *Communications Research*, vol. 21, no. 6, (Dec.1994), pp. 742-765.

28. *The Estate of Jacqueline Kennedy Onassis*, New York, Sotheby's, 1996, p. 320.

29. Dianne Russell Condon, *Jackie's Treasures: The Fabled Objects from the Auction of the Century*, New York, Cader Books, 1996, pp. 54-55.

30. John Duka, "Brooke Shields and Company – Manufacturing a Superstar," *New York Times* (2 Aug. 1981), pp. D1,15.

31. *New York Times* (20 Nov. 1980), pp. D1,7; *New York Times* (21 Nov. 1980), p. D5.

32. Elizabeth Peer with Eric Gelman, "The Two Faces of Brooke," *Newsweek* (9 Feb. 1981), p. 80.

33. Joan Goodman, "Pretty Baby," *New York Magazine* (26 Sept. 1977), pp. 32-35.

34. Roderick Mann, "Brooke Shields: $1 Million a Year, But Only $10 a Week," *Los Angeles Times* (21 July 1981), Calendar, p. 22.

35. "Shields' Mother Fights Photos of Nude Brooke," *Los Angeles Times* (26 Sept. 1981): sec. 1, p. 22.

36. "Notes on People," *New York Times* (11 Nov. 1981), p. B8.

37. "Brooke Shields Gains Ban on Use of Photos," *New York Times* (18 June 1982), p. D19.

38. "Brooke Shields Loses Court Case," *New York Times* (30 Mar. 1983), p. B4.

39. "Personalities," *Washington Post* (14 May 1983), p. C3.

40. Ivor Davis, "Baby Brooke Takes Her Stuff to the Masses," *Los Angeles* (Jan. 1979), pp. 135-37ff; Alan Ebert, "Brooke Shields: Sexy Rep, Movie Millions, but Mom's Rules Are Strict – No Dates Yet," *US* (15 May 1979), pp. 24-26; "From 'Blue Lagoon' to Blue Ads for Blue Jeans, Nothing is Coming Between Her and Success," *People* (29 Dec.1980/5 Jan. 1981), pp. 82-83.

41. Tom Zito, "Brooke Shields, Pure and Simple," *Washington Post* (22 June 1981), p. C1.

42. Interview in *Rolling Stone* (6 Apr. 1978), p. 42.

43. Interview with M. R. Axelrod, *Splash* (Oct. 1988), np.

44. Maureen Dowd, "What Calvin Means," *New York Times* (31 Aug. 1995), p. A25.

45. *New York Times* (28 Aug. 1995), p. A5.

46. Pat Sloan and Jennifer DeCoursey, "Gov't Hot on Trail of Calvin Klein Ads," *Advertising Age* (11 Sept. 1995), pp. 1, 8; Guy Trebay, "Is Calvin Clean?" *Village Voice* (19 Sept. 1995), p. 17.

47. Camille Paglia, "Kids for Sale," *The Advocate* (31 Oct. 1995), p. 80.

48. Barbara Lippert, "Calvinst Youth," *Adweek* (31 July 1995), p. 34.

49. Michelle Ingrassia, "Calvin's World," *Newsweek* (11 Sept. 1995), pp. 60, 66.

50. Robert E. Clark and Judith Freeman Clark, *The Encyclopedia of Child Abuse*, New York, Facts on File, 1989, p. 164.

51. For instance Tad Friend, "Lolita in Hollywood," *Vogue* (Nov. 1996), pp. 294-297, 344-45.

52. Elizabeth Kaye, "'Lolita': the Second Coming," *Esquire* (Apr. 1997), pp. 58-62ff.

53. "The New Queens of Teen!" *Spy* (June 1997), pp. 42-49.

54. George Howe Colt, "Who was Pocahontas?", *Life* (July 1995), p. 69.

55. Charles Gandee, "The Making of a Model," *Vogue* (Aug. 1994), pp. 268-71.

56. Nicholas D. Kristof, "A Plain School Uniform as the Latest Aphrodisiac," *New York Times* (2 Apr. 1997), p. A4.

57. Rich Cohen, "Ballad of a Teenage Queen," *Rolling Stone*, issue 716 (7 Sept. 1995), pp. 44-50.

58. Kathy Merrell, "The Scent of a Woman,"

*Allure*, 1996, pp. 140-142ff.

59. Richard D. Mohr has written an excellent short essay on this issue: "The Pedophilia of Everyday Life," *Art Issues*, no. 42 (Mar./Apr. 1996), pp. 28-31.

60. Diana Ketcham, "Desert Swank," *House & Garden* (Sept. 1996), pp. 298-99.

61. Julie V. Iovine "Helter-Shelter: New Look for Dream Books," *New York Times* (22 Aug. 1996), pp. C1, C8.

**Part 2: Chapter Eight**
*Notes to pages 159-192*

1. "Albert II Calls on Nation to Seek a 'Moral Revival'," *International Herald Tribune* (19-20 Oct. 1996), pp. 1,5; "300,000 Belgians Show Their Anger," *International Herald Tribune* (21 Oct. 1996), pp. 1, 10.

2. "Children as Sex Slaves: Exposing a Dirty Secret," *International Herald Tribune*, (28 Aug. 1996), pp. 1, 6.

3. *Ibid.*

4. Title 18 of the United States Code, amended by the Child Sexual Abuse and Pornography Act of 1986; Chapter 110, Sexual Exploitation of Children, and later by the 1988 Child Protection and Obscenity Act, which was revised in October 1990. Enforcement of these laws was carried out by the National Obscenity Enforcement Unit created in 1986 by then Attorney General Edwin Meese, and now by the Child Exploitation and Obscenity Section.

5. The Meese report has been sharply criticized for its conservative bias and sloppy arguments. See Barry W. Lynn, *Polluting the Censorship Debate. A Summary and Critique of the Final Report of the Attorney General's Commission on Pornography.*

Washington, DC, American Civil Liberties Union, 1986.

6. *Attorney General's Commission on Pornography Final Report*, Washington, DC, Department of Justice, 1986, p. 405.

7. *Ibid.*, p. 597.

8. *Ibid.*, p. 597.

9. *Ibid.*, pp. 596-97.

10. Some comparisons were also made to the work of Jock Sturges, a photographer who specializes in the cusp of adolescence. Harrison herself said she had not been thinking of Mann's work as she wrote her novel, but rather of Mapplethorpe's. Wendy Smith, "Shooting His Daughter," *Washington Post Book World*, 23, no. 10 (7 Mar. 1993), p. 7; David Shields, "*Exposure* Sees Inside the Alluring, Shiny Object: the Photographer's Child," *Boston Globe* (21 Feb.1993), p. B44; Joseph Kahn, "Kathryn Harrison's Troubled Families," *Boston Globe* (15 Mar. 1993), pp. 32-33; Louise Bernikow, "Books," *Cosmopolitan* (Feb. 1993), p. 16; Laura Mathews, "X-Rated Dad," *Glamour*, 91 (Feb. 1993), p. 133; David Sacks, "Indecent Exposure," *Harper's Bazaar* (Mar. 1993), pp. 134, 314; Vince Passarro, "Private Eye," *Los Angeles Times Books Review* (14 Feb. 1993), pp. 3,7; Michiko Kakutani. "Growing Up Abused: A Painful Then, A Painful Now," *New York Times* (16 Feb. 1993), p. C15; Howard Coale, "The Photographer's Daughter," *New York Times Book Review*, 98 (14 Mar. 1993), p. 10; Karen Heller, "A Heroine Committed to Self-Destruction," *Philadelphia Inquirer* (21 Feb. 1993), p. F3; Sybil Steinberg, "Forecasts: Fiction," *Publishers Weekly*, 239 no. 52 (30 Nov. 1992), p. 38; Patricia O'Connell, "Kathryn Harrison: Her Harrowing Psychological Novels Are Fictional, But Seem Vividly Real," *Publishers Weekly*, 240, no. 9 (1 Mar. 1993), p. 33; Joy Press, "Photo-Op," *Village Voice*,

38 (23 Mar. 1993), p. 83.

11. See Ian Hacking, "The Making and Molding of Child Abuse," *Critical Inquiry*, 17 (Winter 1991), pp. 253-288. To some Europeans, an intense preoccupation with child abuse seems particularly American. Jean Baudrillard, for example: "The latest obsession of American public opinion: the sexual abuse of children. There is now a law that two people must be present when very young children are being handled for fear of unverifiable sexual abuse. At the same time, supermarket carrier bags are adorned with the portraits of missing children. Protect everything, detect everything, contain everything – obsessional society." *America*, tr. Chris Turner. London, New York, Verso, 1988, p. 40.

12. Andrew Vachss, "Age of Innocence," *London Observer* (17 Apr. 1994), p. 14.

13. Letter from Ronna Harris, 6 Aug. 1997.

14. *Ibid.*

15. See Arthur C. Danto, *Playing with the Edge; the Photographic Achievement of Robert Mapplethorpe*, Berkeley, University of California Press, 1996, pp. 15-17, 59-63.

16. A contrast pointed out to me in class by a student, Julia Alexander.

17. Cited in Arthur Danto, *Playing with the Edge*, p. 61.

18. *Ibid.*, p. 61.

19. *Ibid.*, p. 78.

20. U.S. postal inspector Robert Northrop, quoted by Alice Sims in Elizabeth Hess, "Snapshots, Art, or Porn?" *Village Voice* (25 Oct. 1988), pp. 31-32.

21. Susan H. Edwards, "Pretty Babies: Art, Erotica or Kiddie Porn?" *History of Photography*, vol. 18, no. 1 (Spring 1994), pp. 38-46; Allen Ginsberg and Joseph Richey, "The Right to Depict Children in the Nude," in *The Body in Question*, ed. Melissa Harris, New York, Aperture, 1990, pp. 42-45; Laura U. Marks, "Minor Infractions: Child Pornography and the Leglislation of Morality," *AfterImage* (Nov. 1990), pp. 12-14; Lawrence Stanley, "Art and Perversion: Censoring Images of Nude Children," *Art Journal*, vol. 50, no. 4 (Winter 1991), pp. 20-27.

22. Hess, "Snapshots, Art, or Porn," pp. 31-32.

23. Jamie Jamieson, "Village Exposed to Art," *Brookline Tab* (31 May 1994), pp, 1, 4; Jason B. Johnson, "Flashing Lights!" *Boston Herald* (25 May 1994), pp. 1, 6; Jason B. Johnson, "Brookline Art Honcho Defends Flashy Sign," *Boston Herald* (26 May 1994), p. 1; Matthew Kelly, "Traffic Stops for Art Project," *Brookline Citizen Journal* (27 May 1994), pp. 1, 11; Christine Temin, "Mother and Child Stir Up Trouble," *Boston Globe* (27 May 1994), pp. 33, 37.

24. Interview with Denise Marika, spring 1995.

25. Letters from Robyn McDaniels [formerly Stoutenberg] to the author, 19 July 1995 and 11 Sept. 1995.

26. *National Campaign for Freedom of Expression Bulletin* (Winter 1994), p. 1.

27. Amy Hufnagel, "Patti Ambrogi," *Contact Sheet 73*, Syracuse, NY, Light Work, 1992, np.

28. *Sexual Exploitation of Children*. A Report to the General Assembly by the Illinois Legislative Investigating Commission, Chicago, IL, 1980, p. 27.

29. "In the Matter of Glenn G. and Another, Children Alleged to be Abused. Patsy C. G.

et al., Respondents," Docket Nos. Na6697-8/91 Family Court, Kings County. 154 Misc. 2d 677; 587 N.Y.S. 2d 464; 1992 N.Y. Misc. LEXIS 304.

30. "Man Accused of Child Killings 'Admitted Interest in Young Girls'," *The Manchester Guardian* (29 Apr. 1994), p. 4; John Mullin, "Architect of Evil Whose Chance Arrest Solves Series of Child Killings," *The Manchester Guardian* (20 May 1994), p. 4; Malcolm Pithers, "Killer Faces Questions on More Sex Murders," *The Independent* (20 May 1994), p. 3.

31. Tom Mashberg and Ed Hayward, "State Developed 3-Pronged Prosecution of Amiraults," *Boston Sunday Herald* (3 Dec. 1995), pp. 26-27.

32. Laura Kiernan, "Ex-Teacher at Exeter Guilty of Porn Charges," *The Boston Globe* (10 Oct. 1992), pp. 1, 38.

33. William A. Fisher and Azy Barak, "Pornography, Erotica, and Behavior: More Questions Than Answers," *International Journal of Law and Psychiatry*, vol. 14 (1991), pp. 65-83; Robert L. Geiser, *Hidden Victims: The Sexual Abuse of Children.* Boston, Beacon Press, 1979; Michael J. Goldstein and Harold Sanford Kant, *Pornography and Sexual Deviance*, Berkeley, University of California Press, 1973; Nadine Strossen, *Defending Pornography: Free Speech, Sex, and the Fight for Women's Rights,* New York, Scribner, 1995.

34. National Committee to Prevent Child Abuse, "Child Abuse and Neglect Statistics," April 1996.

35. Robin E. Clark and Judith Freeman Clark, eds. *The Encyclopedia of Child Abuse*, New York and Oxford, Facts on File, 1989, p.164.

36. *Sexual Exploitation of Children.* A Report to the Illinois General Assembly by the Illinois Legislative Investigating Commission, Chicago, IL, 1980, p. 3.

37. Judy Rakowsky, "Phillips Fires Teacher; DA Enters Probe," *Boston Globe* (2 Sept. 1995), p. 1.

38. Catharine McKinnon, *Only Words*, Cambridge, MA, Harvard University Press, 1993.

39. Reports of endemic child pornography uniformly rely on empty rhetoric, isolated anecdotes, and oddly obsessive witnesses. For instance, a report by the Senate Judiciary Committee: "Cyberporn and Children: The Scope of the Problem, the State of the Technology and the Need for Congressional Action," Washington, DC, 24 July 1995.

40. *Sexual Exploitation of Children*, p. 27.

41. *Ibid.*, p. 30.

42. *Ibid.*, pp. 59-61.

43. *Attorney General's Commission on Pornography Final Report.* Department of Justice, Washington, DC, July 1986, pp. 415-416.

44. Doreen Carvajal, "Pornography Meets Paranoia," *New York Times* (19 Feb. 1995). See also Lawrence A. Stanley, "The Child Porn Myth," *Cardozo Arts and Entertainment Law Journal*, vol. 7, no. 2 (1989), pp. 295-359.

45. David Johnston, "Use of Computer Network For Child Sex Sets off Raids," *New York Times* (14 Sept. 1995), pp. A1, A18.

46. Stephen Labaton, "As Pornography Arrests Grow, So Do Plans for Computer Stings," *New York Times* (16 Sept. 1995), pp. A1, A8. Repeated written queries to two FBI offices about the results and costs of their child

pornography investigations have gone unanswered.

47. "Siding with Rosie," *The New Statesman*, vol. 125, no. 4301 (20 Sept. 1996), p. 5.

48. Sara O'Meara, quoted in "Childhelp Strongly Disagrees with Justice Department, Applauds Senate's Unanimous Condemnation," *PR Newswire* (5 Nov. 1993). O'Meara was reacting to *Knox*.

49. Of course a related issue would be what kinds of depicted actions are considered criminal. Should all child nudity, for instance, be considered equally pornographic?

50. Interview with Drew Days III, 14 Aug. 1996.

51. *Ibid.*

52. Interview with Harold Koh, Yale Law School Professor, Dec. 1994.

53. Implicitly recognizing Days's argument, however, the court of appeals also maintained for the first time in *Knox*'s history that the movements of the children in the tapes seemed to be directed by someone outside the image frame, movements which might therefore be "unnatural."

54. Linda Greenhouse, "U.S. Changes Stance in Case on Obscenity," *New York Times* (11 Nov. 1994).

55. *Congressional Record – Senate.* vol. 141, no. 142 (13 Sept. 1995) S.1237.

56. FDCH Congressional Hearings Summaries, 4 June 1996.

57. Cited in John Schwartz, "New Law Expanding Legal Definition of Child Pornography Draws Fire," *New York Times* (4 Oct. 1996), p. A10.

58. MTV week of 11/5 "News in Rock"; see also Steve Morse, "Covers That Rock the Senses," *Boston Globe* (10 Feb. 1995), pp. 59, 63.

59. Mitchell Martin, "Germany Forces CompuServe to Censor Sex on the Internet," *International Herald Tribune* (29 Dec. 1995), p. 1.

60. Dalya Alberge, "Child Charities Attack Gallery's Explicit Display," *The Times,* London (9 Sept. 1996).

61. Suzanne Moore, "Photography and the New Censorship," *The Independent* (12 Sept. 1996), p. 1.

62. Dee Jepsen, "Written Testimony," p. 4, Senate Judiciary Committee, "Cyberporn and Children: The Scope of the Problem, the State of the Technology and the Need for Congressional Action," 24 July 1995.

63. Roger Rosenblatt, "The Society That Pretends to Love Children," *New York Times Magazine* (8 Oct. 1995), p. 60.

64. Dale Russakoff, "The Protector," *The New Yorker* (21 Apr. 1997), p. 60.

65. David van Biema, "Abandonned to Her Fate," *Time ,*vol. 146, no. 24 (11 Dec. 1995), p. 35.

66. Nina Bernstein, "Caseworkers Pressured to Close Children's Files," *New York Times,* (2 Dec. 1995), p. 1.

67. United States of America v. Robert David Sirois. no. 1276, Docket 95-1547, United States Court of Appeals, Second Circuit, vol. 87 F.3d series p34: 41, 39.

68. Photo Law Reform Group, *California Child Pornography Laws: A Guide for Photo Processing Labs and Photographers,* San Francisco, 1993, p. 2.

69. Brian MacQuarrie, "No Clear Focus on Nude Photos," *Boston Globe* (6 Jan. 1996), pp. 1, 4.

70. Paul Wilkinson, "Father Tells How He Rescued Daughter from Kidnap Van," *The Times*, London (29 Apr. 1994), p. 3; Paul Wilkinson, "Abandoned, Ridiculed, and Widely Despised," *The Times,* London (20 May 1994), p. 4.

71. Goldstein and Kant, *Pornography and Sexual Deviance*, p. 31.

## Part 2: Chapter Nine
*Notes to pages 193-225*

1. Shannah Ehrhart, "Sally Mann's Looking Glass War", in *Tracing Cultures: Art History Criticism, Critical Fiction,* New York, Whitney Museum of American Art, 1994, pp. 52-56.

2. Lynn Hirschberg, "Strange Love," *Vanity Fair* (Sept. 1992), p. 299.

3. Kimm Neely, "Courtney Love," *Rolling Stone* (23 Dec. 1993 – 6 Jan, 1994), p. 73.

4. Julia Kristeva, "Stabat Mater," in *Histores d'amour*, Paris, Denoël, 1983, pp. 225-247.

5. Julia Kristeva, "Motherhood According to Giovanni Bellini," in *Desire in Language. A Semiotic Approach to Literature and Art,* ed. Leon S. Roudiez, tr. Thomas Gora, Alice Jardine, Leon Roudiez, New York, Columbia University Press, 1980, pp. 237-269.

6. Diana Fuss, *Identification Papers*, New York and London, Routledge, 1995, pp. 2-3.

7. Ewa Lajer-Burcharth, "Real Bodies: Video in the Nineties," *Art History*, vol. 20, no. 2 (June 1997), pp. 185-213.

8. "Matrix is an unconscious space of simultaneous emergence and fading of the *I* and the unknown *non-I* which is neither fused nor rejected. Matrix is based on feminine/prenatal inter-relations and exhibits a shared border space in which what I call *differentiation-in-co-emergence* and *distance-in-proximity* are continuously rehoned and reorganised by metramorphosis (and accompanied by matrixial affects) created by – and further creating – *relations-without-relating* on the borderspaces of presence and absence, subject and object, me and the stranger. In the unconscious mind, the matrixial borderline dimension, involved in the process of creating feminine desire and meaning, both coexists and alternates with the phallic dimension." Cited in Griselda Pollock, "After the Reapers: Gleaning the Past, the Feminine and Another Future, from the Work of Bracha Lichtenberg Ettinger," in Bracha Lichtenberg Ettinger, *Halala-Autistwork*, Jerusalem, The Israel Museum, 1995, p. 130.

9. Jane Gallop, "Observations of a Mother," forthcoming in *The Familial Gaze*, ed. Marianne Hirsch, Hanover, NH, University Press of New England.

10. Jane Livingston, *Lee Miller Photographer*, New York, Thames and Hudson, 1989, p. 27.

11. Annette Michelson, "Lolita's Progeny," *October* 76 (Spring 1996), pp. 3-14.

12. Sally Mann, *Immediate Family*, New York, Aperture, 1992, np.

13. "What Grownups Don't Understand," *New York Times Magazine* (8 Oct. 1995), p. 54.

14. *Ibid.*, p. 66.

15. Cited by Camille Sweeney, "What Grownups Don't Understand," pp. 52-3.

16. Dorothy Allison, *Bastard Out of Carolina*, New York, Dutton, 1992; Arlie Russell

Hochschild, "There's No Place Like Work," *New York Times Magazine* (20 Apr. 1997), pp. 51-55 ff.

17. Letter from the artist, 9 Aug. 1997.

18. Betty Freidan, "Children's Crusade," *New Yorker* (3 June 1996), p. 6.

19. *Photographing Children*, New York, Time-Life Books, 1971, p. 64.

20. See Emmet Gowin, *Photographs*, New York, Knopf, 1976; Barbara Tannenbaum, *Ralph E. Meatyard: An American Visionary*, New York, Rizzoli, 1991; Arthur Tress, *The Dream Collector*, text by John Minahan, Richmond, VA, Westover, 1972.

21. For a very revealing essay on the underlying issues of Ockenga's work, see T.B. Brazelton, M.D., "Thoughts on Starr Ockenga's Pictures," *Polaroid Close-Up*, vol. 14, no. 2 (Winter 1983), pp. 35-39.

22. Interview with Dick Blau, May 1997.

23. Gertrude Stein, *The Autobiography of Alice B. Toklas*, New York, Harcourt, Brace and Co., 1933, p. 231.

24. Wendy Ewald, "Black Self/White Self," *Doubletake*, vol. 2, no. 3 (Summer 1996), p. 57.

25. Jackie Wullschläger, *Inventing Wonderland. The Lives and Fantasies of Lewis Carroll, Edward Lear, J.M. Barrie, Kenneth Grahame and A.A. Milne*, New York, The Free Press; London, Methuen, 1995.

26. *Daybooks of Edward Weston; How Young I Was*, 1965. *Daybooks of Edward Weston: Strongest Ways of Seeing*, 1965. National Educational Television. Distributed by Indiana University Audio Visual Center.

27. Cited in Ingrid Sischy, "Photography. White and Black," *The New Yorker* (13 Nov. 1989), p. 142.

28. Talk by John Dixon on the panel "A Family Album: Personal Recollections of Dorothea Lange," San Francisco Museum of Art, June 1994, courtesy of Sally Stein, panel moderator.

29. Nancy Hutchings, *The Violent Family*, New York, Human Sciences Press, 1988, pp. 92-93.

Majesty Queen Elizabeth II

Plympton St. Maurice Guildhall Collection

42  KATE HAYLLAR A Thing of Beauty is a Joy Forever 1890. The FORBES Magazine Collection, New York. All rights reserved

43  KATE GREENAWAY 'Ring-a-Ring-a-Roses' 1881, from Mother Goose sketchbook. Mary Evans Picture Library, London

44  BETSY CAMERON Baby Blue Eyes 1994. Courtesy the artist

45  ANNE GEDDES Cheesecake 1993. © 1997 Anne Geddes

46  (and frontispiece) SHEILA METZNER Stella on Fire 1982. © 1982 Sheila Metzner/Graphistock

47  NAN GOLDIN Io in Camouflage 1994. Courtesy the artist

48  GLEN WEXLER AND VAN HALEN Balance album cover 1994. Courtesy Glen Wexler and Warner Brothers Records

49  CHARLES DODGSON (LEWIS CARROLL) Alice Liddell and sisters Edith and Lorina c.1859. Gernsheim Collection, Harry Ransom Humanities Research Center, University of Texas at Austin

50  WILLIAM BLAKE RICHMOND Edith, Lorina and Alice Liddell 1864. Oil on canvas. Private Collection/The Bridgeman Art Library, London

51  JULIA MARGARET CAMERON Devotion (My Grandchild) 1865. Gernsheim Collection, Harry Ransom Humanities Research Center, University of Texas at Austin

52  EDWARD WESTON Neil (from behind) 1925. © Center for Creative Photography, Arizona Board of Regents

53  DOROTHEA LANGE Damaged Child,

Shacktown, Elm Grove, Oklahoma 1936. Copyright The Dorothea Lange Collection, The Oakland Museum of California, The City of Oakland. Gift of Paul S. Taylor

54  HELEN LEVITT New York 1942. © Helen Levitt. Courtesy Laurence Miller Gallery, New York

55  JOSÉ ANGEL RODRÍGUEZ Los Chorros, Chenalhó, Chiapas 1981. Courtesy the artist

56  JUAN DE DIOS MACHAIN Portrait of a Dead Child, late nineteenth-early twentieth century. Courtesy Gutierre Aceves, Instituto Cultural Cabañas, Mexico

57  E. THOMAS GILLIARD Melanesian Girl with Pandanus Specimens 1950. Courtesy Department of Library Services, American Museum of Natural History, New York

58  CHARLES DODGSON (LEWIS CARROLL) Reclining Nude 1879. Rosenbach Museum and Library, Philadelphia

59  CHARLES DODGSON (LEWIS CARROLL) Alice Liddell as The Beggar Maid c.1859. Gilman Paper Company Collection, New York

60  JULIA MARGARET CAMERON Cupid (The Adversary) c.1866. J. Paul Getty Museum, Los Angeles

61  CLEMENTINA HAWARDEN Daughters on a Balcony c.1865. V&A Picture Library, London

62  CALDESI Prince Albert 1857. Royal Archives © 1997 Her Majesty Queen Elizabeth II

63  ALICE HUGHES Pamela, Countess Lytton with her son Antony, Viscount Knebworth 1904. Knebworth House Collection, Hertfordshire

64 CLARENCE WHITE Two Nude Figures and a Statue in a Wood 1905. Davis Museum and Cultural Center, Wellesley College, Wellesley, Massachusetts, Museum Purchase 1997.48

65 NELL DORR VND With Nude Baby c.1940. Amon Carter Museum, Texas

66 EDWARD WESTON Neil 1925. © Center for Creative Photography, Arizona Board of Regents

67 SALLY MANN Popsicle Drips 1985. © Sally Mann, courtesy Houk Friedman, New York.

68 EDWARD WESTON Brett Weston, Nude, Reaching Up with Flowers,Trellis Behind c.1913. J. Paul Getty Museum, Los Angeles. © 1981 Center for Creative Photography, Arizona Board of Regents

69 EDWARD WESTON Neil Weston, page from personal photograph album, c.1925. J. Paul Getty Museum, Los Angeles. © 1981 Center for Creative Photography, Arizona Board of Regents

70 JOANNE LEONARD Julia's Morning 1975. Courtesy the artist

71 JOANNE LEONARD page from personal Julia album, 1975. Courtesy the artist

72 Nicole Brown and O.J. Simpson Christmas card 1995. Courtesy Dove Books, Los Angeles

73 GAIL GOODWIN Dressed to Kill 1993. © 1993 Gail Goodwin, San Anselmo, CA

74 MARY ELLEN MARK Beauty Pageant: Hairspray 1997 (original in colour) Courtesy the artist

75 Jacqueline Bouvier Kennedy and John F. Kennedy Jr. upstairs in the White House 1962. John F. Kennedy Library, Boston

76 DEWEY NICKS Two Girls 1996. Courtesy Outline Gallery, New York/Katz Pictures, London

77 DOROTHEA LANGE Torso, San Francisco 1923. Copyright The Dorothea Lange Collection, The Oakland Museum of California, The City of Oakland. Gift of Paul S. Taylor

78 RONNA HARRIS Pygmalion c.1995. Courtesy the artist and Still-Zinsel Contemporary Fine Art, New Orleans

79 CARAVAGGIO Cupid 1598–99. Oil on canvas 154 x 110 (60 $^5/_8$ x 43 $^1/_4$). Staatliche Museen Preussicher Kulturbesitz, Berlin

80 ROBERT MAPPLETHORPE Jessie McBride 1976. © 1976 The Estate of Robert Mapplethorpe/Art & Commerce Anthology, New York

81 ROBERT MAPPLETHORPE Rosie 1976. © 1976 The Estate of Robert Mapplethorpe/Art & Commerce Anthology, New York

82 DENISE MARIKA Crossing 1994. Courtesy the artist

83 ROBYN MCDANIELS Oscar With Birds c.1993. Courtesy the artist

84 PATTI AMBROGI X's and O's; The Sun and the Earth 1992. Courtesy the artist

85 SALLY MANN Jessie at Five 1987. © Sally Mann, courtesy Houk Friedman, New York

86 SALLY MANN Last Light 1990. © Sally Mann, courtesy Houk Friedman, New York

87 SALLY MANN The New Mothers 1989. © Sally Mann, courtesy Houk Friedman, New York

# Acknowledgments

It is a great pleasure to acknowledge the insights and information contributed to this book by so many people: Emily Apter, Valerie Asher, Ian  Ayre, Bettina Bergman, Pat Berman, Ann Bermingham, Susan Casteras, Joan Gallant Dooley, Elsa Dorfmann, Sarah Ganz, Lucy Flint-Gohlke, Henry Hansmann, Marianne Hirsch, Jenni Holder, Elizabeth Honig, Lisa Hsia, Wayne Koestenbaum, Harold Koh, Mack Lee, Mary Beth Lewis, Andrew McClellan, Eleanor Rubin, Ainlay Samuels, Larry Silver, Vernon Shetley, Sydney Speisel, Natasha Staller, Sally Stein, Zoë Strother, Sarah Webb, Laura Wexler, Sarah Winter, and Elizabeth Young.

I wish I knew the names of all those who asked such useful questions after lectures at the Center for Contemporary Art of Mexico City, Dartmouth College, Mt. Holyoke College, Trinity College, Tufts University, and the University of California at Santa Barbara.

This entire project began as a spring 1995 Wellesley College seminar, to whose participants I owe a pedagogic debt: Cassi Albinson, Heather Ba, Alexandra Bermudez, Kristin Curtis, Elizabeth Gorayeb, Shruti Jhaveri, Klara Mezgolitz, Sun Namkung, Martha Norton, Hannah Park, and Lucia Vancura. My Wellesley colleagues have supported me in countless ways. An anonymous donor funded a conference held at Wellesley College on pictures of innocence.

I was blessed with a streak of outstanding research assistants: Alexandra Bermudez, Kristin Curtis, Jennifer Smyth, and Diane Waggoner, and especially Sarah Harrell and Cassi Albinson, whose stamina and creativity never failed. Matthieu Bignolas helped me prepare the index.

Ethel Higonnet, Margaret Higgonet, Patrice Higonnet, Janet King, Maud Lavin and Christina Spiesel read, questioned, and honed chapters. John Geanakoplos tirelessly labored over the introduction. Nikos Stangos, my editor, helped me reshape the book as a whole, and fought battles he should never have had to fight. Fern Bryant polished the final versions of the manuscript. Margaret Cohen, Gloria Kury, Molly Nesbit, and Kristin Ross not only gave the entire project the benefit of their close and constructive readings, they also gave me a sense of intellectual community and purpose.

Most of all, I owe this book to the women who helped me care for my first son and cope with a second pregnancy, then with a newborn, while I researched, wrote and dealt with book production problems: the teachers of the Children's Preschool, Janet King and Virginie Rollet.